OBJECTS OF DESIRE : THE MODERN STILL LIFE

OBJECTS OF DESIRE

THE MUSEUM OF MODERN ART, NEW YORK

MARGIT ROWELL

THE MODERN STILL LIFE

DISTRIBUTED BY HARRY N. ABRAMS, INC., NEW YORK

CONTENTS

Published on the occasion of the exhibition
Objects of Desire: The Modern Still Life, organized
by Margit Rowell, Chief Curator, Department
of Drawings, at The Museum of Modern Art,
New York, May 25 – August 26, 1997

The exhibition will travel to the Hayward
Gallery, London, under the auspices of
The International Council of The Museum of
Modern Art, October 9, 1997 – January 4, 1998

An indemnity for the exhibition has been
granted by the Federal Council on the Arts
and the Humanities.

Generous support is provided by AT&T.

This publication is made possible by a
generous grant from the Blanchette Hooker
Rockefeller Fund.

Produced by the Department of Publications
The Museum of Modern Art, New York
Edited by David Frankel
Designed by J. Abbott Miller, Paul Carlos—
 Design/Writing/Research
Production by Marc Sapir
Printed and bound by Amilcare Pizzi S.p.A.,
 Milan

Library of Congress Catalog Card Number:
 96-080496

ISBN 0-87070-110-X
 (clothbound, MoMA/Thames and Hudson)

ISBN 0-87070-111-8 (paperbound, MoMA)

ISBN 0-8109-6172-5 (clothbound, Abrams)

Published by The Museum of Modern Art
11 West 53 Street, New York, New York 10019

Clothbound edition distributed in the United
States and Canada by Harry N. Abrams, Inc.,
New York

Clothbound edition distributed outside the
United States. and Canada by Thames and
Hudson, Ltd., London

COVER
Domenico Gnoli. *Without a Still Life*. 1966. Synthetic
polymer paint and sand on canvas,
53 15/16 x 79 1/2" (137 x 202 cm). Staatliche Museen
zu Berlin, Preussischer Kulturbesitz, Neue
Nationalgalerie, Berlin. See plate 130

PRINTED IN ITALY

Since its founding, over sixty years ago, The Museum of

Modern Art has presented a series of pioneering exhibitions that have explored critical issues and ideas in modern art. *Objects of Desire: The Modern Still Life* continues this tradition by examining in detail one of art's most intriguing and persistent genres as artists have treated it in this century. Like other modes, such as portraiture and landscape painting, the still life has undergone substantial and radical transformations over the last hundred years as artists have subverted and supplanted traditional notions of still life composition and imagery with new and transgressive modes of expression.

While this catalogue and the exhibition that it accompanies take a broad look at the way twentieth-century artists have responded to the still life genre, they should not be seen as a survey or systematic reading of the still life in that period. Rather, the exhibition examines how radical notions of time and place, reality and fiction, art and society, have reordered our understanding of the still life. It is from this notion of reality transformed that the exhibition and catalogue take their title. For still lifes by their very nature are highly contrived assemblages or narratives, carefully constructed to amplify the quotidian by refracting and magnifying it, turning the commonplace into an object of desire.

There is a certain paradox, however, to the idea of the still life as such an object. Within the system of genres that operated throughout the nineteenth century, still life painting, which has its origins as an independent form in the early seventeenth century, occupied the lowest rank of importance. Yet precisely because the still life was not invested with the complex meanings and aspirations associated with more esteemed genres, such as history painting or portraiture, it became the perfect vehicle for twentieth-century avant-garde artists to transform into a vital means of contemporary expression. It is in the exploration of this paradox and the decoding of the systems that structure and order the still life that *Objects of Desire* reveals its many pleasures. For it is ultimately an exhibition about remarkable works of art—from Picasso's *Still Life with Pitcher and Apples* to Meret Oppenheim's *Object*, Marcel Broodthaers's *Casserole and Closed Mussels*, Charles Ray's *Tabletop*,

Kiki Smith's *Second Choice*, and Wolfgang Laib's *Milkstone*—that are as tantalizing and haunting as they are wondrous and provocative.

This exhibition and catalogue are the result of an extensive amount of research and cooperation, and I want to thank in particular the many lenders for their generosity and this Museum's staff for its contributions to all aspects of the exhibition and its catalogue. I am grateful to the Federal Council on the Arts and the Humanities for providing an indemnity for many works of art in the exhibition that were borrowed from international public and private collections. Generous support was also provided by AT&T, and this book was made possible by a generous grant from the Blanchette Hooker Rockefeller Fund. A project of this scale is necessarily a complicated undertaking, and I would like to express my deep appreciation to Agnes Gund and Daniel Shapiro for their deeply felt commitment to its success.

Above all I want to thank Margit Rowell, the Chief Curator of the Department of Drawings, whose vision and insight have led her to reconsider the whole idea of the still life in the twentieth century. Her discerning eye is evident in the show's selection of works, and her scholarship and knowledge in this catalogue's detailed and revealing essay.

Glenn D. Lowry
DIRECTOR, THE MUSEUM OF MODERN ART

To attempt to tell the story of the modern still life
is virtually equivalent to trying to tell the story of twentieth-century
avant-garde art. This narrowly circumscribed genre has to this day been
locked into a definition (or rather a perception) based on its lowest
common denominator, the inanimate commonplace object, and yet,
precisely *because* of this consistent and presumably unadventurous subject
matter, the still life has lent itself to all manner of adventurous visual
interpretation. These artworks are not just beautiful or realistic
renderings of static objects. The still life, rather, is an evolving system of
representation and of meaning, directly related to the transformations
of society and of artistic discourse. It addresses certain positions a
society maintains in relation to its objects: realities, fantasies, and
desires. Similarly, it transcribes the manner in which the art deals with
these truths or untruths—the way the artist reinvents a visual language
specifically keyed to their implementation.

Since its invention, at the beginning of the seventeenth century,
the still life has indeed kept perpetually the same subject: the familiar,
recognizable object, isolated or in a group. According to its critics,
then, the genre's scope is severely limited. Yet one might argue that
those of portraiture and landscape painting are similarly constricted—
the portrait subject is always a person, and the landscape subject is always
a landscape, even though the artist selectively identifies which aspects
will be emphasized at the expense of others. A still life, on the other
hand, often does not exist until the artist decides to constitute the
model. Which is to say that even the model may be conceived by the
artist, before being executed by his or her hand.

The process of selection is traditionally influenced by the role
certain objects play in the context of a given society. Although the objects
are relatively generic, as subjects they are not timeless; their choice is
dictated by their place, be it passive or aggressive, in a historical and
cultural fabric. The deliberate choice of these objects over others
identifies them, in the simplest sense, as "objects of desire."

Objects of desire are not real but fictive, seen through a distorting
lens. They furthermore enact a structure of desire that is a closed
narrative system. Because the drive or pulsion of desire, in order to be

sustained, must be unsatisfied, the objects desired (or the climax of the story) are ever distant or deferred. Thus the objects of a still life, although they appear accessible, are actually inaccessible, fictional, created; ideal as opposed to real. They and their interpretation and articulation embody ideological conventions and patterns, removed from the direct experience of the real world.

The conventionally "inanimate" material condition of the objects of a still life, and the fact as well that they are fictions, encourage the artist to take infinite liberties in their representation and interpretation, and to invent or obey subtle semantic and formal codes in order to project their mute yet eloquently symbolic messages. Yet even more than this, it is the closed narrative discourse and its conventions, often unseen and overlooked—the structure of the space around the objects and its interstices and tensions, the objects' disparities of scale or hue, their relation or nonrelation to reality, their material or dematerialized condition, and many other factors in an abstract equation—that constitute the ideological codes ultimately defining the still life, and thereby mirroring an ideal vision, or many visions, of a contemporaneous world.

If the mission of a museum of modern art is to aid and abet the experience of seeing, then the goal of this exhibition is to enhance and enrich that experience, by deflecting the viewer's gaze from the common subject/objects depicted in these "still lifes" to the complex formal and semantic systems that they embody and the unique formulations of the world that they portray.

Margit Rowell

OBJECTS
OF
DESIRE

Still life painting, as a pictorial genre, has traditionally been considered a "minor" form of artistic expression and invention. Whereas megalography is the depiction of greatness, the heroic deeds of gods and men, the still life, as Norman Bryson writes, is a form of rhopography—"from *rhopos*, trivial objects, small wares, trifles…the depiction of those things which lack importance, the unassuming material base of life that 'importance' constantly overlooks."[1] Invented around 1600 in European painting as an autonomous mode (rather than as an incident in a grander scene), the still life depiction of inanimate objects or material goods—a depiction from which the human figure had been banished—was relegated to the lowest echelon in the academic hierarchy, after history and religious painting, the landscape, and portraiture. Indeed still life painting was often considered the province of the accomplished craftsman, or assimilated to "woman's work," not only for the circumscribed skills it presumably entailed,[2] but because of its depictions of the kitchen or dining room, seen as the woman's workplace. Nonetheless, a closer look at the greater and lesser examples of this tradition over the last four centuries reveals that these visual renderings of *inanimate* objects are worthy of more attention and respect; they carry significant messages and have a life of their own. Just as an *animate* entity develops and evolves in relation to its innate potential and its nurturing milieu, still life painting has shown constant change, in some relation to the transformations of society as well as to the artistic ambitions of its time. This was true in the past and continues to be so in the present, making the still life a viable (although unexpected) paradigm for the investigation of certain aspects of avant-garde expression in the twentieth century.

The still life is a system of objects, and it is in the word "system" that its secret lies. A system is "a set or arrangement of things so related or connected as to form a unity or organic whole."[3] The system inherent to still life painting can be defined as both visual and signifying. It is based essentially on a choice of objects and a manner of organizing them in a spatial field. That organization is both ideological and formal, relating, on the one hand, to a personal and/or collective world view, and, on the other, to technical innovations. As mentioned in this book's preface, the still life is a fictional system corresponding to a structure of desire,

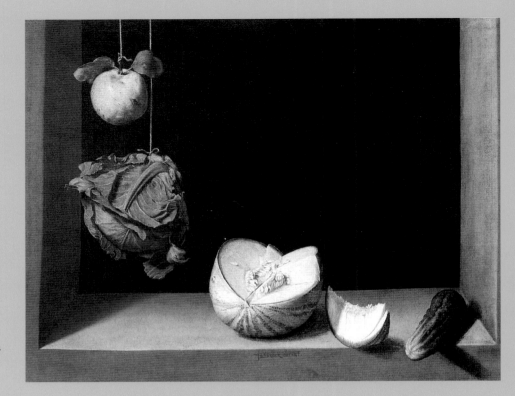

Juan Sánchez Cotán
Still Life with Quince, Cabbage,
Melon, and Cucumber, c. 1600
Oil on canvas
27⅛ x 33¼" (69 x 84.5 cm)
San Diego Museum of Art
Gift of Ann R. and Amy Putnam

within which it has its own singular codes of meaning and codes of representation.

As Bryson convincingly argues throughout his book *Looking at the Overlooked: Four Essays on Still Life Painting,* in order to understand the full effect of the seventeenth-century still life it is essential to understand certain codes of representation specific to that time. One of his demonstrations revolves around the paintings of Juan Sánchez Cotán (1561–1627), a Spanish monk whose hyperrealistic rendering and intense focus on a subject matter of ordinary, unprepared foods totally "decondition" worldly vision. Sánchez Cotán's quinces, melons, and cabbages, rigorously set and framed in the austere (and ideal) geometry of a window or larder, are neither sensuous nor magnetically desirable, and show no references to appetite, conviviality, or potential consumption. Quite to the contrary, the spatial sobriety and complexity of these compositions signify distance and inaccessibility, subliminally evoking the Carthusian monastic concern with solitude and abstinence.[4]

At the other end of the scale is the example of seventeenth-century Dutch painting, with its emphasis on affluence, luxury, and consumption. These characteristics are obvious and apparent in

the depictions of fine china and crystal, elegant cloths and laces, and rare and exotic foodstuffs which we identify with that period and style. But they may also be more subtly represented (and coded), for example by a choice and assembly of fruit and flowers from different parts of the world, ripening and blooming at different seasons, that only the wealthy could afford; or, with a different message, by depictions of tables in disarray, their overturned glasses and abandoned delicacies evoking material waste. As Bryson points out, there were clearly both "moral" and "immoral" images of prosperity, defined succinctly in terms of order and disorder, and this idea introduced another, ethical dimension to still life compositions. Finally, a further code informed these symbolic portraits of social status: that of the value of artistic labor. For the client paid for the hours (days, weeks, months) required for the painstaking execution of the still life's finely tuned highlights, studied contrasts, trompe l'oeil exactitude, and proliferation of artful details. The richness of the execution was richly remunerated, another index of wealth and prestige that did not go unnoticed in the milieu of Dutch bourgeois life.[5]

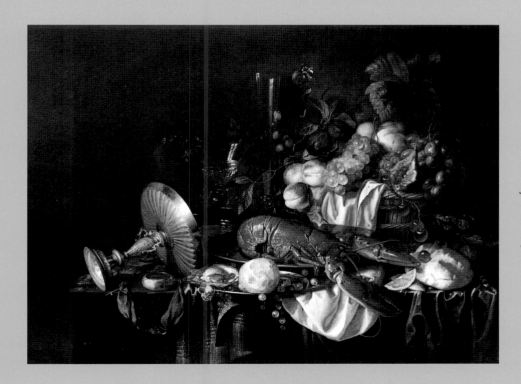

Jan Davidz. de Heem
Still Life with Lobster, late 1640s
Oil on canvas
25 x 33¼" (63.5 x 84.5 cm)
The Toledo Museum of Art
Purchased with funds from the Libbey Endowment
Gift of Edward Drummond Libbey

These few examples indicate the kind of social, moral, economic, and even technical codes that governed these paintings, invisible to the uninformed observer yet embodied in the selection, arrangement, and execution of a distinctive subject matter, in which nothing was left to chance. These still lifes reflected a society's privileged objects and predominant ideologies. Their execution was labor-intensive and virtually anonymous. And indeed the seventeenth-century still life artists, with few exceptions, are remembered more for their skill than for their invention. Of course comparable although not identical codes of representation ruled the other pictorial genres also. But it may be suggested that the still life's range of objects and their disposition, dictated not by observation but by ideological choices in relation to possession and consumption, as well as the immobility and intemporality of the subject, encouraged the creation of an abstract grid or system that is unique to the genre.

Despite the "high" realism or neutral objectivity that we had thought was present in these paintings, it is by now clear that their representations are fictitious, quite far removed from any "real life." Perhaps we should have understood this from the outset, in that "real life" and "still life" oppose contradictory premises. Whereas lived experience is a flow of immediate, unpredictable, undifferentiated sensations on which we subconsciously impose hierarchical patterns of perception and understanding, the still life is otherwise ordered, structured, and articulated by specific semantic codes. Distinct from the reality it is assumed to depict, it corresponds to a self-generated, self-referential, and self-contained system of signs. As mentioned earlier, the specific objects of a traditional still life, and their interrelations, obey a rigorously closed and articulated narrative structure, a structure of desire, "a structure that both invents and distances its object and thereby inscribes again and again the gap between signifier and signified that is the place of generation for the symbolic."[6] In the final analysis, these works (like all artworks) do not depict the real or the natural but are cultural signifiers, and the codes by which they operate are not spontaneously invented and reinvented but ideologically determined, not personal to the artist but strategically symbolic of the priorities and desires of a given society at a given time.

The difference between the paintings of the classical still life tradition and those of the twentieth century is that the relation between the artist and society has fundamentally changed. Art today is no longer the kind of social construct it was then, and, despite the pressures of the market, the artist is rarely directly dependent on and subjected to the exigencies of a ruling and commissioning class. Virtually freed from the fictitious realisms or realistic fictions solicited by a predetermined clientele (whether church, state, or an individual client), twentieth-century artists can generally speaking indulge in the formulation of their own narratives, their own structures and objects of desire.

The modernist or avant-garde still life is still a system of objects; one must not imagine that with the entry into the twentieth century, all prior systems, structures, or objects were brutally excised and replaced by radically new ones. In the general order of things, the still life's closed narrative structure still prevails, based on a yearning for possession of the real that, supplanted by a fiction, is perpetually deferred or denied. The genre's objects are still distanced from their supposedly real models, and still operate according to ideological codes of meaning. However, since the twentieth-century avant-garde artist takes a position outside (often in opposition to) the values of bourgeois culture, art and its narrative are more closely tuned to individual histories and creative ambitions, timely as opposed to timeless discoveries and pleasures, and even irony, subversion, and transgression.

In its subjects, the modernist still life will often extend earlier traditions: the theme of the domestic object, for example, often on a table, is sustained in different guises throughout the century. The theme of the *vanitas* or memento mori will be reinvented around one or several of its classic motifs—a human skull, a burning candle, books, pipes, and musical instruments, connoting the transience of earthly pleasures (see illustration, p. 18). Yet other, virtually unprecedented subjects—symbols of urban conviviality, impersonal manufactured articles, commercially attractive consumer products—will gradually invade the scene, as will discarded or disaffected objects, victims as opposed to protagonists in the dynamic sphere of modern life.

Like the earlier still lifes we have examined, in their arrangement, ordering, or semantic structure these artworks, singly or together,

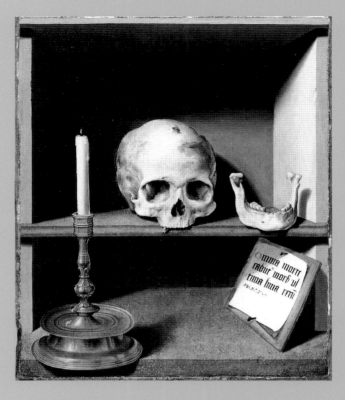

Barthel Bruyn the Elder
Vanitas, 1524
Oil on panel
24 x 20" (60 x 50 cm)
Rijksmuseum Kröller-Müller,
Otterlo

formulate an ideal vision of the world. Whether attempting to portray a
physical or perceptual relation to the natural environment, a rational or
irrational hegemony, emotion or irony, belief or disbelief, acceptance,
disillusion, or criticism, all of these images are distinctly coded and
informed. The codes are expressed through decisions concerning the use
of traditional conventions of illusionism, including, at times, the
distortion or circumvention of those conventions; but they also derive
from more problematic inquiries and solutions in regard to scale, color,
siting, congruous or incongruous juxtapositions, isolation, even the
integration or association of verbal images.

Concomitantly, the conception and realization of these widely
varying and unprecedented approaches to the multiple realities of the
modern world required the invention of new mediums and techniques
to implement them. It is thus that we see the birth of collage and
assemblage, the readymade and the soft sculpture, as well as the
introduction of abandoned actual objects, handcrafted replicas,
mechanical and commercial processes and techniques, and the
industrially fabricated object. It should be emphasized that these
technical innovations were invented in the context of the still life,

even though some of them would subsequently be appropriated by other genres.

What may be initially perceived in the more contemporary interpretations of the genre as a radical subversion and destruction of earlier traditions is in fact a progressive development of new metaphors corresponding to the ideologies of the modern world. These metaphors are constituted as the interrelations among each period, society, individual artist, and model/subject/object ultimately generate a new symbolic discourse. The fact that the motifs of the still life may be freely chosen and created, with or without a model, even disfigured or distorted, seems to ascribe to it more freedom and autonomy than to any other genre. The complex relations it embodies, constantly renewed, and its paradoxical estrangement from the real objects it was initially presumed to depict, allow for a radical reformulation of its own systems of meaning.

Thus the structure of desire is still in place, with its direct connotations of attraction and inaccessibility, and its more abstract definition as a closed semantic system generating and regenerating its own symbolism. In this context, the perceived objects of the still life occupy an ambivalent position between the real world and the system, between the presumed iconographic model and the abstract sign. Yet, paradoxically, their precise iconography, their *reality*, is less appealing and magnetic than their status as a *sign*, its significance elusive and contradictory, and its distance from what it pretends to but does not directly signify sustaining the tension and sensation of unfulfilled desire.

1. Norman Bryson, *Looking at the Overlooked: Four Essays on Still Life Painting* (London: Reaktion Books, Ltd., 1990), p. 61.

2. It is interesting to note, however, that the canonical history of the genre includes few female artists.

3. *Webster's New World Dictionary of the American Language* (Cleveland and New York: The World Publishing Co., 1968), p. 1480.

4. Bryson, *Looking at the Overlooked*, pp. 63–65.

5. See Bryson's chapter "Abundance," pp. 96–136.

6. Susan Stewart, *On Longing* (Durham, N.C., and London: Duke University Press, 1993), p. ix.

A nature morte with a blue bed cover; between the cover's bourgeois cotton blue and the wall, which is suffused with a light cloudy bluishness, an exquisite, large, gray-glazed ginger pot holding its own between right and left. An earthy green bottle of yellow curaçao and furthermore a clay vase with a green glaze reaching down two thirds of it from the top. On the other side, in the blue cover, some apples have partly rolled out from a porcelain dish whose white is determined by the blanket's blue. This rolling of red into blue is an action that seems to arise as naturally from the colorful events in the picture as the relationship between two Rodin nudes does from their sculptural affinity.

—Rainer Maria Rilke

Rilke refers to Cézanne's *Still Life with Apples*, 1893–94, in a letter to Clara Rilke, November 4, [1907]. In Rilke's *Briefe über Cézanne*, 1952, published in English as *Letters on Cézanne* (New York: Fromm International Publishing Corp., 1985), pp. 96–97

Paul Cézanne
Still Life with Apples, 1893-94
Oil on canvas
25¾ x 32⅛" (65.5 x 81.5 cm)
The J. Paul Getty Museum, Malibu

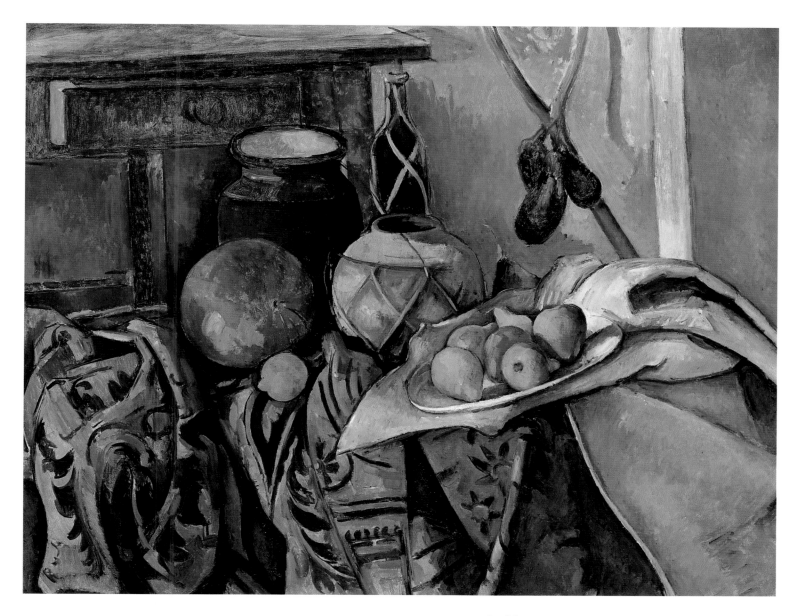

1. Paul Cézanne
 Still Life with a Ginger Jar and Eggplants, 1890–94
 Oil on canvas
 29⅞ x 36½" (72.4 x 91.4 cm)
 The Metropolitan Museum of Art,
 New York

THE WORLD AS PERCEPTUAL FIELD

This essay on the modernist still life will not include extensive studies of such major figures as Paul Cézanne, Paul Gauguin, Vincent van Gogh, and Henri Rousseau. Of these four, all but Rousseau had died by 1907, the year when our survey effectively begins. Yet their contributions to the language of the avant-garde still life will perforce be subliminally present here, in that their visionary formal inventions, and their transgressions in regard to inherited models, made them inevitable references for the artists who came of age in the century's first decade. The impact of two of these artists, Cézanne and Rousseau, on the development of Cubism between 1907 and 1912 is particularly apparent and well documented. Rather than examining their contributions in depth, however, we will limit our study to the original features that each brought to the specific language of the modernist still life.

During the period 1907–12, the example of Cézanne's still life paintings was vividly present, not only in the choice and treatment of subjects but in the organization of the spatial field. In his mature work, Cézanne's most recurrent motifs were modest domestic objects, pieces of fruit, and draped or folded fabrics. Sketchily drawn or outlined, these motifs depended on a subtle handling of graded color to project an illusion of volume or relief. Since lines and contours do not exist in nature, Cézanne's technique made his arrangements of objects appear more faithful to natural vision. His use of color endowed them with a soft, radiant glow, evoking the skin of a peach or an apple, or the worn patina of porcelain or metal, as opposed to the brittle effects sought by early Dutch or Flemish painters, which were achieved through elaborate contrasts of highlighting and shading. Finally and most importantly, Cézanne's pictorial ground showed contradictory perspectival cues, the overall impression being that of a rippling fabric into which the objects were incorporated, as in an interwoven perceptual field. This unity of vision was often reinforced by a reduced palette keyed to one or two dominant hues, or by an atmospheric wash producing a lambent haze.

Yet as close to natural vision as the overall composition of a Cézanne canvas or watercolor presumably appears, the objects have a logic of their own. Not only did Cézanne rigorously organize his chosen subject motifs on a table, but he was known to arrange them in such a way

(canting or tilting them, for example) that even before being painted they seemed to repudiate the laws of unitary perspective.

As we know, Cézanne's subtly skewed translation of traditional perspective was one of his major contributions to the development of twentieth-century avant-garde art. And his methods for achieving the spatial ambiguities seen throughout his mature work are nowhere more visible than in his still life subjects. Aside from the perspectival distortions of the objects themselves, in which, for example, he might depict simultaneously a front and an aerial view, he also chose to frame or crop his compositions closely, amputating or concealing the normal cues for reading perspectival space. At one extreme, one might find indices of multiple perspectives juxtaposed in a single image; at the other, a space consisting of parallel horizontal bands, or the total absence of perspective as we have learned to decipher it.

The predominant subject matter of early-twentieth-century avant-garde still life painting is analogous to that of Cézanne: simple domestic utensils (as opposed to more elegant wares, plate 2), local varieties of fruit (as opposed to richer, more exotic fare, plate 11), tables and draped fabrics. Floral subject matter, favored in the earlier history of still life painting for the varied patterns of colors and shapes it allowed, is relatively rare. Some of the more traditional, even symbolic motifs from the early history of still life painting, however, are maintained in the early twentieth century. The most obvious include the pipe, the book, the skull, and the candle (or gas lamp), all of which are found in the traditional *vanitas* or memento mori compositions of the past (plate 3). Musical instruments and palettes are also familiar and enduring subjects, although as they are transposed here, they do not elicit the religious meanings, economic concerns, even ethical considerations that constituted important subtexts in earlier still life practice. The suppression of these traditional extrapictorial messages conferred on the twentieth-century artist a new freedom to concentrate on the problems of painting and to develop new systems of meaning.

It follows that the interpretation of these motifs in the period 1907–12, particularly in the cases of Pablo Picasso, Georges Braque, and Juan Gris (plates 2–6 and 14), is singularly different from that of earlier tradition, and reflects, among other things, many lessons learned from

Cézanne. In these proto-Cubist and Cubist works, the manner of developing an illusion of volume in regard to the objects is not achieved through the shading and modeling of academic practice, but through subtly graded colors that discreetly and gradually sculpt the objects' surfaces and contours. These compositions show a complex integration of the objects/motifs and their environment, in a fluctuating shallow space. By 1910, Cézanne's disrespect for single-vanishing-point perspective is so freely elaborated upon that the very notion of perspective becomes almost irrelevant. The palettes of these painters also seem to allude to Cézanne's manner of unifying his compositions through one or two dominant hues or a subdued and unified tonality.

Cézanne's organization of his compositions according to a plunging frontal viewpoint and an upward-tilting ground is common to most of these early-twentieth-century works, whether they relate to the specific language of Cubism or not. Sometimes this structure is exaggerated by a virtually upright surface plane, counteracted by illogical linear spatial cues (plate 6). In other instances the space is more subtly staggered in a shallow and undetermined depth (plate 7). Further pictorial devices such as a high horizon line, tight framing, and certain manners of using color (plates 12 and 13) attest to the pervasiveness of Cézanne's example.

One might suggest that Cézanne's infinite appeal to this generation of artists was based on the subtle contradictions in his oeuvre. Although presumably what he sought was to capture the solidity and stability of nature, through his very attentiveness to nature he discovered that nothing there is stable or still; so that his vision and articulation of the pictorial field elided matter, color, and form into a uniform and transparent film of reality, connoting an elusive instability. The shifting relationships of his objects within the shimmering fabric of a shallow or flattened space offered future generations endless alternatives to the inherited conventions of the still life tradition.

The dialogue with Cézanne was fundamental, but it was not these artists' only source of inspiration. Paradoxically, but nonetheless obeying a certain historical logic, another, lesser mentor was the "naive" French painter Rousseau.

Although Rousseau produced many still lifes, his contribution to the artistic breakthroughs accomplished during this decade was of a more

general nature. Many of the artists of the period had an interest in the "primitive" in its many forms, from African sculpture to the art of Java and Polynesia, which inspired Gauguin's paintings and carved wooden sculptures. Primitivism appeared to propose fresh and unexploited spiritual and formal structures to be explored. Rousseau's example was particularly seductive in that it belonged to the Western tradition of painting (as opposed to more exotic or sculptural arts), yet it patently ignored that tradition's academic heritage. In its images and techniques, it expressed a kind of pictorial virginity. Rousseau's stiffly rendered perspectival views, crudely modulated colors, crisp contours, fastidiously detailed execution, and the rigorously hieratic stance of his figures and objects were in total contradiction to Cézanne's vision and formal vocabulary. Furthermore, the nature of the perceived world was not Rousseau's model. His iconography was drawn from the myths, images, and desires of a rich and idiosyncratic imagination.

In the period 1907–12, Rousseau's vision and his unself-conscious techniques inspired similar effects in paintings by Picasso, Paul Klee,

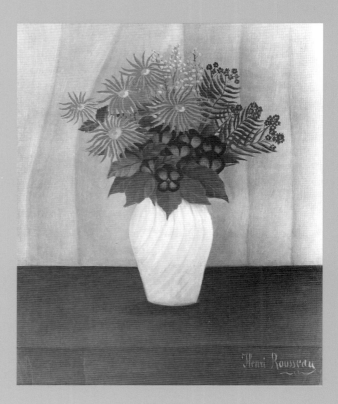

Henri Rousseau
Bouquet of Flowers, 1895–1900
Oil on canvas
24 x 19½" (61 x 50.2 cm)
The Trustees of the Tate Gallery,
London

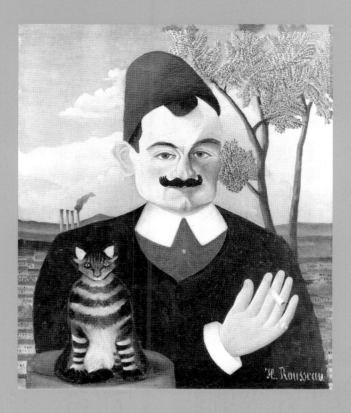

Henri Rousseau
Portrait of Pierre Loti, c. 1891
Oil on canvas
24 ⅜ x 19 ⅝" (62 x 50 cm)
Kunsthaus Zurich

André Derain, and Raoul Dufy (plates 2–4 and 11–13). Their works presented here show a naive yet firm stylization of rudimentary forms and colors, precise contours, and measured, almost static frontal arrangements. Their force and vitality project a nonacademic purity and directness of expression. The unique synthesis produced by the unlikely encounter of Cézanne and Rousseau during this seminal era—the former dissolving the perceptual field, its laws of perspective and illusionism, to create a rippling surface bathed in a luminous haze, the latter transposing the images of his rich inner fantasies into flattened, artificially lit silhouettes that he would anchor or imbricate on the flat surface of the canvas—would contribute to the formulation of a new conceptual and formal language for the art of the twentieth century.

In this period and context, Henri Matisse stands virtually alone. Although Cézanne's example was paramount to his inspiration, his vision and the devices of its implementation—the domestic settings and objects, draped and flowered fabrics, and shallow space of his compositions shown here from c. 1908 to 1911 (plates 9 and 10)—have a totally different resonance from those evoked above. Whereas Cubist works, for example, were constructed by means of gridded and splintered

linear scaffoldings, dissolving at the edges, and unified by a soft quasi-monochromatic palette, Matisse's compositions from this period show not only a rich, exuberant chromatic scale but a picture surface that unfolds in a fluid, uninterrupted discursive flow, stretching undiluted to the edges of the canvas.

Matisse's reading of Cézanne was predominantly structural, spatial, and coloristic, an observation confirmed by the fact that the discrete objects depicted in his still lifes of this period are almost incidental, their silhouettes being virtually confounded with the motifs of his patterned fabrics. Yet the distinct formal characteristics seen in these works may be attributed to a concurrent interest on Matisse's part, starting in 1906: a fascination with the applied arts, and in particular with textiles and ceramics from North Africa. The conventions of these "exotic" traditions, unlike those of Western academic painting, were infinitely liberating for a European-trained painter. In many of the decorative arts, representation is secondary, indeed undesirable, as are the illusionistic devices of modeling, perspective, or gravity. On the contrary, emphasis is placed on flat, bold, abstract motifs, bright contrasting colors, and deliberate and unlimited repetition.

Matisse's major still lifes from this period may be described as flat patterned fields of saturated color, in which the conventional Western spatial relationships (of wall to table, depth to surface, vertical to horizontal plane) are only subliminally cued. One might therefore suggest that Matisse's personal solution for transgressing the inherited traditions of Western art coalesced from an understanding not only of Cézanne's perceptual vision of reality, and his techniques for capturing its fluctuating instability, but also of the flat rhythmic patterns of the decorative arts.

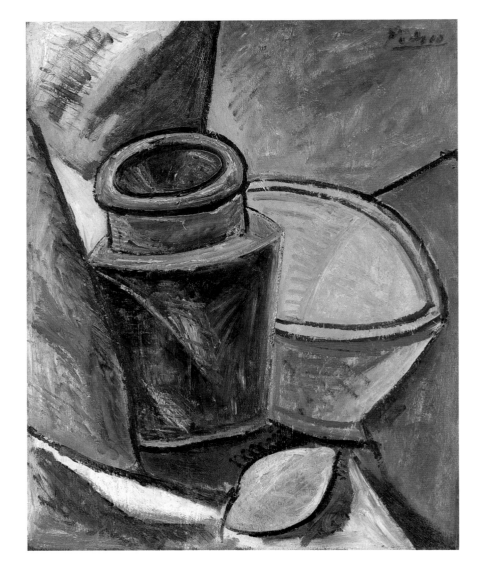

2. Pablo Picasso
 Pitcher, Bowl, and Lemon, 1907
 Oil on panel
 24⅜ x 18⅞" (62 x 48 cm)
 Private collection, courtesy Galerie Beyeler, Basel

3. Pablo Picasso
 Still Life with Death's Head, 1908
 Oil on canvas
 45¼ x 34⅝" (115 x 88 cm)
 The Hermitage Museum, Saint Petersburg

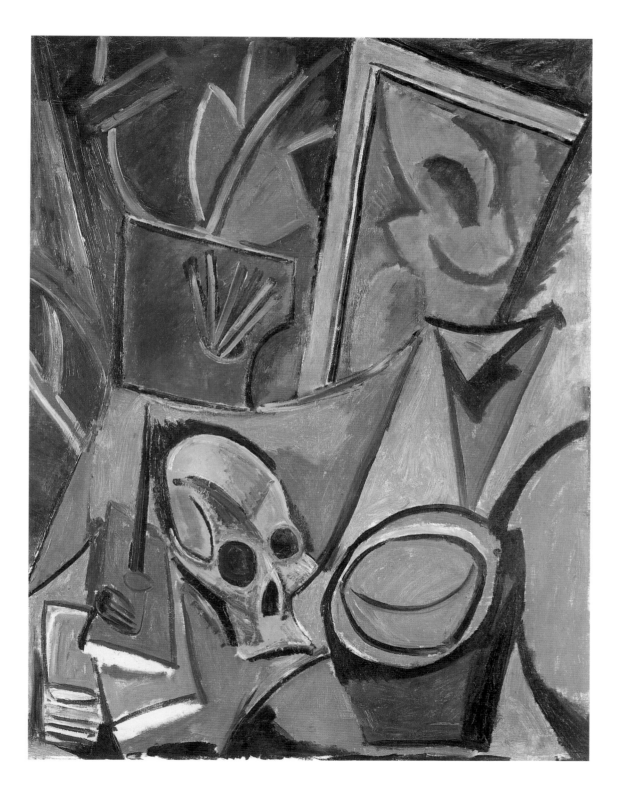

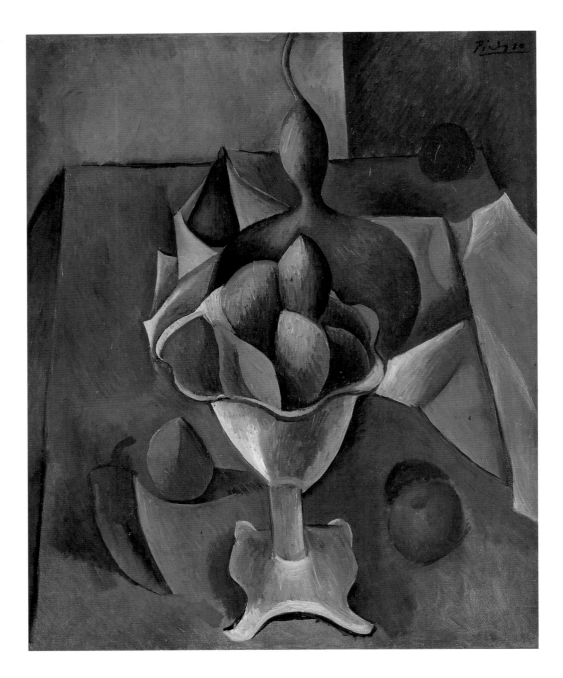

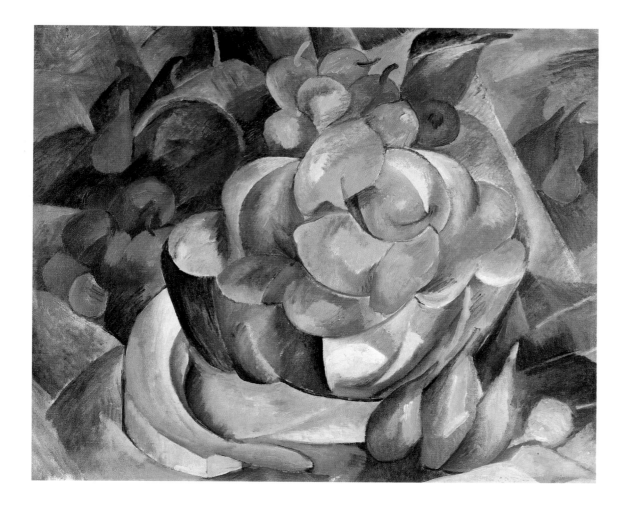

4. Pablo Picasso
 Fruit Dish, 1908–9
 Oil on canvas
 29¼ x 24" (74.3 x 61 cm)
 The Museum of Modern Art, New York

5. Georges Braque
 Fruit Dish, 1908–9
 Oil on canvas
 21¼ x 25½" (54 x 65 cm)
 Moderna Museet, Stockholm

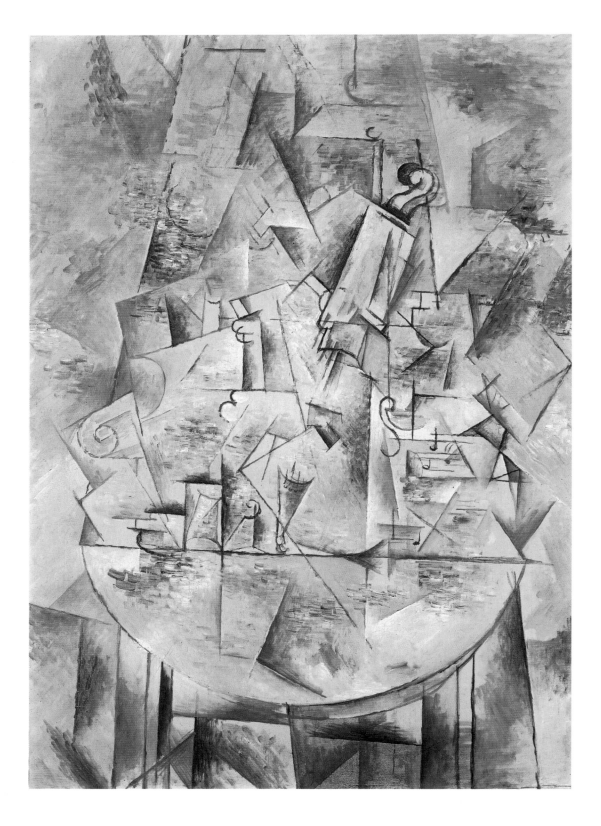

6. Georges Braque
 Pedestal Table, 1911
 Oil on canvas
 45 7/8 x 32" (116.5 x 81.5 cm)
 Musée national d'art moderne,
 Centre Georges Pompidou, Paris

7. Fernand Léger
 Table and Fruit, 1909
 Oil on canvas
 33 x 39" (82.5 x 97.5 cm)
 The Minneapolis Institute of Arts

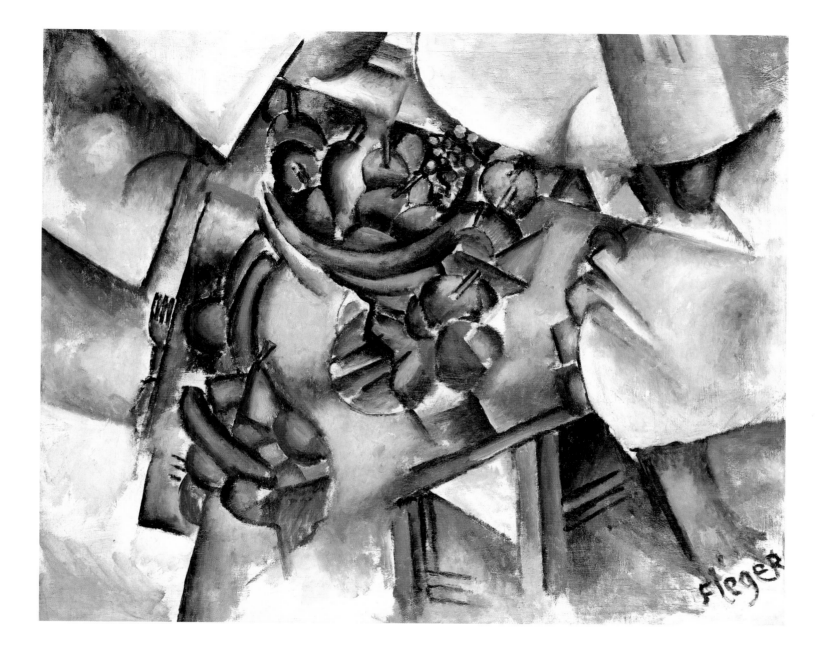

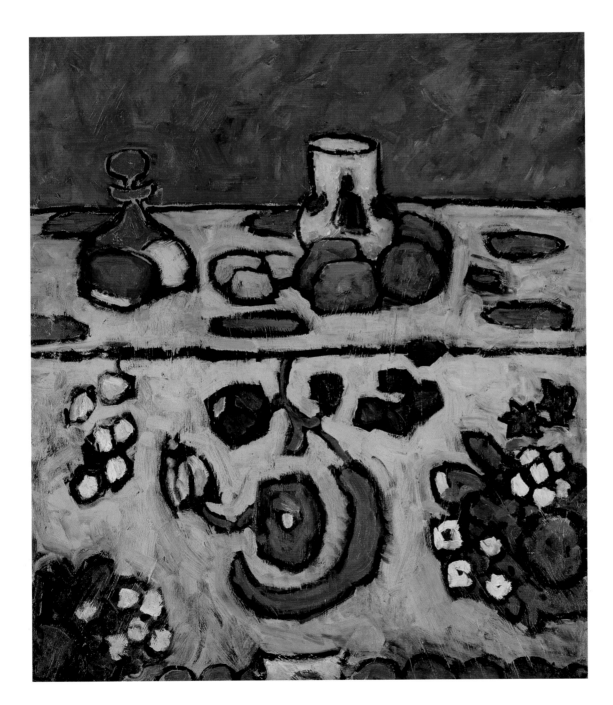

8. Alexei von Jawlensky
 Still Life with Colored Tablecloth, 1910
 Oil on cardboard
 laid down on wood
 34 ⅜ x 28 ⅛" (87.5 x 72 cm)
 Private collection

9. Henri Matisse
 Still Life with Blue Tablecloth,
 c. 1908–1909
 Oil on canvas
 34 ⅝ x 46 ½" (87.8 x 118 cm)
 The Hermitage Museum,
 Saint Petersburg

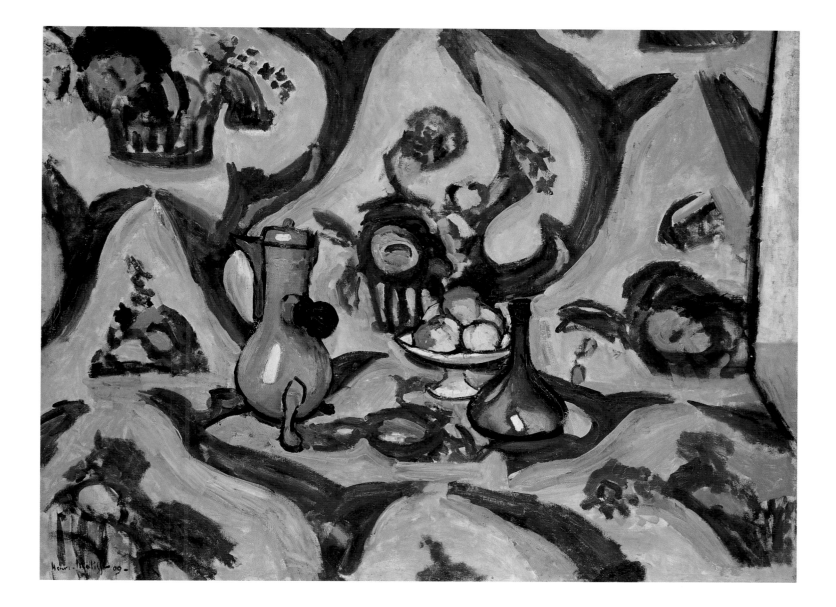

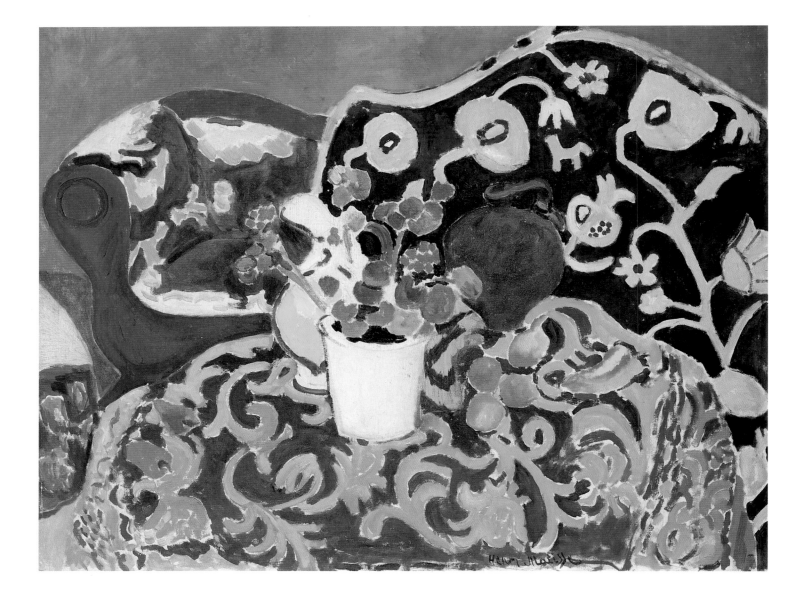

10. Henri Matisse
 Spanish Still Life, 1910–11
 Oil on canvas
 35 x 45⅝" (89 x 116 cm)
 The Hermitage Museum,
 Saint Petersburg

11. Paul Klee
 Still Life with Four Apples, c. 1909
 Oil and wax on paper
 mounted on cardboard
 13½ x 11⅛" (34.3 x 28.2 cm)
 The Museum of Modern Art,
 New York

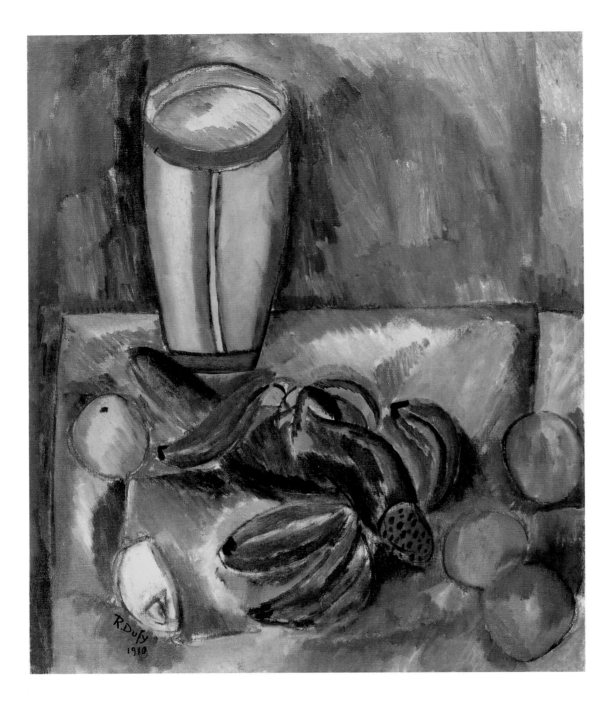

12. Raoul Dufy
 Still Life with Oranges, 1910
 Oil on canvas
 25 ½ x 21 ½" (65 x 54 cm)
 Private collection

13. André Derain
 Pears and Bananas in a Bowl, 1912
 Oil on canvas
 12 ³⁄₁₆ x 14 ³⁄₁₆" (31 x 36 cm)
 Private collection

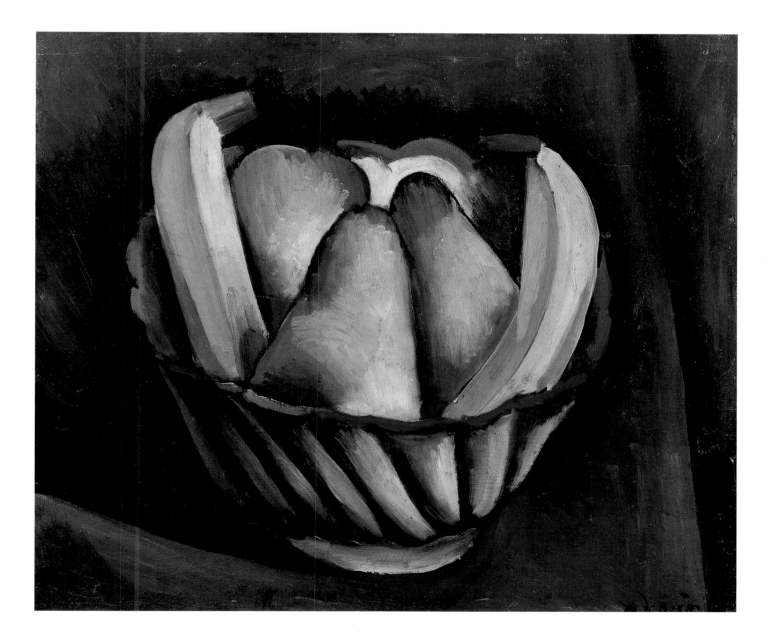

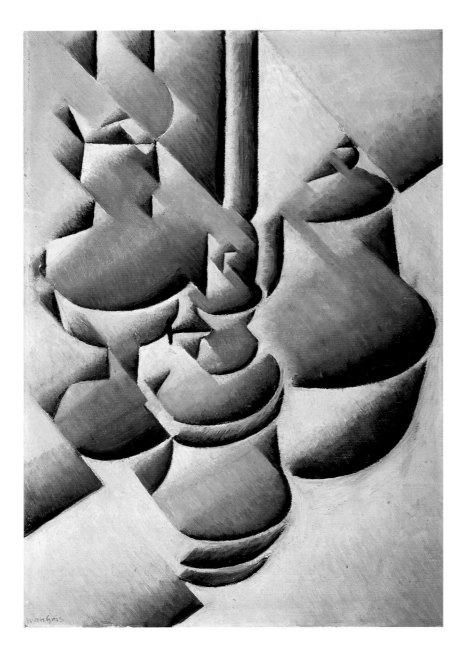

14. Juan Gris
 Still Life with Oil Lamp, 1912
 Oil on canvas
 18 ⅞ x 13" (48 x 33 cm)
 Kröller-Müller Museum, Otterlo

15. Umberto Boccioni
 Development of a Bottle in Space, c. 1912; cast 1931
 Silvered bronze
 15 x 23 ¾ x 12 ⅞" (38.1 x 60.3 x 32.7 cm)
 The Museum of Modern Art, New York

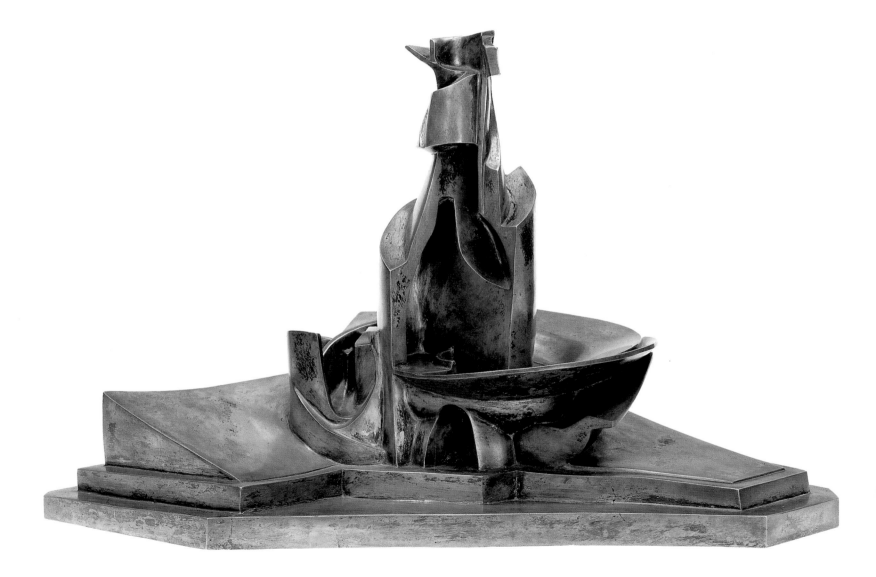

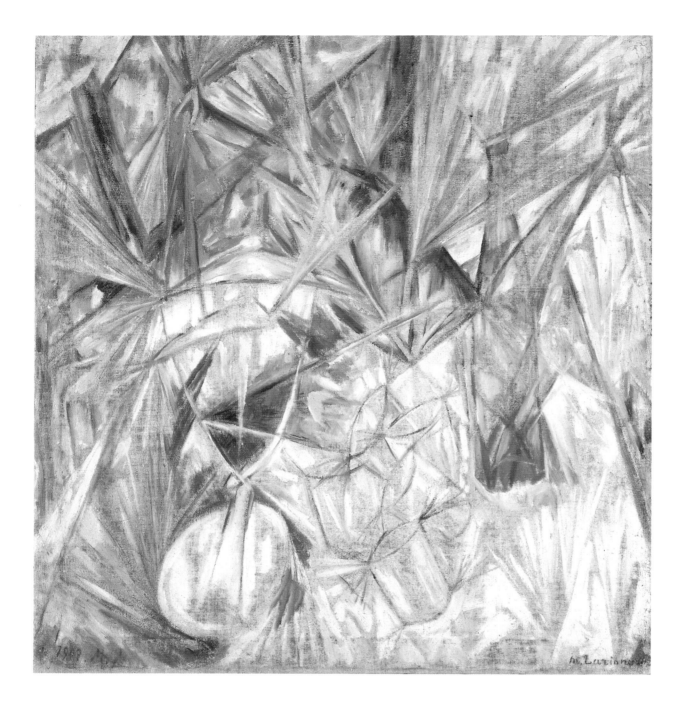

16. Mikhail Larionov
 Glass, 1912
 Oil on canvas
 41 x 38¼" (104.1 x 97.1 cm)
 The Solomon R. Guggenheim Museum,
 New York

17. Piet Mondrian
 Still Life with Ginger Pot II, 1912
 Oil on canvas
 36 x 47¼" (91.5 x 120 cm)
 Haags Gemeentemuseum, The Hague

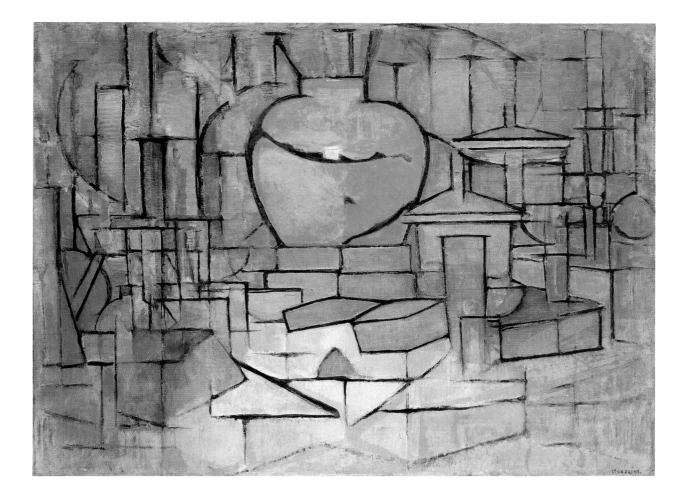

ANATOMIES OF STRUCTURE

The year 1912 witnessed some major breakthroughs in the history of modernism, many of them introduced and enacted in the still life genre. Cézanne's paintings in particular had served as a transition between a historical tradition and a new pictorial language, but starting in 1912, other traditions were born. This is visible in the choice of a different subject matter, in a new relationship to the world of objects, and in technical innovations, such as collage and constructed sculpture, invented in order to implement another vision of reality.

The dialogue with Cézanne was not abruptly terminated but was translated into an ever more modernist tongue. Picasso and Braque, as they continued to "pioneer Cubism,"[1] would address themselves not to the intimate objects and spaces of the private interior but to the arena of public social life. In so doing, they would be joined by artists such as Gris and Fernand Léger. Adventuring as these artists did away from the confines of tradition allowed them increased formal and technical freedom. Other artists, including, for example, Matisse, would remain attached to the space and motifs of domestic life. Their vision and inventions, however, would be no less revolutionary.

The subjects of this phase of mature Cubism were inspired by café and urban life—a male landscape, it has often been argued, in contrast to the domestic interior and its implication of female ascendancy. Although café scenes (complete with figures) had appeared in Dutch genre painting, the isolation of distinctive café-inspired motifs as autonomous subject matter had previously been relatively rare. Rather than transmitting a historical heritage, then, these works are topical and bespeak their time.

Nothing represents an index of meaning more different from the traditional still life's limited number of familiar objects set on a domestic table than the incidental ephemera of the café environment. The smokers' accessories, distinctively shaped bottles and glasses for the consumption of wines and spirits, and folded or unfolded newspapers signify the multiple and quickly shifting settings of the bistro table and the desires and appetites of a transient clientele. These motifs represent objects of choice and desire in a most literal sense, and their reality is neither secure nor eternal but as fugitive and unstable as desire itself.

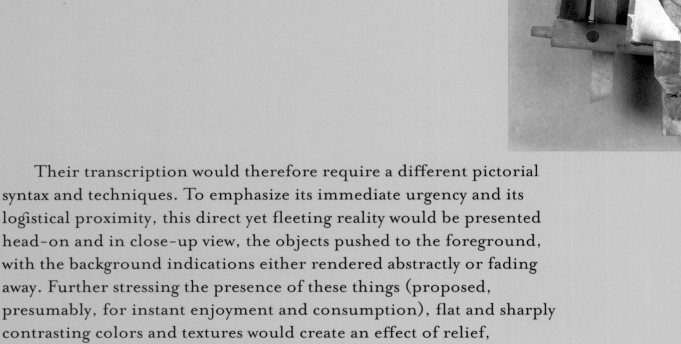

Pablo Picasso
Mandolin and Clarinet, c. 1913
Construction of painted wood
with pencil marks
22 ⅝ x 14 ⅛ x 9" (58 x 36 x 23 cm)
Musée Picasso, Paris

Their transcription would therefore require a different pictorial syntax and techniques. To emphasize its immediate urgency and its logistical proximity, this direct yet fleeting reality would be presented head-on and in close-up view, the objects pushed to the foreground, with the background indications either rendered abstractly or fading away. Further stressing the presence of these things (proposed, presumably, for instant enjoyment and consumption), flat and sharply contrasting colors and textures would create an effect of relief, aggressively imposing them on the viewer's perception. This attempt to possess the viewer's gaze would later be reinforced through the collage of real substances (colored paper, newspaper, or wallpaper, for example) on the surface plane (plates 23 and 31).

What is fascinating in this ambition to capture the viewer's attention is how these collages of 1912–13 actually function. Sometimes a fragment of newspaper represents a newspaper, or wallpaper serves as wallpaper, thereby forcing a shift in perception from a drawn illusion of fictitious objects to a concrete substance at real scale. In most cases, though, the real elements glued to the canvas are foreign to the reality of the objects to which they are assimilated. Picasso's depiction of a bottle through a flat

silhouette cut out of newspaper (in *Siphon, Glass, Newspaper, and Violin*, 1912, plate 23) denies expectations of a curved volume or transparency. Gris's contours of a glass and cup drawn over a "wood-grained" table (in *The Newspaper*, 1914, plate 31) ambiguously telescope the identities of unlike shapes and substances.

In many of these collages it is as though abstract and semiabstract colored and textured forms had been distributed purely as accents over a webbed surface plane, after which the artist drew over and drew out in filigree the objects of a still life. The collaged elements, although they heighten the composition's physical presence, do not give the objects more reality; often, on the contrary, they have the independent shapes and streamlined opacity of flattened shadows. This ambivalent logic of light and shadow, background and relief, all laid within a single plane, so fundamental to the collages of Braque and Picasso, is also explored, although differently, in Picasso's constructions in wood and metal (plates 24 and 27), and, somewhat later, similarly by Laurens (plate 30). Using bottles, glasses, or musical instruments as his models, Picasso

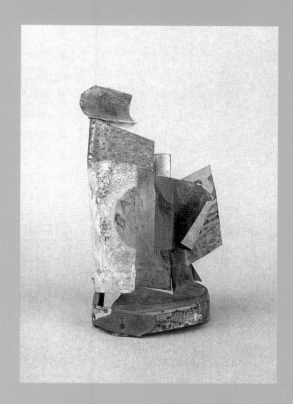

Pablo Picasso
Bottle of Bass, Glass, and Newspaper, 1914
Construction of painted tin
8 x 5⅜ x 3⅛" (20.7 x 13.5 x 8 cm)
Musée Picasso, Paris

abandoned the conventions of sculpture in the round, substituting a complex play of voids and planes that creates an interlacing of real and virtual volumes. Ironically, while the illusionistic devices for indicating depth are rendered in concrete form, the object's substance is hollowed out, so that it becomes a virtual volume of intangible space. Silhouettes of glasses are splayed open, for example, yet their liquid contents appear to remain solid and intact. The orifices of musical instruments are presented in relief, while their surface planes are broken apart and presented as open and empty shells (see illustration, p. 48).

It seems obvious that most of these artists did not set up still life models or arrangements of motifs in their studios, then slowly observe and capture them, as had Cézanne. Yet their compositional mechanisms derive nonetheless from Cézanne's perceptions. In Cubist paintings and collages, the organization of the entire field or surface primes the interest of a single tangible object, the collaged or painted planar elements merely serving to bring into sharper focus certain areas of the patterned ground. At the same time that these shifting gridded images— based more on memory imprints than on immediate observation— propose a different iconography, their formal interpretations echo the hard silhouettes and crisp definition seen in Rousseau's imaginary subjects. They are far more sophisticated and complex, however, in their translation of residual memories, deconstructed and transposed.

Matisse, once again, speaks a language of his own. Whereas in his earlier paintings his still life motifs are barely differentiated from his richly patterned grounds, starting in 1912 they may be seen as the increasingly central protagonists of his luxuriantly colored compositions. The vivid hues and purified shapes of his centered or evenly distributed objects are closely connected to, indeed evoke without imitating, a natural reality. Often set up out-of-doors, or in relief against a window, they are bathed in an even natural light. Yet more important, these paintings are not organized according to the flow of perceptual vision. On the contrary, the structure of each canvas, whether loosely spiraling (*Purple Cyclamen*, 1911–c. 1913, plate 19), geometrically gridded (*The Blue Window*, 1913, plate 20), or aggressively centered and frontally focused (*Apples*, 1916, plate 21), is generated by the specific objects themselves, and translates the artist's emotional response to

them. The unprecedented structural rigor and tight control seen in these depictions of natural subjects and settings betray Matisse's acknowledgment of a cultural reference, that of Cubism, albeit tuned to another key.

The verticality of these still lifes from the mid-to-late teens, a format traditionally reserved for portraits and figure painting, is also found in Cubist works of 1911 (for example Braque's *Pedestal Table*, 1911, plate 6), yet the effect intended and produced is altogether different. Matisse did not adopt it in order to stagger the objects on a table in height (or shallow depth), but to allow him to open or broaden his perspective to include the sensory and emotional context and content of the entire field. In so doing, he introduced a sense of deliberate detachment from the presumed model, thereby distancing and diluting, even sublimating, the phenomenal existence of his subject matter into a more transcendent and ideal effect.

Clearly, Matisse did not conceive a still life as a closely cropped and focused arrangement of objects on a table; nor did he propose an exercise in formal deconstruction. On the contrary, he saw the still life as translating a universe of feeling, inspired by the natural world through the immediate sensations of sight and touch, into an organic and sensuous architecture of vibrant color and radiant light.

1. The reference here is to William Rubin, *Picasso and Braque: Pioneering Cubism*, exh. cat. (New York: The Museum of Modern Art, 1989).

18. Odilon Redon
Yellow Flowers, c. 1912
Pastel on paper
25½ x 19½" (64.6 x 49.4 cm)
The Museum of Modern Art,
New York

19. Henri Matisse
Purple Cyclamen, 1911–c. 1913
Oil on canvas
28¾ x 23⅝" (73 x 60 cm)
Private collection

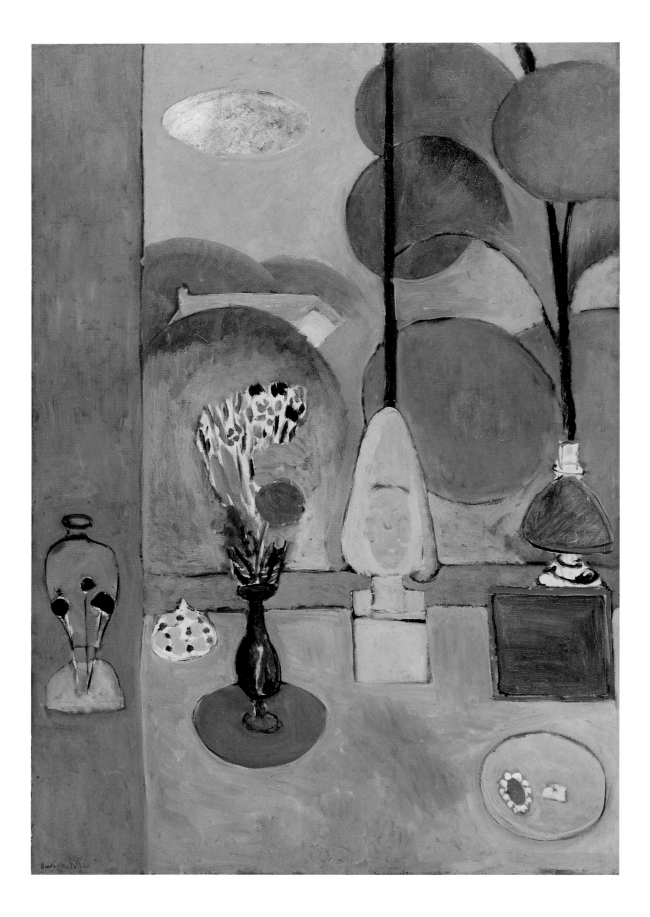

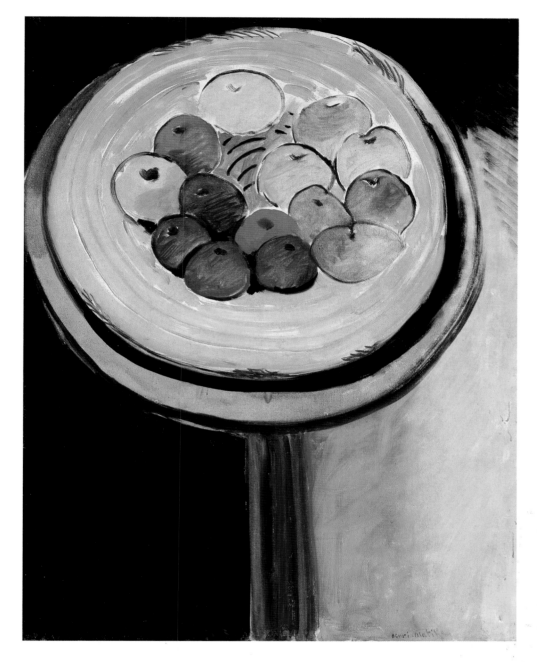

20. Henri Matisse
 The Blue Window, 1913
 Oil on canvas
 51½ x 35⅝" (130.8 x 90.5 cm)
 The Museum of Modern Art,
 New York

21. Henri Matisse
 Apples, 1916
 Oil on canvas
 46 x 35³⁄₁₆" (116.8 x 89.4 cm)
 The Art Institute of Chicago

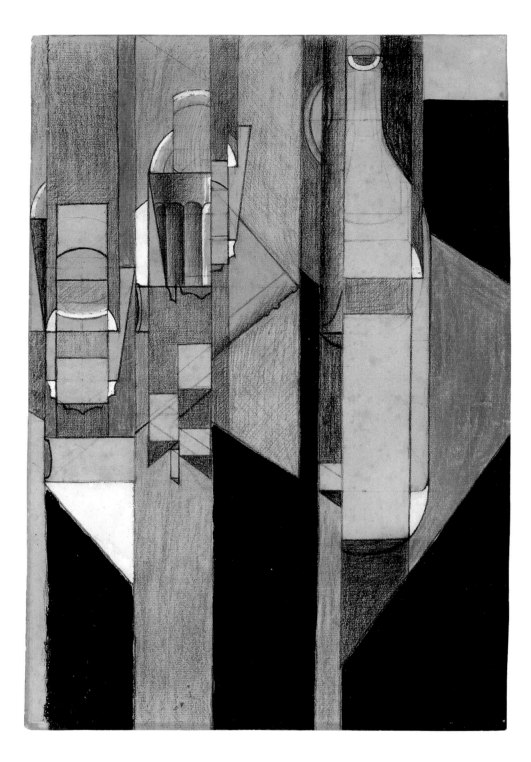

22. Juan Gris
 Glass and Bottle, c. 1913
 Ink, gouache, watercolor,
 charcoal, and pencil
 on gray paper
 18 ¼ x 12 ¼" (46.3 x 31.1 cm)
 The Museum of Modern Art,
 New York

23. Pablo Picasso
 Siphon, Glass, Newspaper,
 and Violin, 1912
 Pasted paper and charcoal
 18 ½ x 24 ⅝" (47 x 62.5 cm)
 Moderna Museet, Stockholm

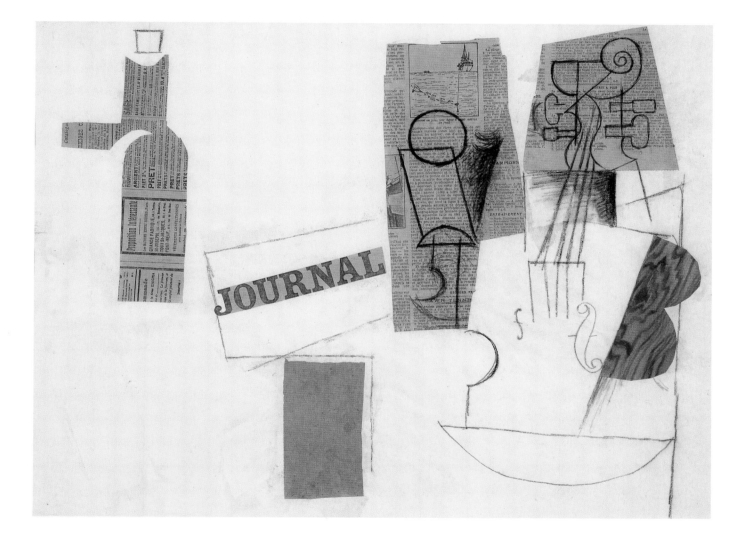

24. Pablo Picasso
 Guitar, 1912–13
 Sheet metal and wire
 30½ x 13⅛ x 7⅝"
 (77.5 x 35 x 19.3 cm)
 The Museum of Modern Art,
 New York

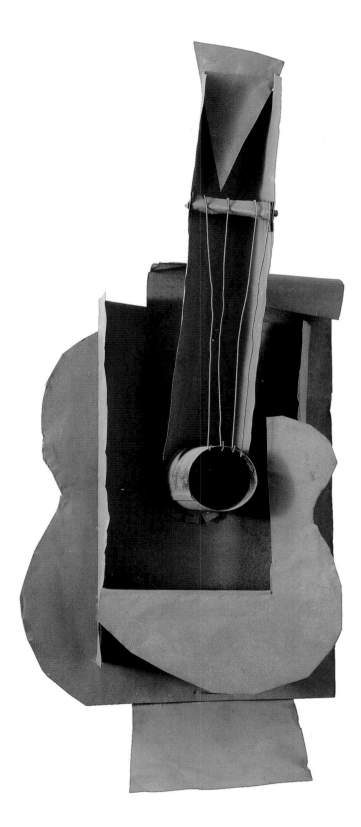

25. Pablo Picasso
 Guitar, 1913
 Oil on canvas
 mounted on panel
 34¼ x 18¾" (87 x 47.5 cm)
 Musée Picasso, Paris

26. Georges Braque
 Guitar, c. 1913
 Gesso, pasted paper, charcoal,
 pencil, and gouache on canvas
 39¼ x 25¾" (99.7 x 65 cm)
 The Museum of Modern Art,
 New York

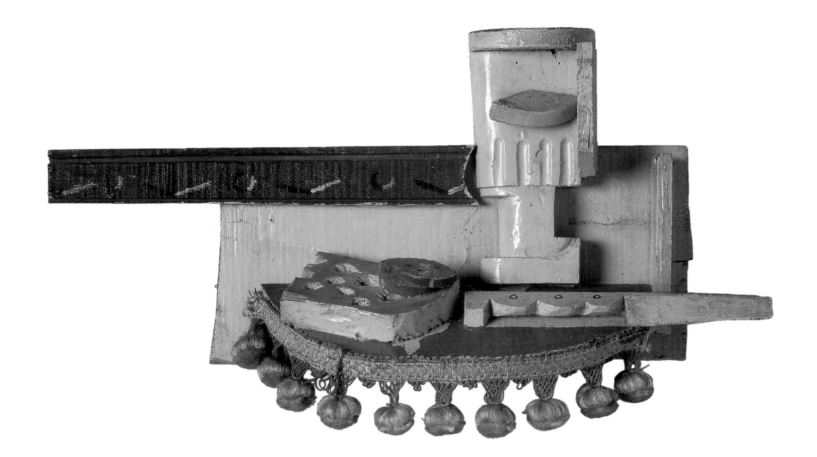

27. Pablo Picasso
Still Life, 1914
Construction of painted wood with
upholstery fringe
10 x 18 x 3⅝" (25.4 x 45.7 x 9.2 cm)
Tate Gallery, London

28. Georges Braque
Still Life with Tenora, 1913
Pasted paper, oil, charcoal, chalk,
and pencil on canvas
37½ x 47⅜" (95.2 x 120.3 cm)
The Museum of Modern Art, New York

Errata

P. 123: Because of a printing error, several lines have been omitted at the bottom of this page. Starting with the last line, the passage should read:

The artists rather arbitrarily grouped in this section, despite disparate geographical backgrounds and historical contexts, share several characteristics in their approach to the creative process and in their subjects and stylistic concerns. The first might be identified as a *lack* of objectivity, which is replaced by an emotional intensity. With a few exceptions (the *papiers découpés* of Matisse and Picasso, plates 71 and 72), their variations on the still life genre are governed by the conditions and the events of their personal histories and temperaments.

A second trait, related to the first, is a desire to channel their emotion through iconographic themes and motifs of established. . . .

Pp. 135 and 159: Plates 72, showing Pablo Picasso's *Still Life with Three Apples and a Glass*, and 91, showing Frida Kahlo's *Still Life with Prickly Pears*, are flopped.

P. 156: The credit line for plate 87 in this book, showing René Magritte's *Personal Values*, should read: Collection Harry Torczyner, New York.

P. 203: The dimensions of Kiki Smith's *Second Choice* (plate 121) are 6 x 24 x 11" (15.2 x 60.9 x 27.9 cm).

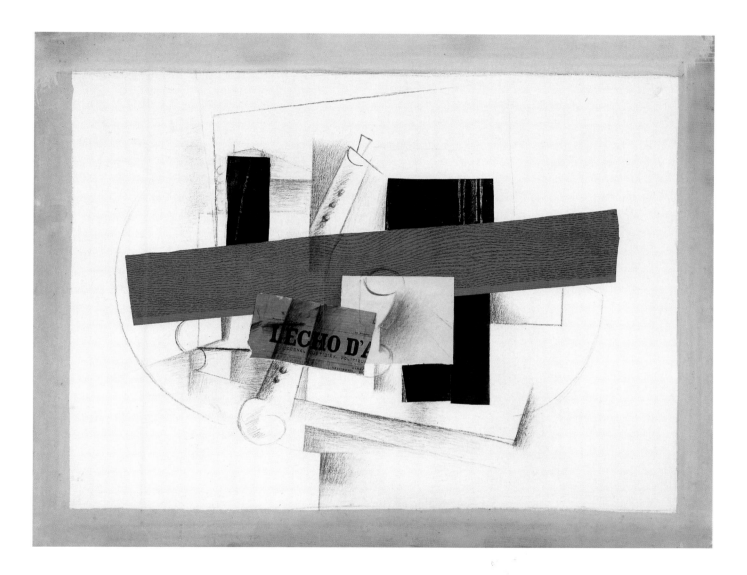

29. Pablo Picasso
 Glass of Absinthe, 1914
 Painted bronze with
 found absinthe spoon
 9½" (23.7 cm) high
 Private collection

30. Henri Laurens
 Fruit Bowl with Grapes, c. 1918
 Painted sheet metal and wood
 27⅛ x 24⅞ x 18⅞"
 (68 x 62 x 47 cm)
 Private collection

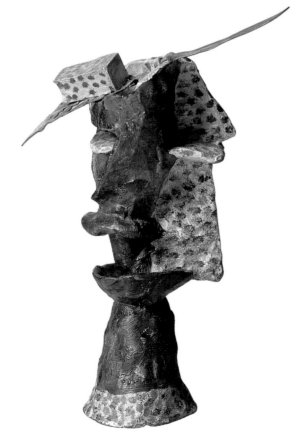

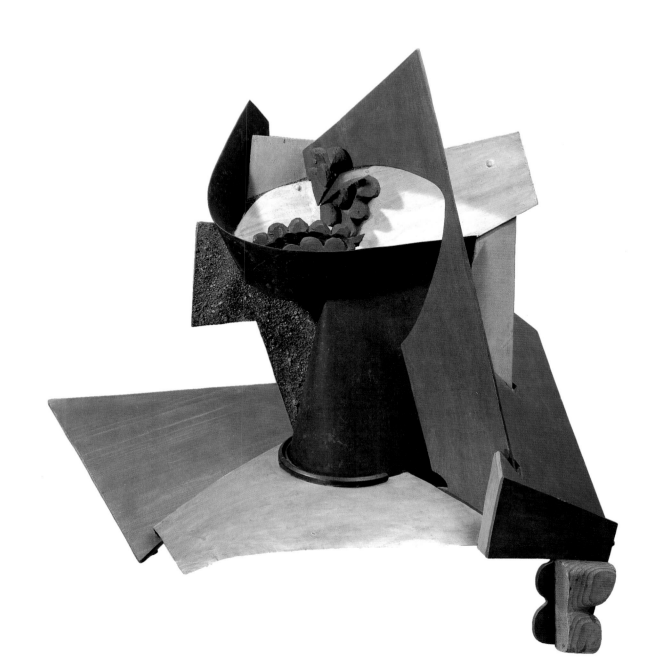

31. Juan Gris
 The Newspaper, 1914
 Oil, pasted paper,
 and pencil on canvas
 21⅝ x 18⅛" (55 x 46 cm)
 Private collection

32. Juan Gris
 Flowers, 1914
 Cut and pasted papers, oil,
 and crayon on canvas
 21⅝ x 18½" (53.7 x 46.2 cm)
 Private collection

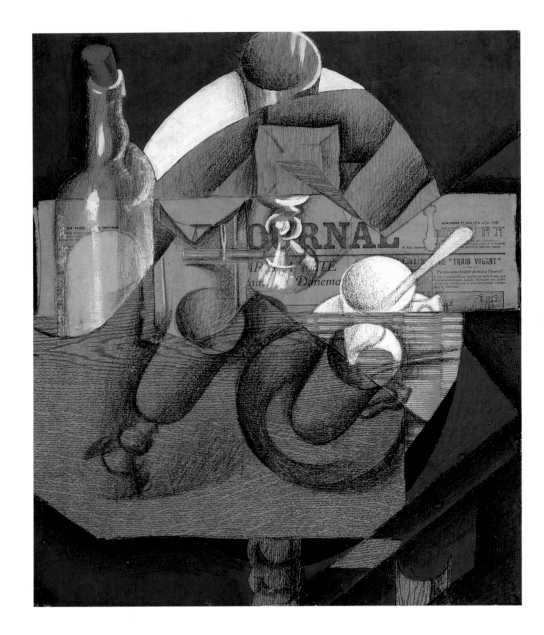

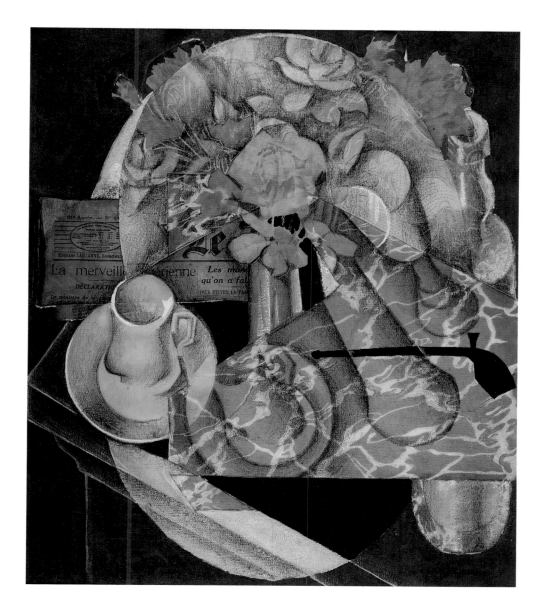

33. Fernand Léger
Composition, 1919
Oil on canvas
32 x 25½" (81 x 65 cm)
Collection Hester Diamond

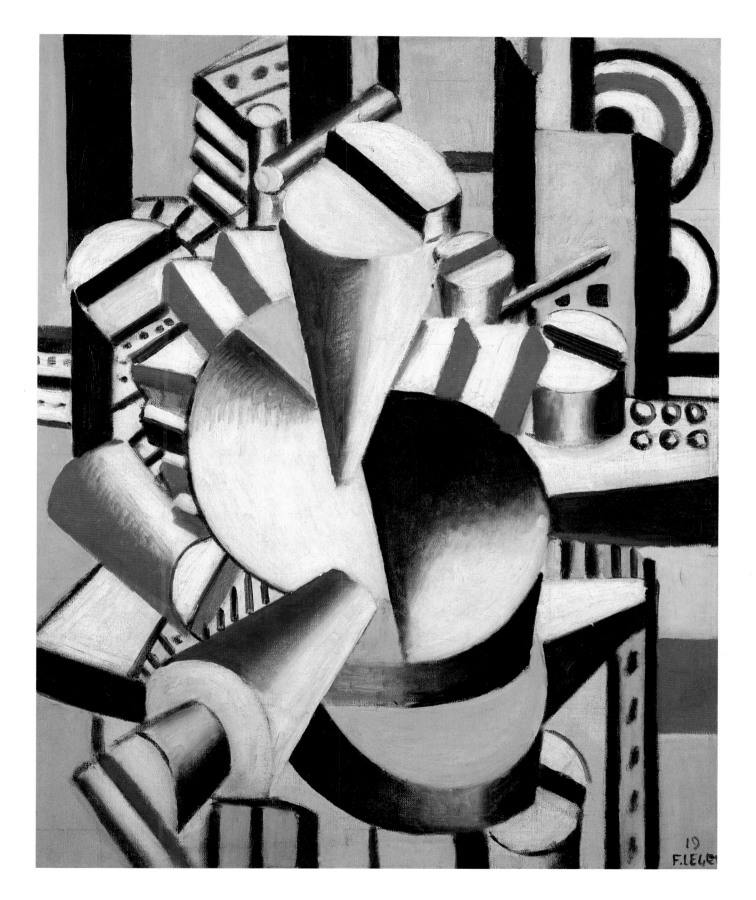

REAL
FICTIONS

To speak of readymades, machine paintings, and other Dada gestures as forms of still life would surely make many of their authors turn over in their graves. But perhaps not, given that paradox was a major constituent of the Dada state of mind. Since one aim of these artists, working in the teens and early '20s, was to repudiate all Beaux-Arts subjects and conventions, the still life was high on their list of artistic practices to undermine. Yet at the same time, the ordinary object, in its commonplace banality, was a subject they loved to use and abuse. Indeed a case may be made that certain readymades and other Dada experiments not only can be identified as variations on the still life theme, but, as such, posited a radically new interpretation of that genre. In one sense, through the Dadaists' reinvention of the still life, the mode and its destiny would be infinitely enriched and prolonged.

It is common in discussions of the Dada movement to speak of Dada objects per se, defined as actual objects that, through an artist's sleight of hand, metamorphosed into poetic statements. Since this phenomenon is central to the whole Dada enterprise, it is necessary from the outset to distinguish between the Dada artists' manipulation and redefinition of a common object, and the recasting of that object (or objects) as a constituent of a still life. This distinction is not easily made. It is nonetheless crucial to the understanding of one of the vitally significant impulses contributing to later developments of the still life mode.

Whereas Marcel Duchamp's *Bicycle Wheel* of 1913 (plate 34) may aspire to inclusion in a discussion of the still life, his *Bottlerack* of 1914 may not. Although one might hastily conclude that the still life's appropriation of the former draws its justification from the fact that this work is an assemblage of objects, whereas the latter is not, this argument is unconvincing. For the issue, as we will see throughout this exhibition, does not hinge on the quantity of objects, but on a mysterious quality of displacement. Displacement is not synonymous with decontextualization, for in this instance both objects are more or less decontextualized, transplanted from one realm of experience to another. Yet the *Bottlerack*, whether placed on the ground or suspended in space, continues to be identified as a piece of hardware designed for a unique and specific use. As autonomous and isolated in its artistic

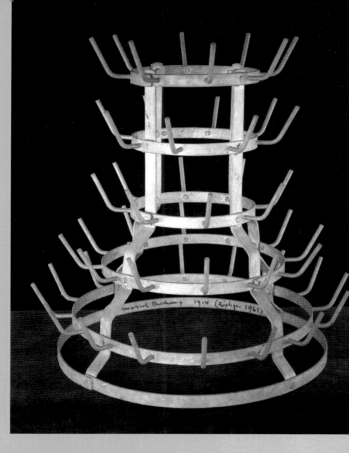

Marcel Duchamp
Bottlerack (Bottle Dryer), 1964;
after lost original of 1914
Readymade; galvanized-iron
bottle dryer
25" (63.5 cm) high
Philadelphia Museum of Art

life as in its real life, its phenomenal existence and aura are the same, which is to say that even if, thanks to Duchamp, it has provisionally and notionally been dubbed with the status of a work of art, it has not been permanently deprogrammed of its initial function. If returned to the store from which it came, or abandoned in the street, it would surprise no one.

Conversely, the *Bicycle Wheel* (on a kitchen stool) has been totally dispossessed of its original function. Returned to the street under its new guise, it would astonish and surprise as the anomalous (not even immediately perceived as aesthetic or artistic) object it has become. So whereas the *Bottlerack* remains within the usual circuits of common perception and experience, the *Bicycle Wheel* has been disconnected and displaced to another, closed, circuit of signification. It has been transformed from a reality to a fiction. And a fiction, by definition, is not of this world. It is a self-contained system and generates its own peculiar time and space, at a concerted distance from the reality that inspired it.

It is a truism that the key to the artistic revolution wrought by Duchamp lies in the act of choice: that the mere selection of a

miscellaneous object—as opposed to the considered conception and crafted execution of a new, material, and signifying entity—bestows upon this object the definition of a work of art, displacing it automatically from the arena of the mundane to that of the aesthetic. However, as we sort through Duchamp's oeuvre, attempting to determine what can aspire to a still life status and what cannot, it becomes apparent that the choice and displacement of a single object or objects is not enough. If the work is to constitute a still life, subsequent decisions (additions, subtractions) that correspond to the idiosyncratic impulses of a particular subjectivity (despite Duchamp's absolute disavowal of such a premise) must inform the final effect, thereby deprogramming the object and endowing it with a fictional identity.

Duchamp's Underwood typewriter cover or *Traveler's Folding Item* of 1916 (plate 36) presents another example, this time of a subtractive process (as opposed to the additive one of the *Bicycle Wheel*) engendering displacement and transformation. Unaccompanied by the typewriter that gives it its nobility of meaning and its sole raison d'être, it is nonetheless endowed with the typewriter's shape, as though this support were actually there. Unappealing in substance and color, this severed accessory thus assumes an autonomous (and ambivalent) identity that challenges the viewer's response. Unlike the *Bottlerack*, it has transcended its use function and been reborn as a parody of itself, or a poetic fiction.

Another important factor in the phenomenon of displacement, transformation, or fictionalization of a common object is the process of renaming. The Underwood cover has been renamed; the *Bottlerack* has been not only *not* transformed but *not* renamed. Although the *Bicycle Wheel* was not poetically transformed in its title, its original designation is not inclusive of its new physical condition (poised on a kitchen stool), thereby introducing a hiatus between the object and its proposed identity, between expectation and reality. As for the Underwood cover, its rechristening as *Traveler's Folding Item* collapses the thing into its name, emphasizing its otherness. This was not a casual procedure on Duchamp's part. As he would later state, his inscriptions or titles for his readymades were "meant to carry the mind of the spectator towards other regions more verbal."[1]

Marcel Duchamp
The Chocolate Grinder (No. 2), 1914
Oil and thread on canvas
25 ½ x 21 ¼" (65 x 54 cm)
Philadelphia Museum of Art
The Louise and Walter Arensberg Collection

This metamorphosis from a reality to a fiction is one of the basic tenets of the still life, as of all representation. For it is obvious (as we have seen) that both before and after Duchamp, the still life is a fiction; it is not a faithful and photorealist rendering of familiar, useful objects, but a self-contained pictorial grammar manipulated so as to manifest a particular artist's vision. Yet one of the most obvious and fundamental distinctions between a traditional still life and these transposed objects from the Dada period is the seeming absence of the mediating process by which a subject in the actual world is translated into an illusion, through the use of other mediums such as paint, plaster, wood, or bronze.

As we may surmise from Duchamp's example, the subjects favored by the artists associated with the Dada movement, whether they worked with actual objects or in more traditional modes, were unprecedented, neither drawn from the conventional repertory of the domestic scene nor related to the charms of café life. For these artists, impersonal manufactured articles (machines, office equipment, household utensils of the lowest order), although common in everyday life, were new to art, and brought a certain virginity to the art experience. These "modernistic" motifs were devoid of an aesthetic history or of moral or

emotional associations, and discouraged traditional allegorical readings, even though, in many instances, they were intended to encourage other readings of ambivalent, sometimes even erotic content.

In Dada paintings, as opposed to objects (for many of these artists continued to practice the medium of painting, not *despite* its academic connotations but *because* of them), this presumed purity of the subject matter was reinforced by a determined reductiveness in its presentation and a mechanical anonymity in its execution. In works such as Duchamp's *Chocolate Grinder (No. 2)*, of 1914, Francis Picabia's *Very Rare Picture on Earth,* of 1915, or Morton Schamberg's "machine" paintings (plate 40), the objects are staged in such a way that a single frontal image crowds the frame. The image is emptied of background incident, perspectival cues, gravitational pull, atmospheric color, or spatial illusionism of any kind. Personal affectations or interpretations and expressive brushwork are also conspicuously absent, replaced by an almost automated precision and technique. These seemingly mechanized routines render the objects more technologically seductive and

Francis Picabia
Very Rare Picture on Earth, 1915
Gouache and ink on composition board
45 ⅛ x 34 ½" (113 x 86.5 cm)
The Peggy Guggenheim Foundation, Venice

presumably absolutely real. At the same time, though, they constitute a mythicization that distances the objects both from the world of common experience (e.g., their use and exchange value) and from that of artistic conventions. This fundamental ambiguity, seen in objects that simultaneously embody an immediate presence, a detached indifference, and an unsettling interlacing of contradictory experiences and ideas, defines the uncanny fictions of the Dada enterprise, and its singular contributions to the future development of the still life genre.

1. Marcel Duchamp, "Apropos of 'Readymades,'" in *The Writings of Marcel Duchamp*, ed. Michel Sanouillet and Elmer Peterson (New York: Da Capo Press, 1989), p. 141.

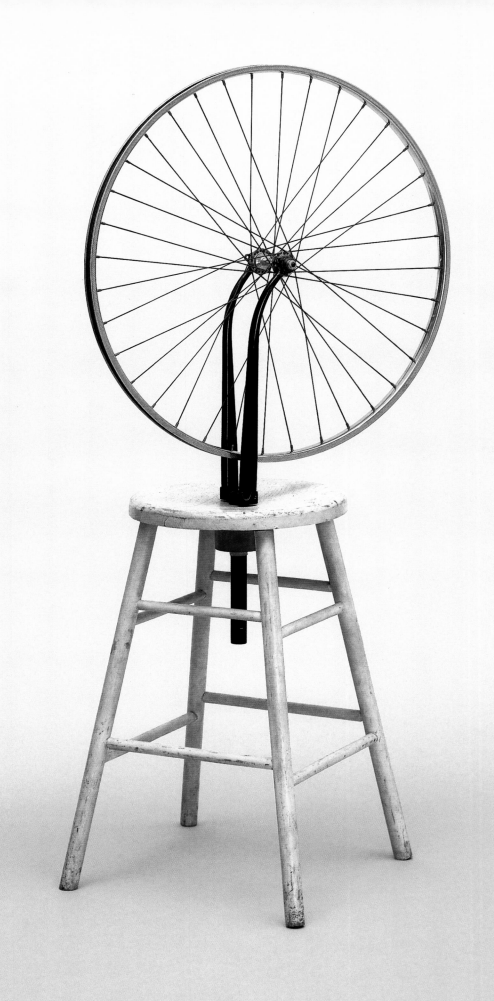

34. Marcel Duchamp
Bicycle Wheel, 1951; third version,
after lost original of 1913
Assemblage: metal wheel mounted
on painted wood stool
50 ½ x 25 ½ x 16 ⅝"
(128.3 x 63.8 x 42 cm) overall
The Museum of Modern Art,
New York

35. Marcel Duchamp
Chocolate Grinder (No. 1), 1913
Oil on canvas
24 ⅜ x 25 ⁹⁄₁₆" (62 x 65 cm)
Philadelphia Museum of Art

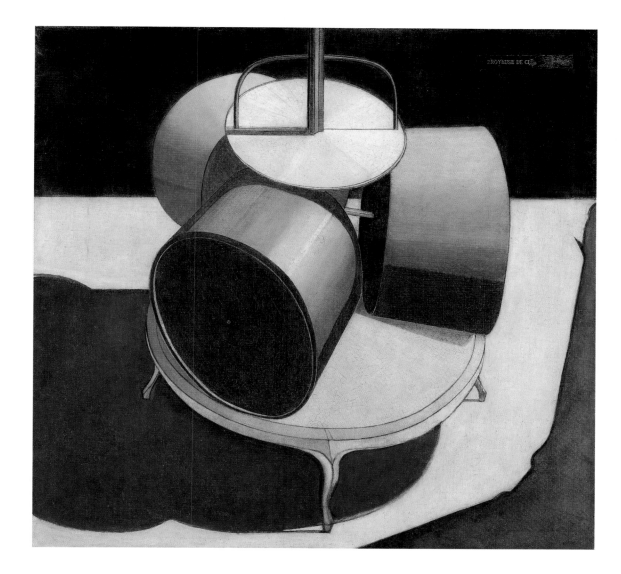

36. Marcel Duchamp
Traveler's Folding Item, 1964; third version,
after lost original of 1916
Readymade: Underwood typewriter cover
9 1/16" (23 cm) high
Musée national d'art moderne,
Centre Georges Pompidou, Paris

37. Marcel Duchamp
Why Not Sneeze Rose Sélavy?, 1964;
replica of original of 1921
Painted metal birdcage containing
151 white marble blocks, thermometer,
and piece of cuttlebone
Cage: 4 7/8 x 8 3/4 x 6 3/8" (12.3 x 22.1 x 16 cm)
The Museum of Modern Art, New York

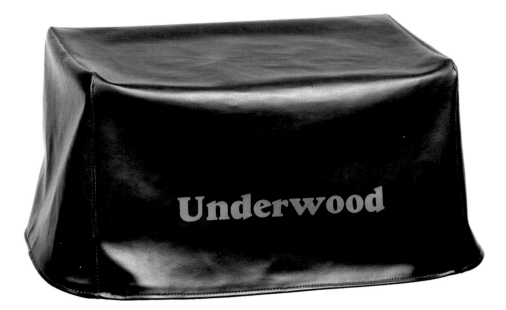

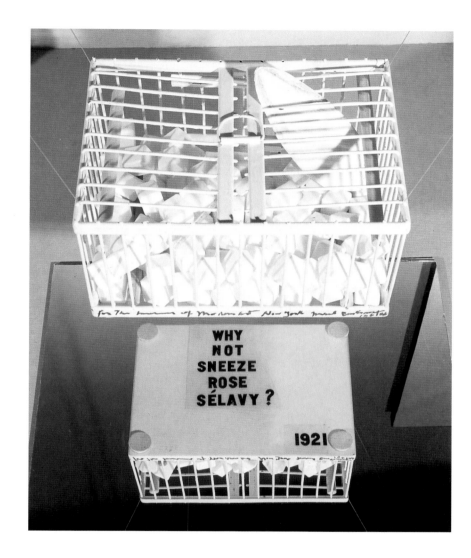

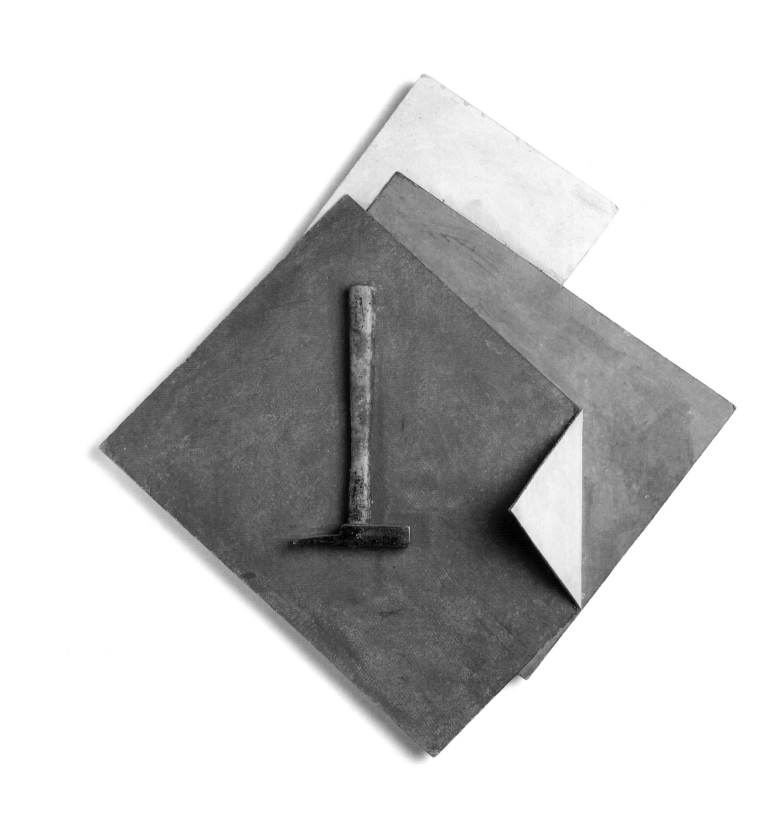

38. Iwan Puni (Jean Pougny)
Still Life—Relief with Hammer, c. 1920;
reconstruction of original of 1914
Gouache on cardboard with hammer
31 5/8 x 25 3/4 x 3 1/2" (80.5 x 65.5 x 9 cm)
Collection Herman Berninger, Zurich

39. Man Ray
Gift, c. 1958; replica of original of 1921
Painted flatiron with row of thirteen
tacks, heads glued to the iron's bottom
6 1/8 x 3 5/8 x 4 1/2" (15.3 x 9 x 11.4 cm)
The Museum of Modern Art, New York

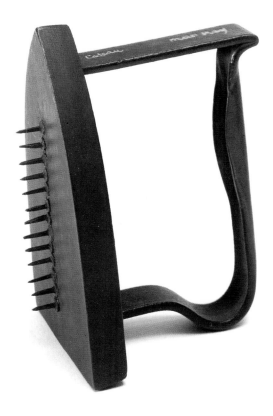

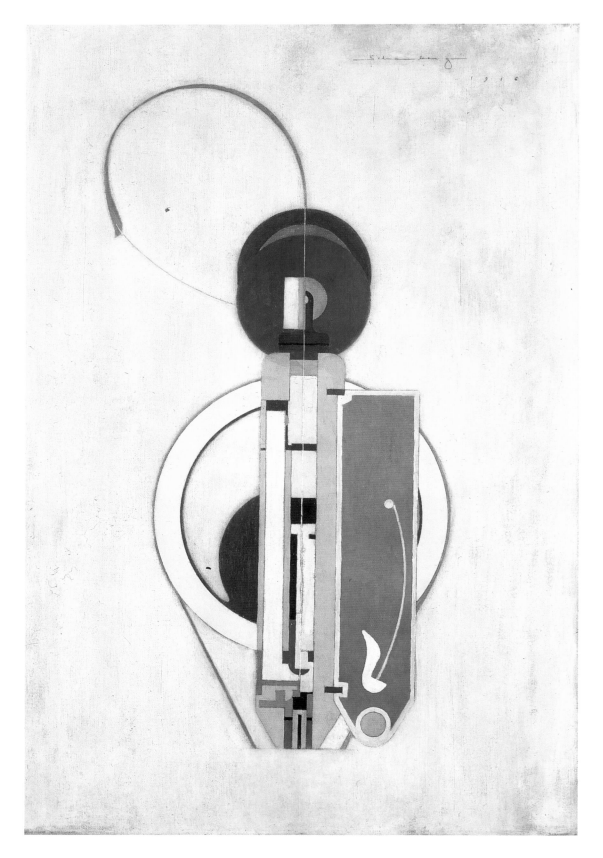

40. Morton Schamberg
Painting VIII (Mechanical Abstraction), 1916
Oil on canvas
30 x 20¼" (76.2 x 51.4 cm)
Philadelphia Museum of Art

41. Francis Picabia
Resonator, c. 1922
Gouache and ink on
composition board
28½ x 21" (72.4 x 53.3 cm)
Grey Art Gallery & Study
Center, New York University

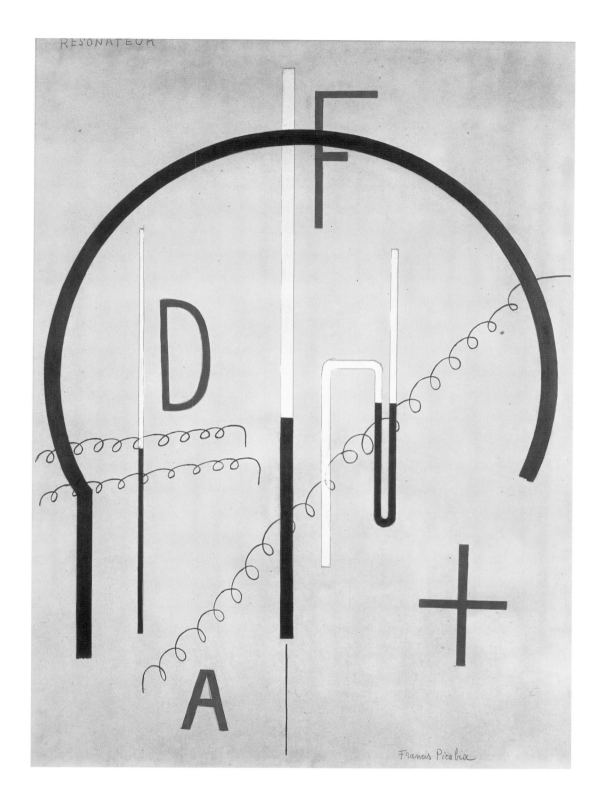

METAPHYSICAL PAINTING:

MODERN CLASSICISMS/

IDEAL GEOMETRIES

Traditionally, the basic constituents of a still life are objects (or an object) framed in their (or its) immediate environment. Indexes for measuring a still life's modernity have been seen to include the kinds of objects chosen, the degree of illusionism employed, and the use of artificial, as opposed to naturalistic, color, light, scale, or spatial syntax. These are diversely handled, interpreted, and coded as a function of a society's changing relationship to its objects and of incumbent new sensibilities, new pictorial objectives and techniques. Whereas the Dada variations on the still life mode focused primarily on the placement and displacement of banal or "indifferent" objects in isolation, purposely stripped of all illusionistic and contextual clues, the Metaphysical style of painting more often emphasized the spatial context or environment, with the intention of representing a visionary theater of the world.

The term "Metaphysical," as applied to painting, was first defined by the writer Filippo de Pisis in 1918, in a defense of the Italian painters Giorgio de Chirico and Carlo Carrà. (Carrà had already used the word more casually somewhat earlier, and would reuse it later, in 1919, according to a personal, and somewhat different, understanding.) According to de Pisis, this "new art which we call Metaphysical... expands the barriers of the knowable immeasurably." It is based on "the direct vision of mystery, contained in the most common and insignificant objects."[1] Giorgio Morandi, on the basis of his still life paintings of 1918–19, would also be briefly associated with this tendency. In view of the fact that other artists foreign to this group, some of them working in Paris, for example,[2] may be seen to share some of these ambitions, or at least to produce somewhat similar effects, we have taken the liberty of broadening the term's initial scope.

The artists of the Metaphysical school aimed not to subvert or transgress inherited pictorial traditions but to sustain them, although remodeling them according to a singular and unprecedented vision. When de Chirico's and Carrà's Metaphysical paintings from 1917 were first brought to the Italian public's attention, in 1917–18, they were presumed to represent a return to tradition and a radical disavowal of Futurism, the dominant avant-garde ideology and practice in Italy at the time. Yet the artistic visions of de Chirico, Carrà, and Morandi between

1913 and 1919 (plates 42, 43, 47, and 48) were not conservative or regressive, but infinitely modern. Whereas the classically rendered motifs and rigorous ordering of their compositions appear initially reassuring, this impression is quickly dispelled by the realization that the supposed order is radically unnatural, and that the objects, as obvious and familiar as they might first seem, exist in some anomalous world beyond reason, perception, or experience. Moreover, it is easy to perceive that these objects (and the system that encloses them) correspond to the nostalgic structure of desire, a longing for the past projected into a utopian future, or "a deferment of experience in the direction of origin."[3]

Although these artists looked toward tradition (and notably toward fifteenth-century Florentine painting) as an alternate source of inspiration to the Futurist model, they would filter its lessons through an enigmatic modernist mode. The resulting paintings may be generally described in terms of a spatial ordering that follows strict yet illogical underlying geometries, and of a choice of universal commonplace objects, sometimes distilled to idealized silhouettes. Color and light are artificial, whether in the brilliant palette, and sharply contrasted light and shade, from which de Chirico generated his theatrical effects, or in the muted chromatic registers, often unified to a virtually monochromatic ambient light, of Carrà and Morandi. If these works contain all the attributes of the conventional still life, their manner of presentation, combined with their subtle deviations from established norms, produces a disturbingly distanced and spectral effect.

The style of each of these artists, despite general and shared characteristics, was distinct and personal. The structure of de Chirico's paintings is certainly the most complex: apparently perspectival, his linear vectors in fact obey an outright illogic that deconstructs all notions of illusionism, reordering the surface according to ineffably conflicting geometries. His subject matter further confounds the viewer. Whereas the components of his still lifes (familiar objects often combined with motifs from classical antiquity or Renaissance painting) appear totally unrelated, their very unrelatedness, their telescoping of past and future, and the extreme incompatibility of their associations create an enigmatic poetry. And their bizarre location in outdoor cityscapes fuses two historically distinct modes. Without dissolving the autonomy of each

(indeed conflicting scales and perspectives emphasize the spatial and contextual separateness of objects and landscape), de Chirico superimposes these two image-worlds, thereby creating a pictorial reading that is structurally and iconographically unsettling and strange. His metaphoric and nostalgic titles only reinforce the spatial and temporal elusiveness of the total effect.

De Chirico's commonplace or classical repertory of motifs, crudely rendered, brightly colored, harshly lit, slightly out of scale, recall the paintings of Rousseau, an artist whom he admired. The multiple-vector perspectives and tilted planes of his spatial organizations betray his knowledge of French Cubism. De Chirico's deliberate paraphrasing, ironic reinvention, and bold conflation of inherited conventions, all indexes of the singular modernism of his paintings, would have a lasting effect on the art of the twentieth century. Moreover, as importantly as the subversive play of Duchamp and Picabia, de Chirico would help to destroy the intimist parameters of the still life, taking it off the table, out of the interior, and into the infinite spaces of the world.

To Carrà, Italian Renaissance painting represented spirituality and austerity. *Still Life with Triangle* of 1917 (plate 47) is exemplary of his ambitions during the brief Metaphysical period of his career: his choices of modest familiar objects, placed in the symbolic spatial structure of a closed, cell-like room and bathed in a muted and uniform atmospheric light, express a sense of closure, of separation and estrangement, in direct contrast to de Chirico's intricate spatial tricks and garish colors. The idea of landscape is not foreign to this work, or to Morandi's paintings of the same period, but Carrà's landscapes are tightly controlled interior ones. Since the space is configured as a room (or box), the still life objects that inhabit it (and that are set or stand on the ground) have a strange uncanny scale, as though we were in the presence of spectral figures. These paintings appear to suggest a singular vision, translated as a distilled, airless atmosphere, or the stage of a "mystery" play in a metaphysical theater. In spirit if not in facture, they recall the ascetic inaccessibility of Sánchez Cotán's larder scenes where the foodstuffs are bracketed by a geometric framework parallel to the frame of the canvas (see illustration, p. 14): objects of desire to be seen but not touched or enjoyed.

Alberto Magnelli met de Chirico in Paris in 1914, when he also encountered the paintings of Matisse. His exposure to fifteenth-century Florentine painting—which he would later state had oriented him toward an architectonic organization of the surface plane—prepared him for de Chirico's and Matisse's lessons: de Chirico's example showed him that geometry should be structural as opposed to representational or allusive, whereas he was impressed by Matisse's "cloisonné" effects, achieved by enclosing simply contoured shapes in broad expanses of flat unmodulated color (as in the first version of *The Dance*, 1909, which he saw in Matisse's studio). The ideal geometry seen in Magnelli's still life compositions of 1914 (plate 44), and their radical frontality, saturated color, and softly outlined motifs, reflect a synthesis of past and present references.

To associate Matisse with Metaphysical painting is unprecedented, yet his paintings of the mid-teens reveal several formal analogies. These interior landscapes, geometrically structured, show a reductive use of color in contrasting panels of light and shadow, and a simplified idealization of vision, composition, and motifs. Matisse's paintings of 1914–16 (plates 45 and 46) were indeed the most structurally austere and chromatically purified of his career to that date. They of course show none of the theatrical complexity of de Chirico, and are estranged from the extreme monochromatic severity and closed spectral images of Carrà and Morandi. On the contrary, Matisse's new attention to structure and his relatively restricted palette have not eliminated but concentrated to their essence the fullness, richness, and sensuality of reality. Nature was still his primary model, yet here he has tightened his focus to the organizing forces of sunlight and shadow, displaced and redistributed in flat architectonic planes. One might suggest that these paintings are Matisse's most eloquent expression of a metaphysical vision. They are a spiritual, essentialist statement, expressed through an ideal geometry, of his sensations and emotion before the world.

The classicism of Picasso, and indeed, we might say, his metaphysical vision, are comparable in substance to that of Matisse, although quite differently formulated. His singular *Still Life with Pitcher and Apples* of 1919 (plate 49) shows a sensuous physicality in an idealized configuration that echoes a distant and timeless Mediterranean

classicism. For Picasso as for Matisse, a metaphysical dimension is inherent to the world of the senses, reordering and mediating the direct experience of specific things. As for the Purist still life, as developed in France by Amédée Ozenfant, Le Corbusier, and even Patrick Henry Bruce (plates 50–53), it is closer in its spatial conception, its transcendence through distantiation, and its geometricized world view to the Italian Metaphysical school.

The so-called Metaphysical still life, as presented here, is not a homogeneous stylistic tendency. Nonetheless, the prevalence of a quintessential ideality in the treatment of still life subjects, and of an abstract geometry in their global organization, suggests a common attempt to reconnect with an ideological past, and to recast it according to modern codes of representation and of meaning. It was a nostalgia for a spiritual and eternal order of the universe that these artists sought metaphorically to portray, not the more accessible experiences of their immediate phenomenal existence.

1. See Joan M. Lukach, "De Chirico and Italian Art Theory, 1915–1920," in William Rubin, ed., *De Chirico*, exh. cat. (New York: The Museum of Modern Art, 1982), p. 46. Lukach quotes from a lecture given by de Pisis in Viareggio on August 29, 1918, cited in de Pisis, *La Città dalle Cento Meraviglie*, pp. 126–43; and also from de Pisis, "*Esposizione di pittura moderna a Viareggio: Carlo Carrà—Giorgio de Chirico*," in *Fronte Interno*, August 30, 1918.

2. It should be noted that de Chirico's earliest so-called Metaphysical paintings, dating from 1913–14, were executed in Paris, not Italy.

3. Susan Stewart, *On Longing* (Durham, N.C., and London: Duke University Press, 1993), p. x.

42. Giorgio de Chirico
 The Transformed Dream, 1913
 Oil on canvas
 24 ¾ x 59 ⅞" (63 x 152 cm)
 The Saint Louis Art Museum

43. Giorgio de Chirico
 The Song of Love, c. 1914
 Oil on canvas
 28 ¾ x 23 ⅜" (73 x 59.1 cm)
 The Museum of Modern Art, New York

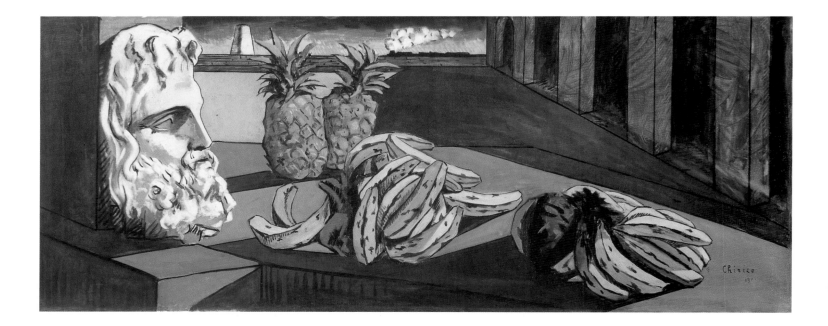

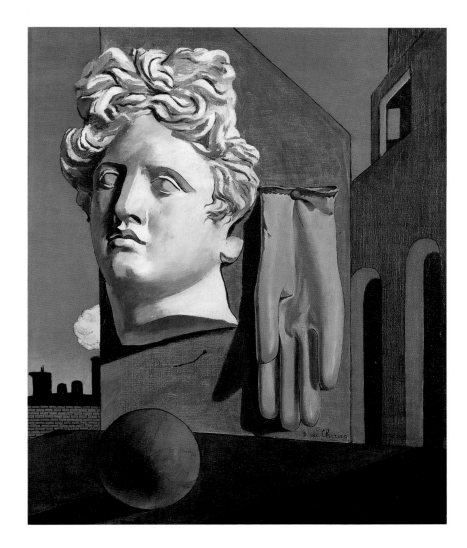

44. Alberto Magnelli
 Still Life with Apple, 1914
 Oil on canvas
 27 ½ x 21 ⅝" (70 x 55 cm)
 Musée national d'art moderne,
 Centre Georges Pompidou, Paris

45. Henri Matisse
 Goldfish and Palette, 1914
 Oil on canvas
 57 ¾ x 44 ¼" (146.5 x 112.4 cm)
 The Museum of Modern Art,
 New York

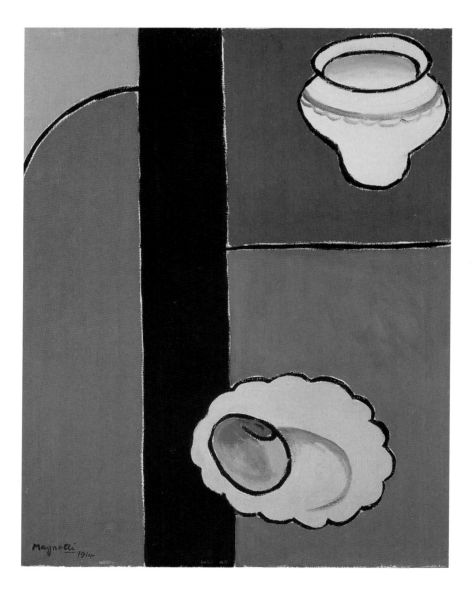

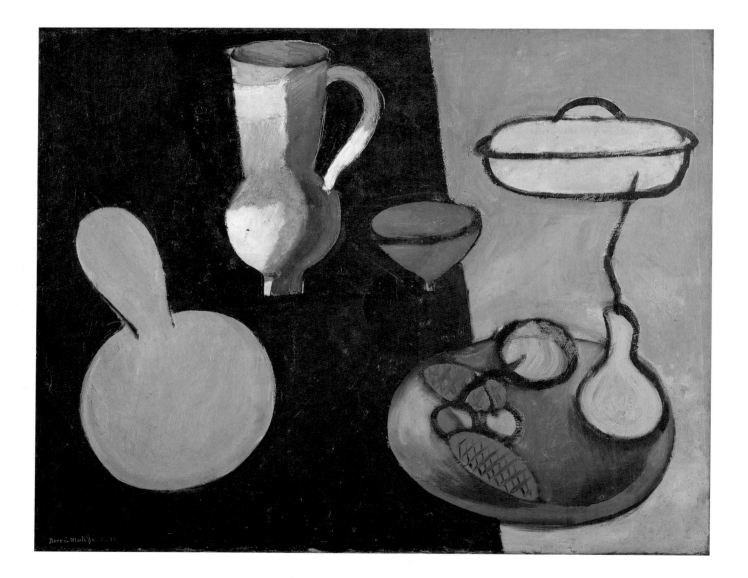

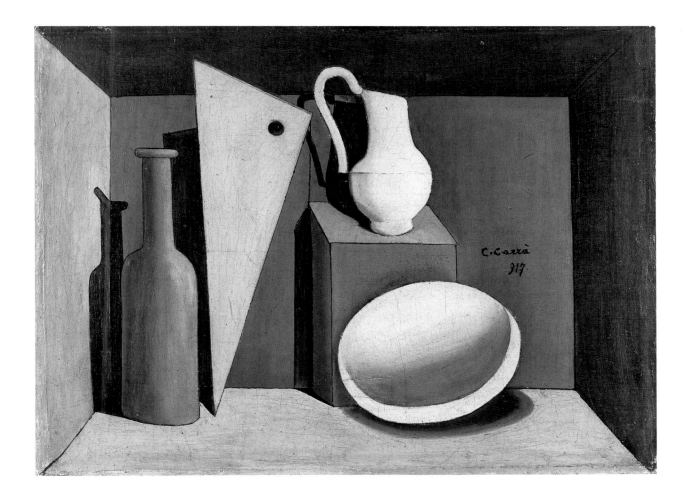

46. Henri Matisse
Gourds, 1915–16
Oil on canvas
25 5/8 x 31 7/8" (65.1 x 80.9 cm)
The Museum of Modern Art,
New York

47. Carlo Carrà
Still Life with Triangle, 1917
Oil on canvas
18 1/8 x 24" (46 x 61 cm)
Civiche Raccolte d'Arte, Milan

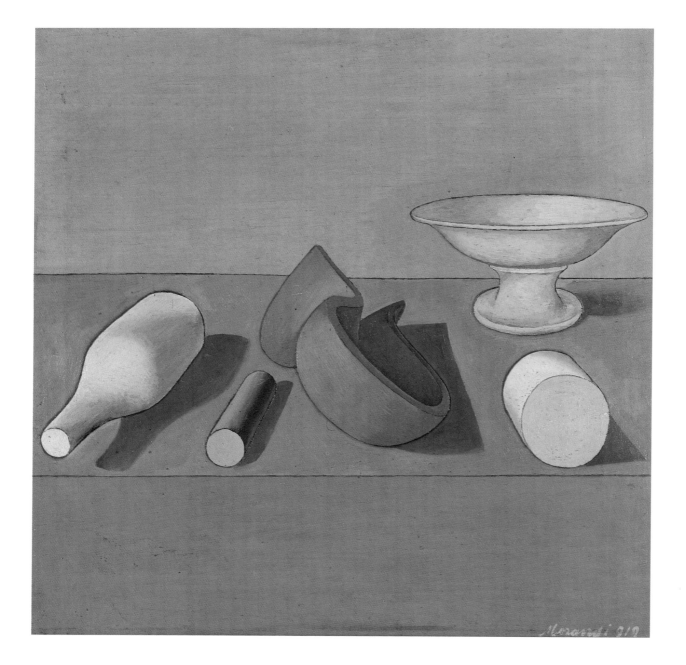

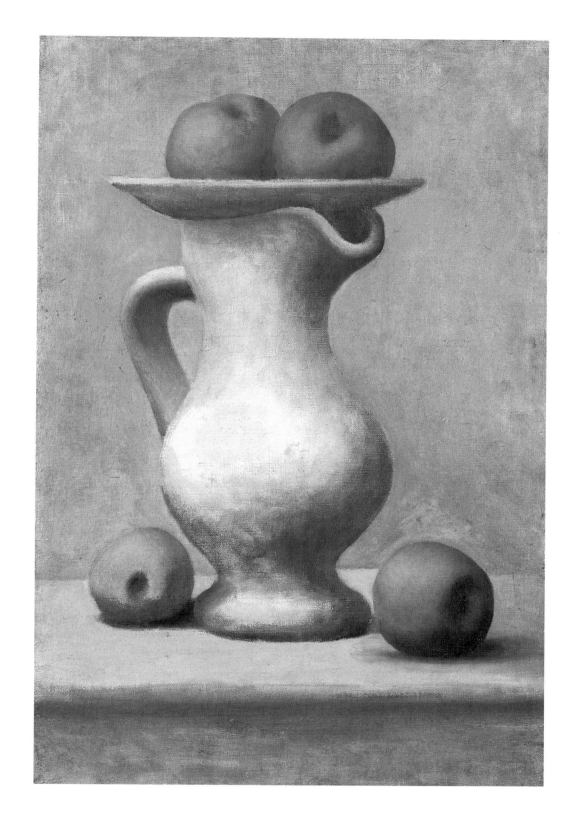

48. Giorgio Morandi
 Still Life, 1919
 Oil on canvas
 23 ⅝ x 23 ¼" (60 x 59 cm)
 Pinacoteca di Brera, Milan

49. Pablo Picasso
 Still Life with Pitcher and Apples, 1919
 Oil on canvas
 25 ½ x 17 ⅛" (65 x 43.5 cm)
 Musée Picasso, Paris

50. Patrick Henry Bruce
Painting, c. 1919
Oil and pencil on canvas
23 ½ x 28 ⅜" (59.7 x 72 cm)
Private collection

51. Le Corbusier
The Red Bowl, 1919
Oil on canvas
31 ⅞ x 25 ½" (81 x 65 cm)
Fondation Le Corbusier, Paris

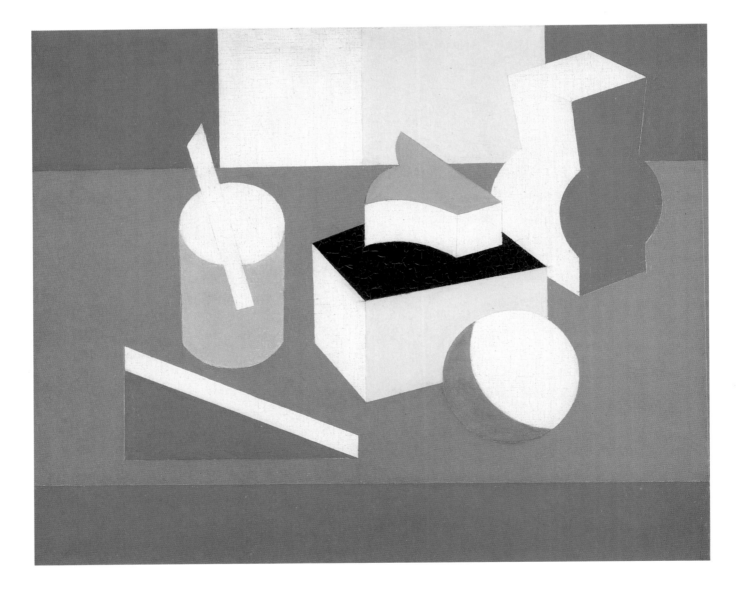

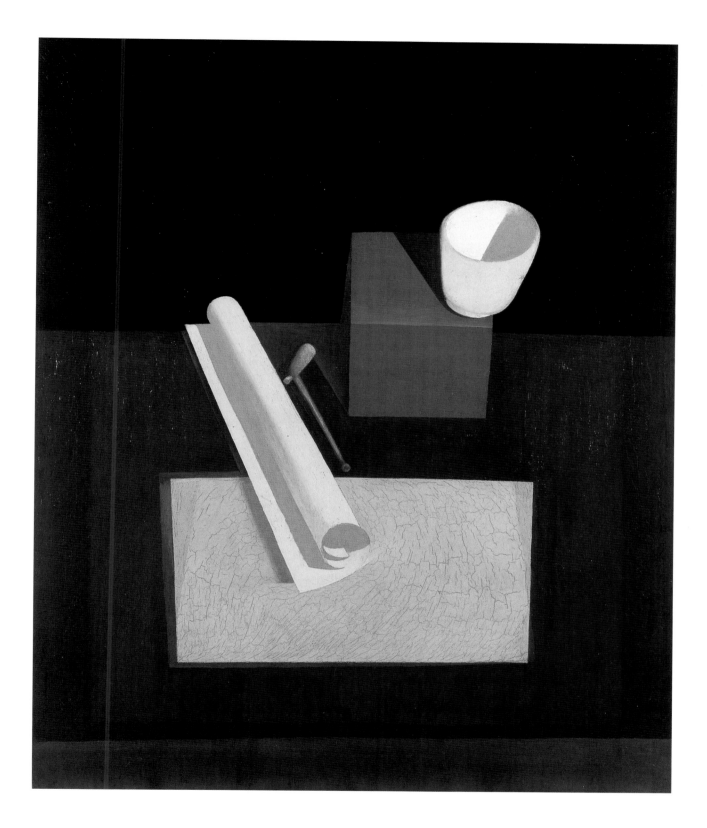

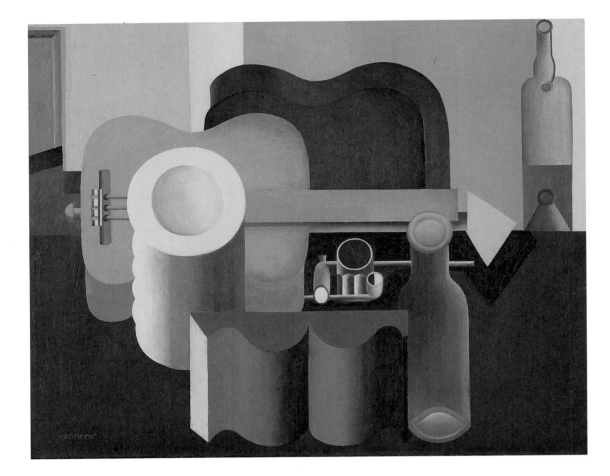

52. Le Corbusier
Still Life, 1920
Oil on canvas
31 ⅞ x 39 ¼" (80.9 x 99.7 cm)
The Museum of Modern Art,
New York

53. Amédée Ozenfant
The Vases, 1925
Oil on canvas
51 ⅜ x 38 ⅜" (130.5 x 97.5 cm)
The Museum of Modern Art,
New York

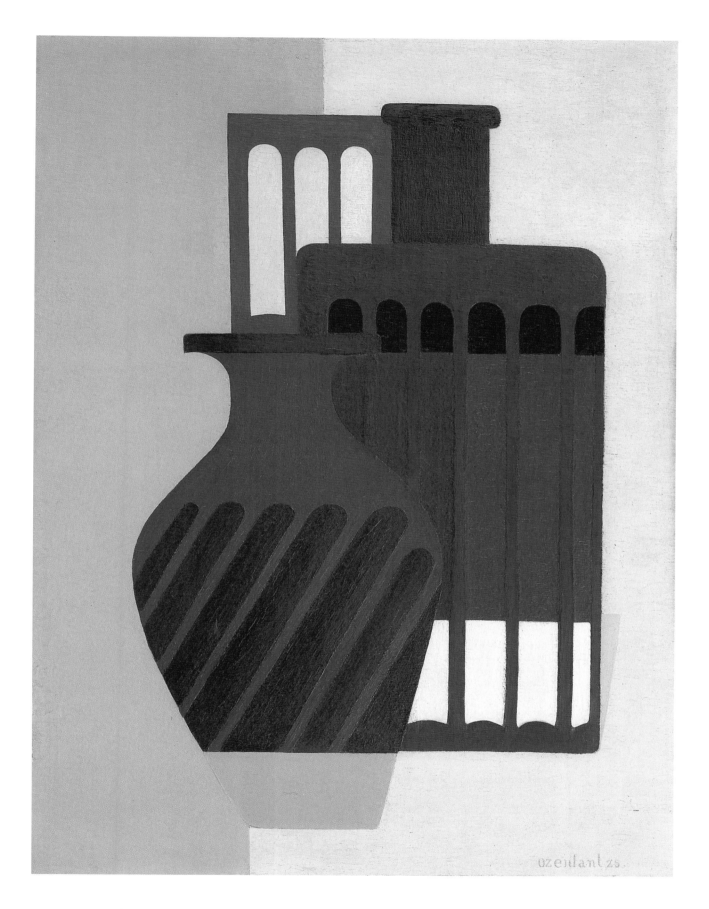

FORMS
OF
NEW
OBJECTIVITY

To a greater or lesser degree, all artists tend to look to the past in order to prepare the future. Sifting through their visual heritage, they decide what to preserve, what to discard, and from what to generate new life. Few artists have attempted to break with the continuity of history as radically as did Duchamp. Equally rare in the avant-garde of the first half of the twentieth century, however, were artists aspiring to quote or pastiche earlier academic themes and techniques as did those of the German *Neue Sachlichkeit* or "New Objectivity" group, with the intention of formulating nonetheless a pictorial idiom of their time. This school, which began to emerge around 1919, partly in reaction to German Expressionism, will be only sparely represented here. This is largely because, despite the roots of the term itself, "objects" and the still life genre were not the most effective themes for these artists "objectively" to interpret and renew. Portraits and figure painting, permitting ironic comments on society and current events, better served their aims.

The original German term referred to two distinct kinds of artists: those who worked in a precise yet uncanny "magic realist" style and those who practiced a more concrete realism, defined by a sober, detached, and indeed skeptical vision of modernity and by a cold and anonymous technique. Once again, our adoption of an established terminology will encompass a broader range of endeavor than that in reference to which it was originally invented; yet our discussion will be similarly oriented, identifying two separate groups of artists with distinct motivations as to style and content. The original division of the German school will still be pertinent, then, although it will be differently applied. Our first group is committed to certain academic traditions, which it nonetheless translates and reforms in a "magic realist" idiom; our second is attracted to the motifs and symbols of a modern present, and to presenting them crisply and buoyantly—if not always "objectively" in the conventional sense—through emblematic configurations that explicitly emphasize their claim to modernity. Despite their obvious differences in approach and subject matter, common to the paintings of all these artists are a concrete precision and an abundance of detail in their execution. Unlike many of the works we have studied thus far, these paintings are labor intensive, evoking the thoroughly worked and highly finished canvases of

the original Spanish and Flemish masters who gave the still life its original letters of nobility.

In the first category of works (which includes paintings by artists as diverse as Joan Miró, Salvador Dalí, Iwan Babij, and Hannah Höch), deliberate references to more academic styles of painting are adapted to a subject matter that is also relatively traditional: the interior still life on a table. Miró's compositions from the early 1920s depict modest familiar objects, directly inspired by the domestic landscape of his family's farm at Montroig, Spain. They exhibit perspectival devices learned from Cézanne and Cubism, a naive deliberateness worthy of Rousseau, and the geometric complexity of de Chirico, artists whose work Miró knew, either directly or through reproductions, and whom he admired. Yet in *Still Life with Rabbit (The Table)* of 1920—21 (plate 54), aside from these obvious references (seen in the stiffly controlled arrangement of the subject matter, the disjointed perspectival geometries, and the high horizon line and tilted space), Miró's density of color, carefully modeled forms, combination of flora and fauna, sharp contrasts between light and shadow, and consummate finish in his execution also echo the supremely accomplished painterly practices of early European still life. An analogous attention to techniques of execution informs his still lifes of 1922—23 (plates 55 and 56), which paradoxically implement a more abstract vision. The intense contradiction between a largely illusionistic facture as concerns his motifs, and a geometric ground, abstractly lit and tilted virtually to the surface plane, creates an uncanny tension between the real and the unreal, which, quite independently from the German situation, earned this phase of Miró's activity the term "magic realism."

This "magic" or uncanniness also pervades paintings by Dalí, Babij, and Höch, yet each according to distinctly different artistic ambitions and stylistic premises. Dalí's reference, in *The Basket of Bread* of 1926 (plate 59), is obviously to the grand tradition of seventeenth-century Spanish painting and, in particular, to Francisco de Zurbarán, who included an identical motif combining a woven basket and a dramatically folded white cloth in his *Young Virgin* (1600s) and *The Holy House of Nazareth* (c. 1630). Dalí's basket, however, filled with strangely mapped pieces of broken bread, and his virtuoso rendering through long-past academic

techniques, at once replicates and violates Zurbarán's calm, virginal
domestic symbolism, transforming it into a restless, secularized,
yet deliberately empty Eucharistic iconography that projects an aura
of mystery.

Deliberate references to much earlier European styles and subjects
are also present in paintings by Babij and Höch, two artists associated
during this period with the New Objectivity group. The motifs in
Babij's small *Geometric Still Life* of c. 1924 (plate 57), painted on wood,
are meticulously textured, lit with trompe l'oeil precision, and appear
casually organized, as though the human protagonists had just left the
space; all these devices it shares with early Northern painting. Yet the
tight framing, which abruptly crops the motifs (thereby reinforcing
the effect of abandon), forces the viewer's attention to the dynamic
geometrical structure organized around a virtually empty center, which
emerges as the composition's true subject. Höch's *Glasses* of 1927 (plate
58)—a playful exploration of transparency in all its forms, including
the reflection of a window in the foreground decanter—is an indirect

Francisco de Zurbarán
The Young Virgin, 1600s
Oil on canvas
46 x 37" (116.8 x 94 cm)
Metropolitan Museum of Art, New York
Fletcher Fund, 1927

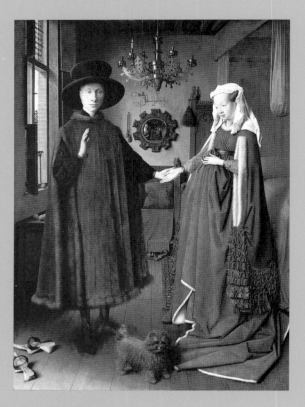

Jan van Eyck
"The Arnolfini Marriage," 1434
Oil on oak
32 3/16 x 23 1/2" (81.8 x 59.7 cm)
The National Gallery, London

evocation of such early masters as Pieter Claesz and of course of Jan van Eyck's *"Arnolfini Marriage"* of 1434.

Despite these references to much earlier codes of representation, none of these works could be confused with earlier precedents. Their high horizon lines, vertiginously tipped perspectives, abstract or idealized geometries, and the crowding or cropping of their frames indicate peremptorily that the surface plane is the true space and subject of these paintings, and that they are of the twentieth century. At the same time, they too reflect a nostalgic vision, a formal or semantic structure of longing for an inaccessible past.

The exhibition's second sequence of works grouped under the heading "New Objectivity" shows an altogether different inspiration and approach. The subjects of the paintings by Stuart Davis, Gerald Murphy, and Léger (plates 60, 61, 63, and 64) are generally modern ones, rather than the domestic vessels and foodstuffs of tradition. They include razors, compasses, and typewriters, for example, painted in crisp, flat, and opaque colors. Frontally and emblematically organized, evenly lit, the paintings show no attempt to suggest a natural disposition of objects or source of light. Whether the motifs are stacked or layered,

interlaced or staggered in an indeterminate space, the reading of foreground and background defies traditional convention. The areas surrounding the motifs are as assertive, brightly painted, and densely patterned as the objects themselves. And therefore the usual hierarchies between figure and ground, meaning and nonmeaning, are also suppressed. The subject is the picture plane; and its only spatial parameter is that of the frame.

Icons of a new and modern society, these self-referential objects, devoid of historical or cultural associations, project a radically different aura from those considered thus far. Given that the space or landscape of a still life, and its manner of displaying or containing its objects, usually express an artist's world view, here that vision is formulated as a virtually continuous flat fabric, generated by a "collaged" aggregate of scaleless objects in close-up view. These objects of use, of practicality, but also of industrial beauty seem to crowd out all investigations of perceptual reality, and all philosophizing on nature and metaphysics, just as they disavow all references to the past. Their inspiration is not the continuity of history but the seductive tabula rasa of a consumer-oriented present. They seem to indicate that the modern appetite is for a sensuality transformed, distanced, and encased in technologically perfect things, not for the past's mysteriously sensuous or erotic objects of nature or of pleasure. The plastic immediacy of their rendering further suggests that this appetite or desire seeks instant gratification or fulfillment.

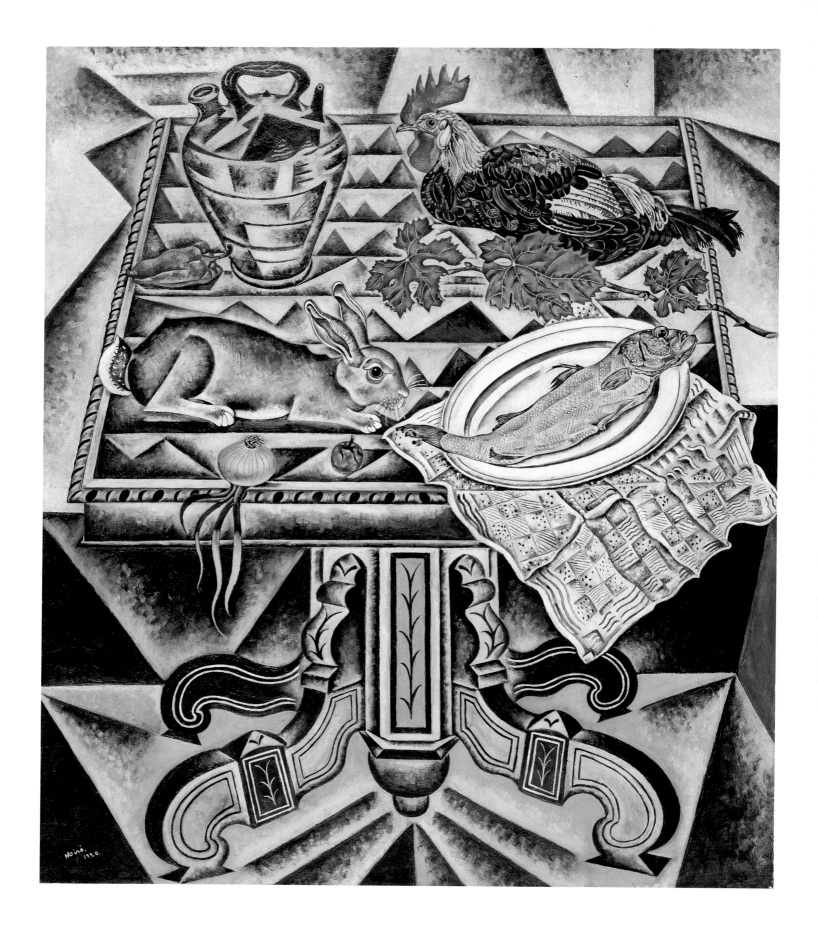

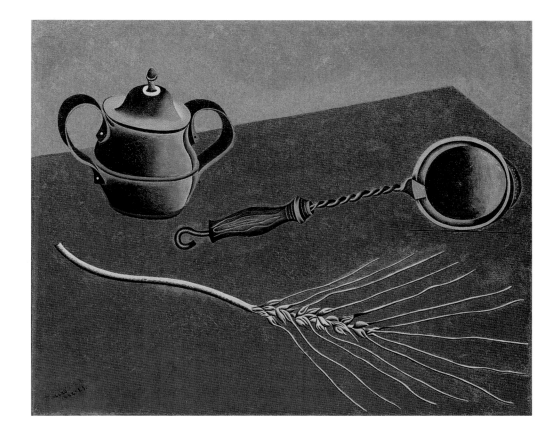

54. Joan Miró
 Still Life with Rabbit (The Table), 1920–21
 Oil on canvas
 51⅛ x 43¼" (130 x 110 cm)
 Private collection

55. Joan Miró
 Still Life I (The Ear of Grain), 1922–23
 Oil on canvas
 14⅞ x 18⅛" (37.8 x 46 cm)
 The Museum of Modern Art, New York

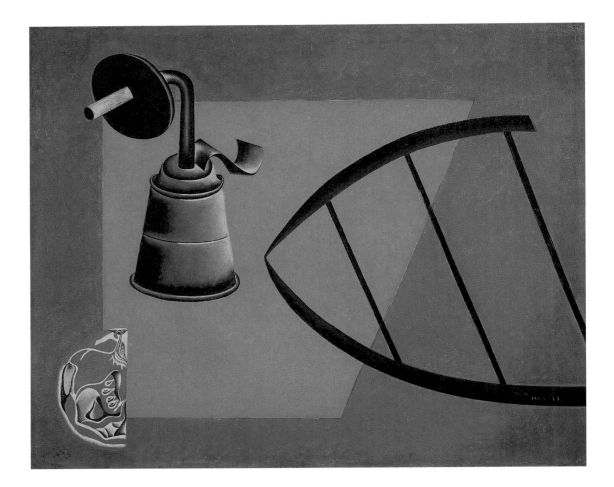

56. Joan Miró
 Still Life II (The Carbide Lamp), 1922–23
 Oil on canvas
 15 x 18" (38.1 x 45.7 cm)
 The Museum of Modern Art, New York

57. Iwan Babij
 Geometric Still Life, c. 1924
 Mixed mediums on wood
 14 ½ x 18 ½" (36 x 46.5 cm)
 Kunsthalle Mannheim

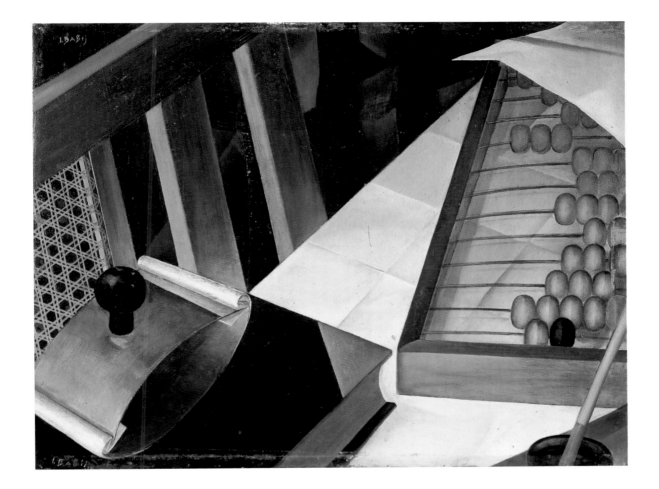

58. Hannah Höch
 Glasses, 1927
 Oil on canvas
 31 x 31" (77.5 x 77.5 cm)
 Neue Galerie, Staatliche Museen Kassel

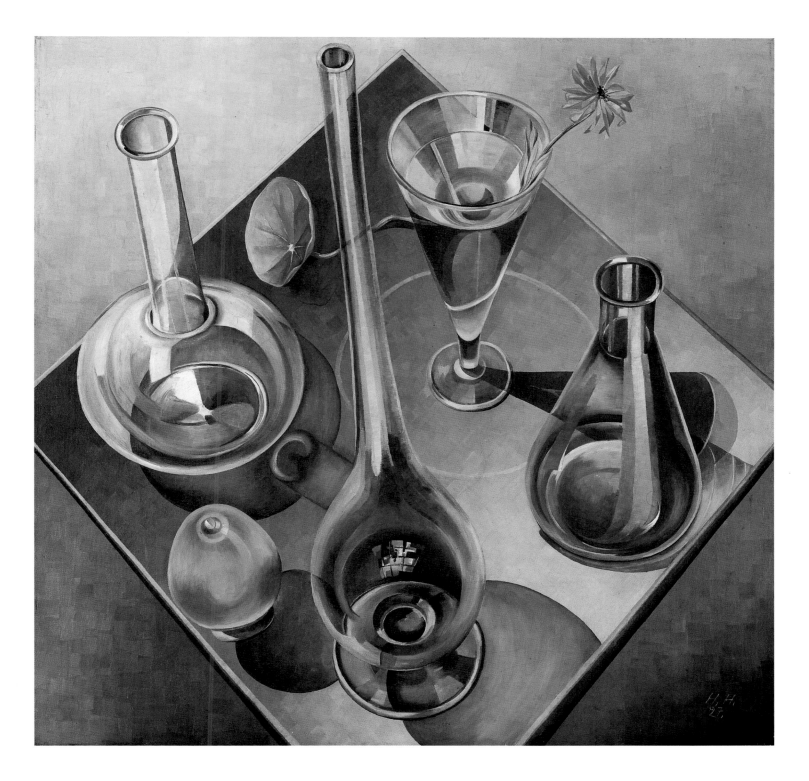

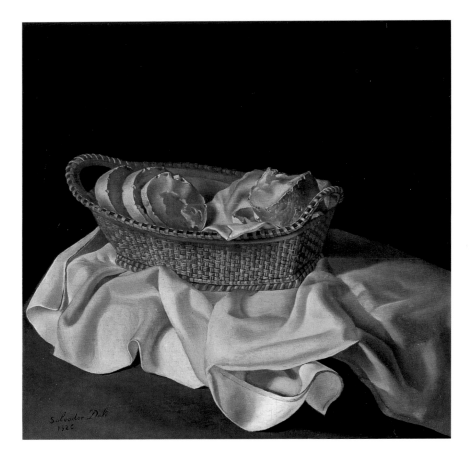

59. Salvador Dalí
 The Basket of Bread, 1926
 Oil on panel
 12 ½ x 12 ½" (31.3 x 31.3 cm)
 Salvador Dali Museum,
 St. Petersburg, Florida

60. Stuart Davis
 Odol, 1924
 Oil on cardboard
 24 x 18" (60.9 x 45.7 cm)
 Cincinnati Art Museum

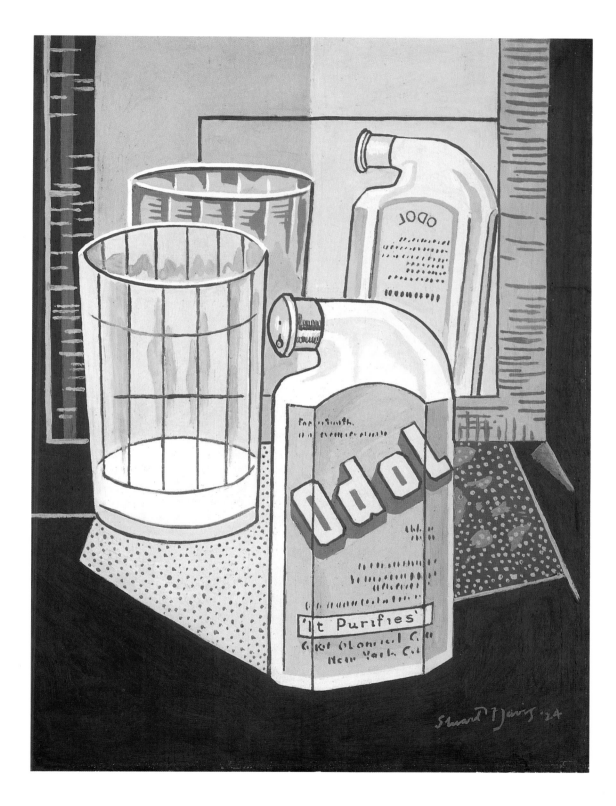

61. Gerald Murphy
 Razor, 1924
 Oil on canvas
 32 ⅝ x 36 ½" (82.8 x 92.7 cm)
 Dallas Museum of Art

62. Fernand Léger
 Still Life (The Bowl of Pears), 1925
 Oil on canvas
 36 ¼ x 25 ½" (92 x 65 cm)
 Staatliche Kunsthalle, Karlsruhe

63. Fernand Léger
Still Life with Compass, 1925
Oil on canvas
25 ½ x 19 ⅝" (65 x 50 cm)
Moderna Museet, Stockholm

64. Fernand Léger
Composition with Two Typewriters, 1927
Oil on canvas
56 ½ x 41 ¾" (144 x 106 cm)
Private collection, Switzerland

ALLEGORIES OF LIFE AND DEATH: TRADITION REVISITED AND TRANSFORMED

By definition it would appear that the execution of a still life, as a presentation or representation of inanimate *objects*, would call for some degree of *objectivity* in regard to its subject. As we have seen, however, the still life is a form of fiction, and few restrictions govern its manner or content. Indeed the genre may be exploited to signify a natural or conceptual, random or controlled, irrational or rational order; it may be interpreted to emphasize structure at the expense of other defining features or it may take extreme liberties in scale and color; it may prioritize an object in isolation or show an array or assemblage of objects; it can as well imply a fragmented world view as a holistic one. The still life's objects may be chosen from the past or a present, may obey the thematic conventions of food or vessels on a table in a domestic interior or be selected from a more exotic register and set in an outdoor or abstract space. They may be cast as specifically real or generically ideal. And, finally, they may serve as catalysts for the transgression and subversion of their own inner logic, identity, and meaning, through the re-creation and reordering of familiar yet uncannily strange everyday objects in the real world.

Paradoxically, it is because of the still life's relatively stable subject matter, and the presumed banality that traditionally removed it from the respect accorded to historical or religious works, portraiture, or landscape painting, that the genre has been able to lend itself so freely to diversity and digression. So it is no accident that for some of the greatest artists of this century, the still life has been a privileged theme, a subject that, whether dependent on the observation of reality or drawn from a singular imagination, permitted a broad variety of interpretations.

The artists rather arbitrarily grouped in this section, despite

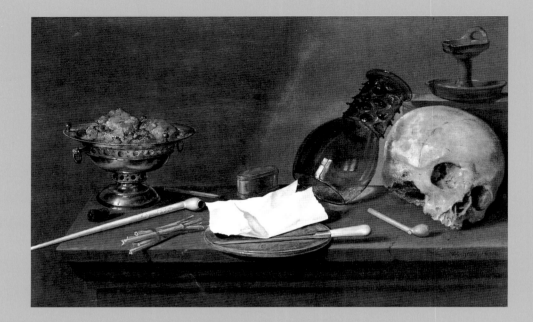

Willem Claesz. Heda
Vanitas, 1628
Oil on panel
17 ⅞ x 27 ⅞" (45.5 x 69.5 cm)
Museum Bredins, The Hague

artistic significance, in order to reconnect with the reassuring continuity of history, and perhaps to legitimize their own expression. Their reactivation of traditional themes—such as a stripped carcass of beef, laid tables in order or in disarray, and skulls or other *vanitas* motifs—betrays the influence of earlier European masters. In their manner of interpreting these motifs, however, the artists personalize and modernize this inherited iconography, and intensify its expressive content.

A disturbing sense of anxiety is vividly present in the paintings here by Chaim Soutine and Max Beckmann, James Ensor and Miró, in each expressed according to a distinct personal vision and technique. This anxiety, this dramatic sense of tragedy and spiritual desolation common to certain artists in the 1920s and '30s, is further reinforced by an iconography traditionally linked to such themes. The cabbage, the apple, and the old shoe echo the repertory of that other master of the tragic sense, Vincent van Gogh; whereas the candles and human skulls seen in Beckmann's still lifes (plates 69 and 73) obviously relate to the *vanitas* tradition. During this period between the two world wars, these motifs connote a distinct metaphysical dimension, that of the

nightmares of history. Whereas Soutine carried his sense of tragic destiny (that of the Jewish people) within himself, it was exacerbated by his desperate poverty to a frenetic hallucinatory vision (plate 67). Beckmann, obsessed by his traumatic experiences during World War I, invested all his still life compositions with an implicit or explicit apocalyptic cast. Ensor's grotesque masks and carnival figures represented the greater truth of the world as he saw it, their painted smiles belying the hypocritical and malevolent reality of bourgeois society (plate 68).

Only Miró's *Still Life with Old Shoe* of 1937 (plate 70) was painted under the direct impact of historical circumstances, portraying, in a rigorously controlled yet no less expressive formal language, an allegory of the Spanish Civil War. Exiled in Paris, Miró identified with Spain's imperiled townspeople and farmers through the commonplace rural objects he knew so well. The motifs—an apple cruelly stabbed with a fork, a bottle, a crust of bread, an old shoe—are depicted as though struck by lightning (or firebombs) and set ablaze against the eerie shadows of a darkening sky. In a certain sense, none of the objects in these paintings is still or inanimate: their deformations, palette, and brushwork transmit a sense of urgency, a precarious tension between life and death.

The energy and vitality that inflect these paintings and invest their individual objects, despite the works' patently pessimistic cast, are also seen in Picasso's still lifes beginning in the mid-1920s (plate 65), yet without the tragic dimension. One key to the difference may be described as a form of artistic detachment. Although Picasso invested his life forces in these paintings (and they are among the most plastically complex, inventive, and vitally exuberant of his career to that date), it is clear to us that he was making a picture, not expressing his inner soul. The plaster casts, architectural details, and classical or academic motifs are themes to interlace and embroider in a grand fabric of playful experimentation. Indeed, even the 1945 *Still Life with Skull, Leeks, and Pitcher* (plate 74), evoking the symbolism of the *vanitas* (as does his 1951 sculpture *Goat Skull and Bottle*, plate 66), shows none of the emotional intensity seen in Beckmann's *Still Life with Three Skulls* of the same year (plate 73). Picasso was obviously conscious of his reference to a memento mori, yet, in order to soften the harrowing image of a skull and bones,

he transformed the bones into the more reassuring image of leeks on a kitchen table, and sweetened the composition through a palette of sunlit hues. This was not solely a meditation on mortality but a gesture of defiance, just as his sculpture is at once severe and jesting. These works manifest not so much a fear of death as an artistically elaborate expression of a lust for life.

Whether the works shown here express primordial or existential fears, responses to historical events, or purely artistic ambitions and vitality, they invoke the still life in its classic form as the ideal vehicle to serve their ends and to achieve a transcendent expression. These close and respectful readings, even quotations, of the still life's traditional themes, motifs, and semantic structure will become increasingly rare in the second half of the twentieth century. In art's attempts to chart the rapid metamorphoses of modern society and its cultural and intellectual priorities, forms of subversion rather than of respect will emerge as the more prevalent norm.

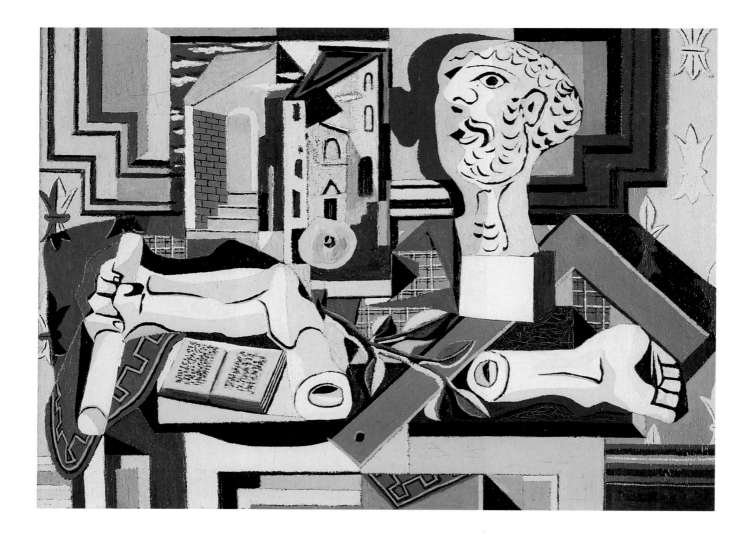

65. Pablo Picasso
 Studio with Plaster Head, 1925
 Oil on canvas
 38⅝ x 51⅝" (97.9 x 131.1 cm)
 The Museum of Modern Art, New York

66. Pablo Picasso
 Goat Skull and Bottle, 1951; cast 1954
 Painted bronze (after assemblage of
 bicycle handlebars, nails, metal, and
 ceramic elements)
 31 x 37⅝ x 21½" (78.8 x 95.3 x 54.5 cm)
 The Museum of Modern Art, New York

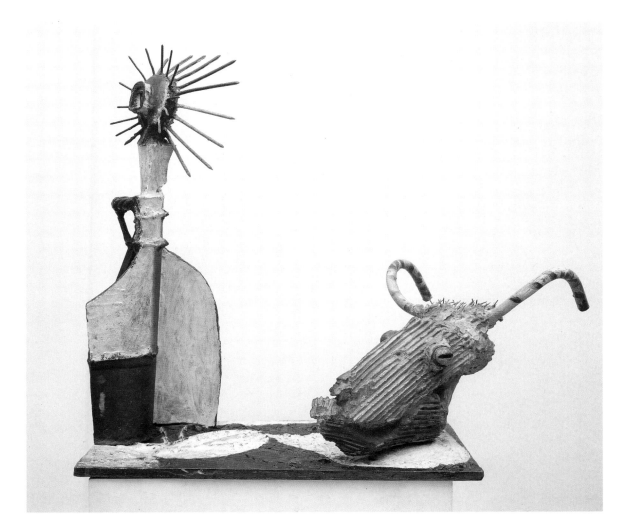

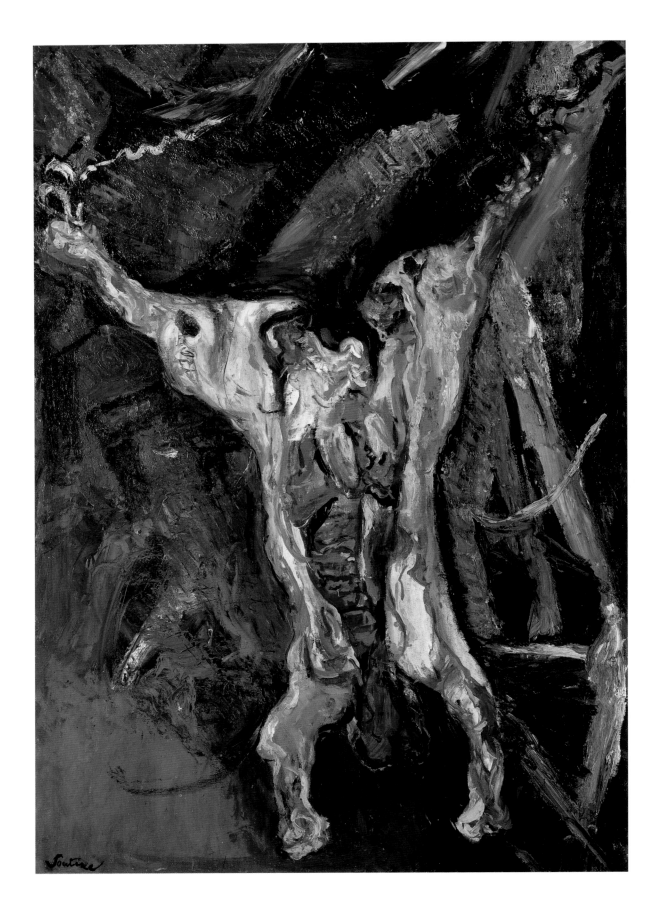

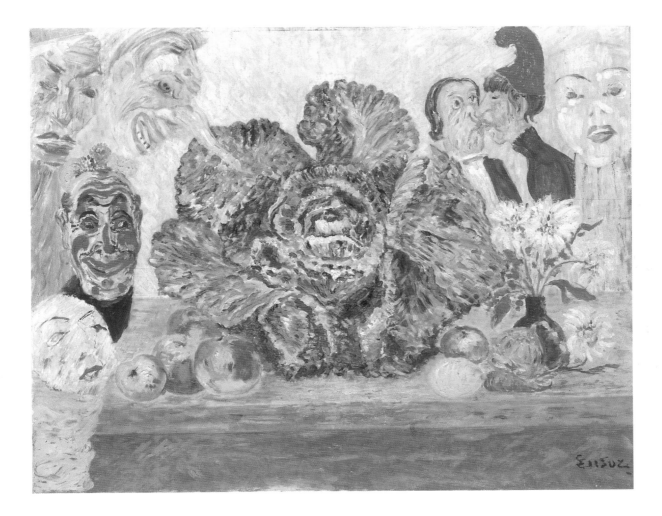

67. Chaim Soutine
The Carcass of Beef, c. 1924
Oil on canvas
46½ x 32½" (118.1 x 82.5 cm)
The Minneapolis Institute of Arts

68. James Ensor
Still Life with Cabbage and Masks, 1928
Oil on canvas
26¼ x 32½" (65.5 x 81.5 cm)
Sammlung Basler Kunstverein, Basel

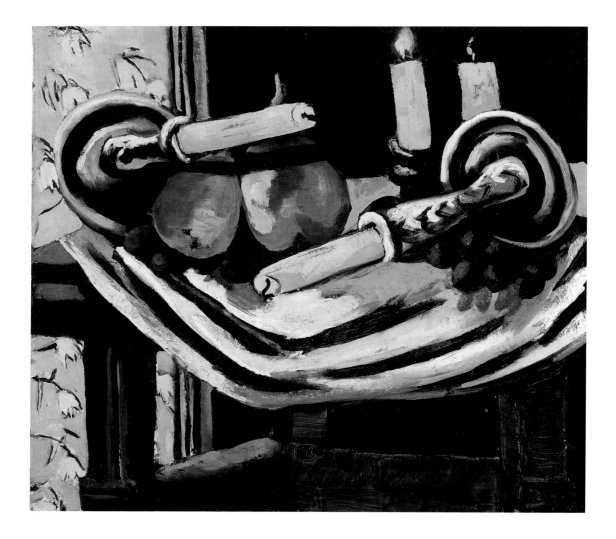

69. Max Beckmann
 Still Life with Fallen Candles, 1929
 Oil on canvas
 22 x 24 ¾" (55.9 x 62.9 cm)
 The Detroit Institute of Arts

70. Joan Miró
 Still Life with Old Shoe, 1937
 Oil on canvas
 32 x 46" (81.3 x 116.8 cm)
 The Museum of Modern Art, New York

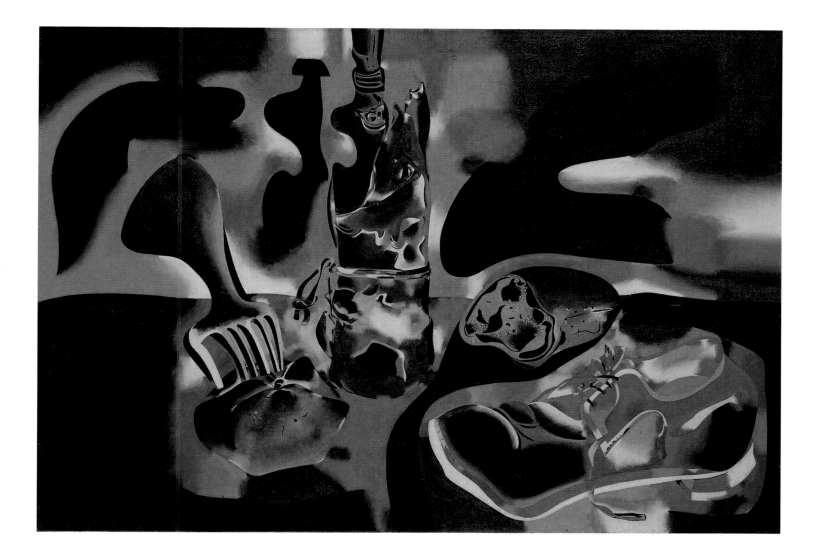

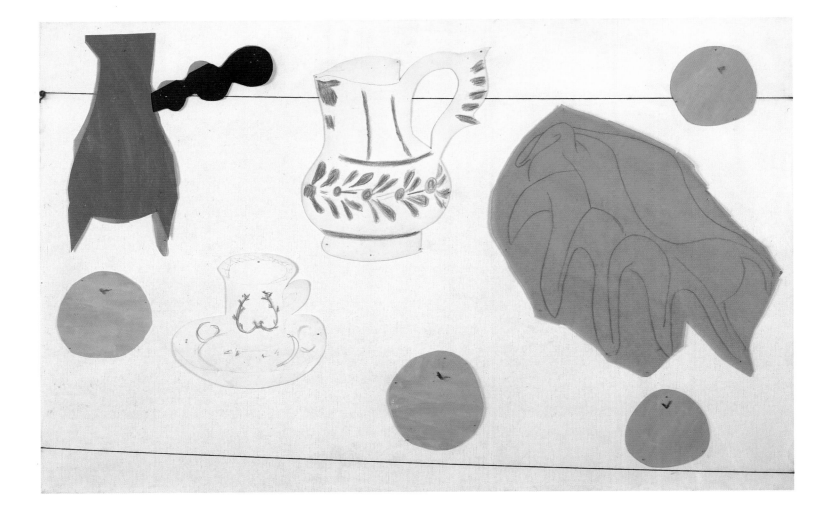

71. Henri Matisse
 Still Life with Shell, 1940
 Paper, string, and mixed mediums
 on canvas
 23 ⅝ x 36" (60 x 91.4 cm)
 Private collection

72. Pablo Picasso
 Still Life with Three Apples and a Glass, 1945
 Charcoal, colored and printed cut
 and torn papers
 13 x 17" (33 x 43.2 cm)
 Museum Ludwig, Cologne

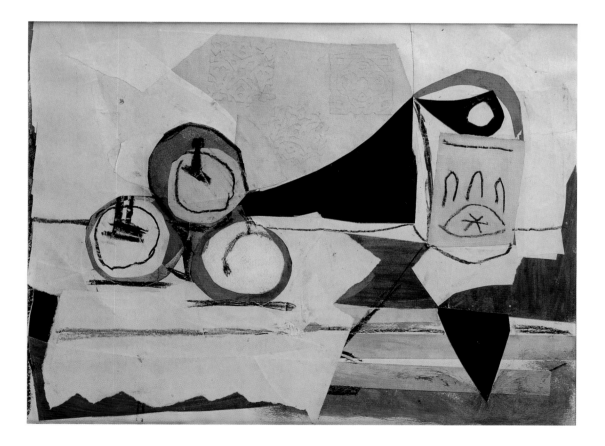

73. Max Beckmann
Still Life with Three Skulls, 1945
Oil on canvas
21¾ x 35¼" (55.2 x 89.5 cm)
Museum of Fine Arts, Boston

74. Pablo Picasso
Still Life with Skull, Leeks, and Pitcher, 1945
Oil on canvas
28¾ x 45⅝" (73 x 116 cm)
Fine Arts Museums of San Francisco

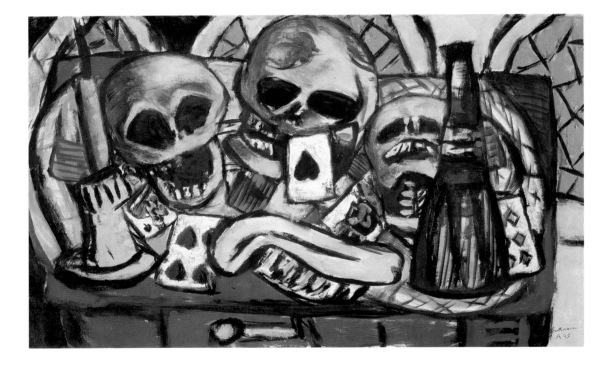

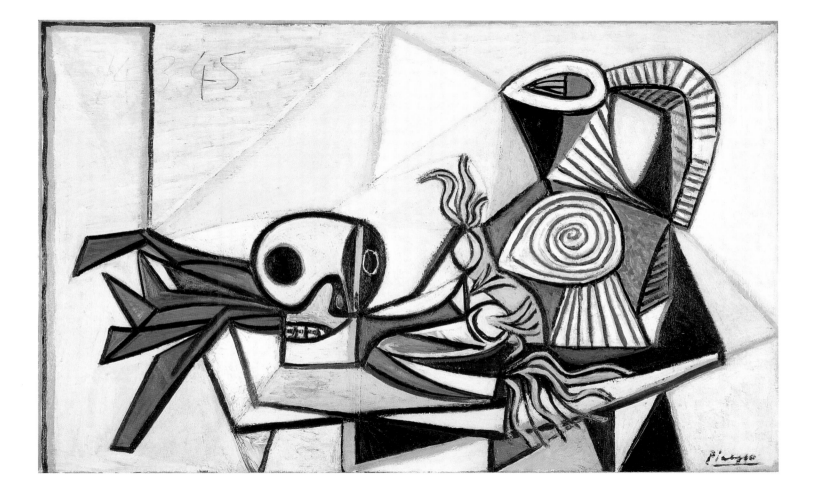

Languages of
Surrealism

Languages of
Subversion

An attempt to discuss the still life in the context of
Surrealism, a movement established in order to repudiate, pervert,
and subvert all accepted cultural norms, appears at first glance as
a sterile exercise, so contradictory are its terms. Indeed the ambition
of Surrealism, a primarily literary and poetic movement launched in
Paris in 1924, was to challenge the hegemony of rational thought and
traditional conventions (and particularly those artistic) by privileging
the processes, associations, and images of the subconscious mind.
A powerful force on the international artistic scene throughout the
1930s, Surrealism would have a profound influence on the arts of the
twentieth century, and its repercussions are still in evidence today.

In the realm of the visual arts, the Surrealists favored painting,
collage, and assembled objects, in which they sought to materialize one
of their central tenets: that of the "chance encounter" as the place of
genesis of the ultimate poetic experience. Yet despite the famous image of
the poet Lautréamont's that the Surrealists adopted as exemplary of their
vision—that of the encounter of a sewing machine with an umbrella on a
dissection table—few Surrealist painters but for René Magritte, and to a
lesser extent Dalí, found the representation of objects, or the semantic
structure of the still life, a receptive arena for their poetic imaginations.
The landscapes and chimeras of the dream were their preferred subjects,
as more apt vehicles for capturing the ineffable meanderings, fantasies,
and desires of the "real functioning of the mind."[1]

Paul Klee's appearance in the Surrealist universe may appear to
force the issue, yet Klee was much admired by the movement's writers
and artists. This is comprehensible in that the magical mystery of
certain of his paintings of the late 1920s is surprisingly close in spirit to
that of early Magritte. If we juxtapose Klee's Still Life (Jars, Fruit, Easter Egg,
and Curtains) (plate 76) to Magritte's Table, Ocean, and Fruit (plate 77),
both of 1927, the loose structures and vaporous grounds that situate
each artist's rudimentary rendering of objects in a child's no-man's-
land (nonetheless delicately framed like a picture within a picture)
reflect a comparable poetic license and a whimsical disregard of inherited
artistic conventions.

Magritte would elaborate and intensify his subversive pictorial and poetic language in an extensive production that has never ceased to astound. Indeed one might identify him, in this context, as the quintessential Surrealist. The question that begs to be asked, as we attempt to decipher his enigmatic images, is "When is a still life not a still life?" For whereas the orderly presentation of disarmingly prosaic objects is central to Magritte's poetic enterprise, these motifs diffuse an aura of irreality, because they never represent what they appear to present. His paintings quote many timeworn conventions yet at the same time subvert and transgress all accepted standard forms. Is *Table, Ocean, and Fruit* or *The Interpretation of Dreams* (1930, plate 78) a still life, a landscape, both, or neither? Is *Portrait* (1935, plate 79) a portrait or a still life? Is *Personal Values* or *The Listening Room* (both 1952, plates 87 and 88) an interior, a still life, or something else?

Magritte's perverse practice of "naming" objects or images, or of titling paintings in contradiction to what they appear to represent, was just one manner of liberating them from predetermined ideas. The associations triggered by the drinking glass in *The Interpretation of Dreams*, for example, are dispelled by its verbal identification as "the storm" (*l'orage*). Our immediate recognition of the leaf in *Table, Ocean, and Fruit* is confounded by the written indication that it is a table. Finally, another question to be asked is which element in these rebuses is more real, the referent (or object depicted), the visual image, or the text? The answer, of course, is all of them simultaneously, or none of them, the truth hovering somewhere in the obscure interrelationships of these deceptively literal representations and their global effect. The deliberately evanescent meanings of these objects of desire will always elude us.

Magritte learned from de Chirico, an early and lasting influence, that painting is the art of describing thought. And indeed his activity may be described as the presentation of mental and visual paradoxes. Like his mentor, Magritte favored motifs and techniques of representation and execution that were deliberately academic, enhancing the presumption of reality in his impenetrable metaphors.

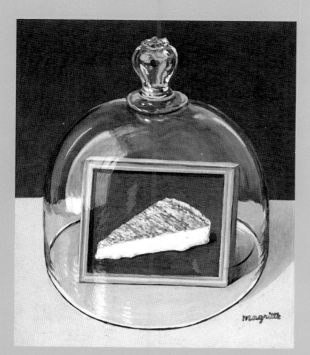

René Magritte
This Is a Piece of Cheese, 1952
Gouache on paper
6 ⅞ x 5⅞" (17.5 x 15 cm)
Private collection

His fundamental contradictions between ideas and images were enhanced by unnatural shifts of scale, radically incompatible juxtapositions, or totally incongruous spatial frameworks, rendered, however, as though they were totally normal. Titles that appear logical yet somehow displaced intensify the irresolvable duality of familiarity and estrangement.

With few exceptions, the fusion of previously incompatible ideas was the very substance of Surrealist painting. The same emphasis on ambushing the images and associations of irrational thought processes was central to the conception and execution of so-called Surrealist objects. These contrivances were more meaningful as poetic exercises than as aesthetically satisfying visual entities. Inspired by the chance encounter, their layerings of found or fabricated elements, embodying irreconcilable functions and ideas, were more elaborate than Duchamp's readymades, even than his "assisted" readymades. Many of the separate constituents of these "objects" by Meret Oppenheim, Dalí, or Miró were worthy in real life of little more than a cursory glance, but their displacement, assemblage, and ultimate transformation, guided either

by a spontaneous impulse or by a more deliberate intention to shock or provoke, rob them of their mundane identities, transmuting them into concrete poetic forms. The objective was to elude the viewer's conditioned response and provide access, through free association, to subconscious images and desires. Despite the fetishistic clichés of a stockinged leg and a high-heeled shoe, Miró's *Poetic Object* of 1936 (plate 81) appears as a relatively innocent montage of disparate objects; whereas the sexual connotations of Oppenheim's *Object* from the same year (plate 80) are patently clear.

Eroticism and sexual desire, emphases central to Surrealist ideology in its ambition to profane Western society's most powerful taboos, were more extensively explored, however, in the movement's literature, or else in other types of painting, collage, and sculpture, than in the presentation of objects. Dalí, for example, excelled in the genre of erotically configured painted landscapes with suggestively animated inanimate objects. Frida Kahlo's still life painting of bleeding fruit (plate 91) is a remarkable example of an erotically charged yet traditionally conceived still life, a somewhat exceptional enterprise given that sexual desire, in order to be aroused and sustained, aspires to a distant and inaccessible object. This idea, in a subtle, personal, and enigmatic sense, inspired the works of Joseph Cornell, who frequented Surrealist circles in America in the 1930s and '40s. His constructions and boxes, delicately and tenderly fabricated, and often conceived as veiled homages to real or imaginary women, were nourished at random by literature, art history, magazine images, or the wishful thinking of a rich fantasy life. (Perhaps *Untitled (Multiple Cubes)* of 1946–48, plate 86, is even an homage to Duchamp's 1921 *Why Not Sneeze Rose Sélavy?*, plate 37.) These constructions, many of them under glass, connote distance and enclosure, the untouchable inaccessibility of these objects of nostalgia or desire.

Thus the mechanism of desire as formulated in Surrealist literature and art was not that which seeks to possess its object but, instead, that which excites and titillates the mind. Instant gratification was not its goal. On the contrary, the objective was to sustain the tension of

unfulfilled desire through works of art whose apprehension remains tantalizingly out of reach.

Lucio Fontana's late-1930s ceramic objects represent a distinctly different language of subversion (plates 89 and 90). Manifestations of distrust and cynicism in regard not only to Beaux-Arts standards but to the values of Western society as a whole, these sculptures, with their populist vernacular, corresponded to a commercially viable Italian tradition of ceramic statuettes and souvenirs designed for the tourist trade. "Maliciously seductive at a popular level,"[2] they proposed to the artistic public what it thought it desired: artworks that were decorative, innocuous, even precious. This was merely a preliminary phase of a long evolution in which Fontana's elegant paradoxes and demystifying gestures would ultimately impose him as an undisputed leader and influence in the art of the twentieth century.

Another master of subversion was of course Jean Dubuffet. His "anticultural" position,[3] eloquently formulated in his writings and his paintings, would of necessity dispense with conventional aesthetic categories and established techniques; yet it was his perverse form of subversion to quote such conventions, if only the better to subvert them. Dubuffet's *Table* series from the early 1950s may, indeed was meant to, refer to the classic still life tradition, yet its interpretations of objects from the perceptual world are so distorted and, in the case of *Table Covered with Natural History Specimens* (plate 92), virtually formless as to be self-denying. Painted in a deliberately crude and agitated visceral substance that unites the space of the canvas in a single plane, this work, even as it paraphrases the order and iconography of the traditional still life genre, is much closer to a mental and physical *landscape*.

1. "*Le fonctionnement réel de la pensée.*" André Breton, *Manifeste du surréalisme* (Paris: Éditions du Sagittaire, 1924), p. 42.
2. Gabriella Drudi, "*Lucio Fontana, El espacio como exploración,*" in *Lucio Fontana*, exh. cat. (Madrid: Palacio de Velázquez, 1982), p. 16.
3. See Jean Dubuffet, "Anticultural Positions," a lecture given at the Arts Club of Chicago, December 20, 1951, and printed (*ronéotypé*) shortly thereafter by Leo Castelli and Sidney Janis, New York. Reprinted in Dubuffet, *Prospectus et tous écrits suivants*, compiled and presented by Hubert Damisch (Paris: Gallimard, 1967), I:94–100. Here Dubuffet takes "position" against all accepted cultural norms (and in particular against those concerning beauty and art).

75. Paul Klee
Colorful Meal, 1928
Oil and watercolor on canvas
33 x 26 ⅜" (84 x 67 cm)
Private collection

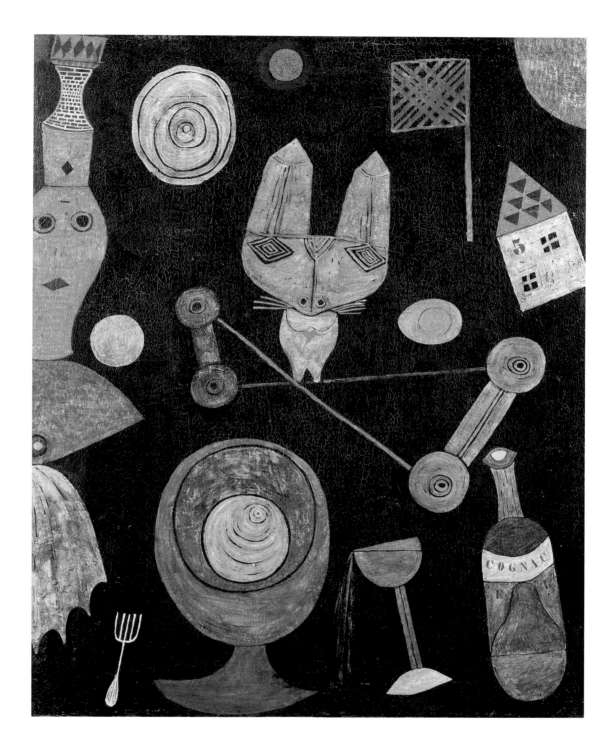

76. Paul Klee
Still Life (Jars, Fruit, Easter Egg, and Curtains), 1927
Oil on gypsum construction
18⅞ x 25¼" (47.9 x 64.1 cm)
The Metropolitan Museum of Art, New York

77. René Magritte
Table, Ocean, and Fruit, 1927
Oil on canvas
19¹³⁄₁₆ x 25¾" (50.3 x 65.4 cm)
Private collection, courtesy
Patrick DeRom Gallery, Brussels

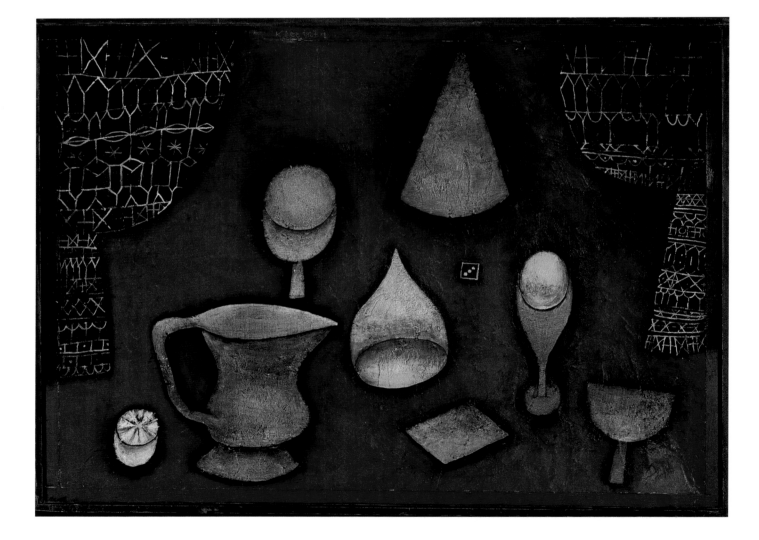

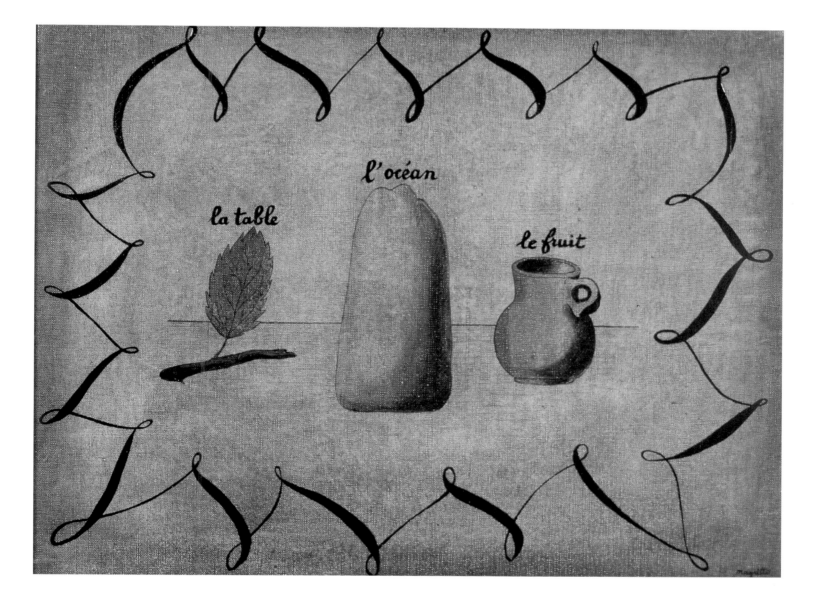

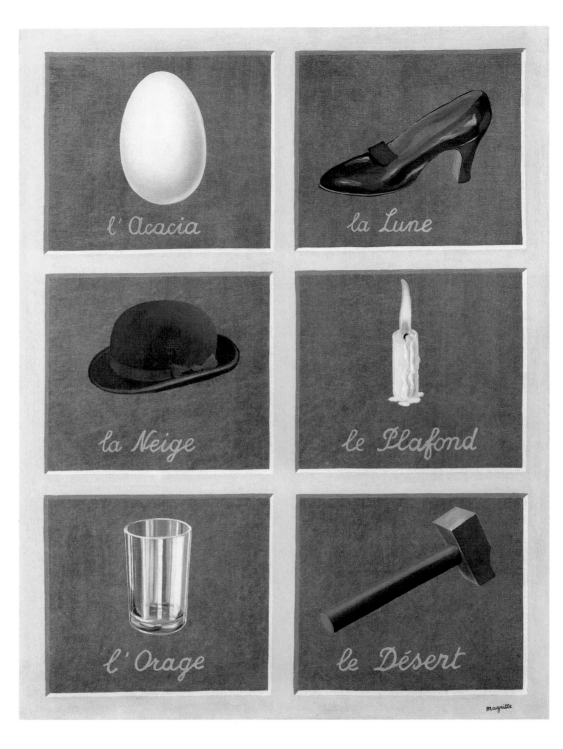

78. René Magritte
The Interpretation of Dreams, 1930
Oil on canvas
31⅞ x 23⅝" (80.7 x 59.8 cm)
Private collection

79. René Magritte
Portrait, 1935
Oil on canvas
28⅞ x 19⅞" (73.3 x 50.2 cm)
The Museum of Modern Art, New York

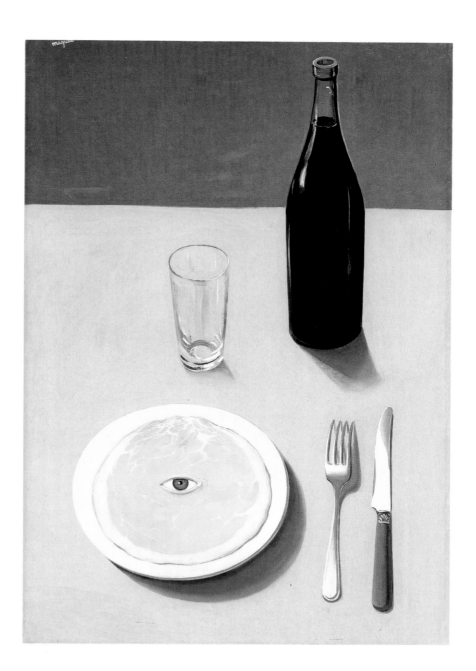

80. Meret Oppenheim
Object, 1936
Fur-covered cup, saucer and spoon
Cup: 4⅜" (10.9 cm) diameter;
saucer: 9⅜" (23.7 cm) diameter;
spoon: 8" (20.2 cm) long;
overall height: 2⅞" (7.3 cm)
The Museum of Modern Art, New York

81. Joan Miró
Poetic Object, 1936
Assemblage: stuffed parrot on wooden
perch, stuffed silk stocking with velvet
garter and doll's paper shoe suspended
in hollow wood frame, derby hat,
hanging cork ball, celluloid fish, and
engraved map
31⅞ x 11⅞ x 10¼" (81 x 30.1 x 26 cm)
The Museum of Modern Art, New York

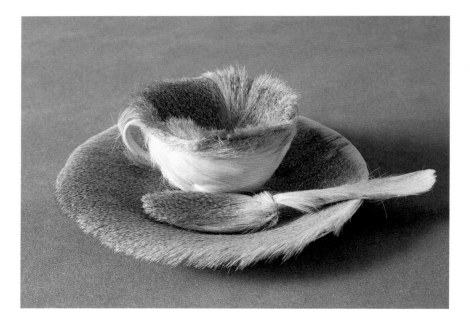

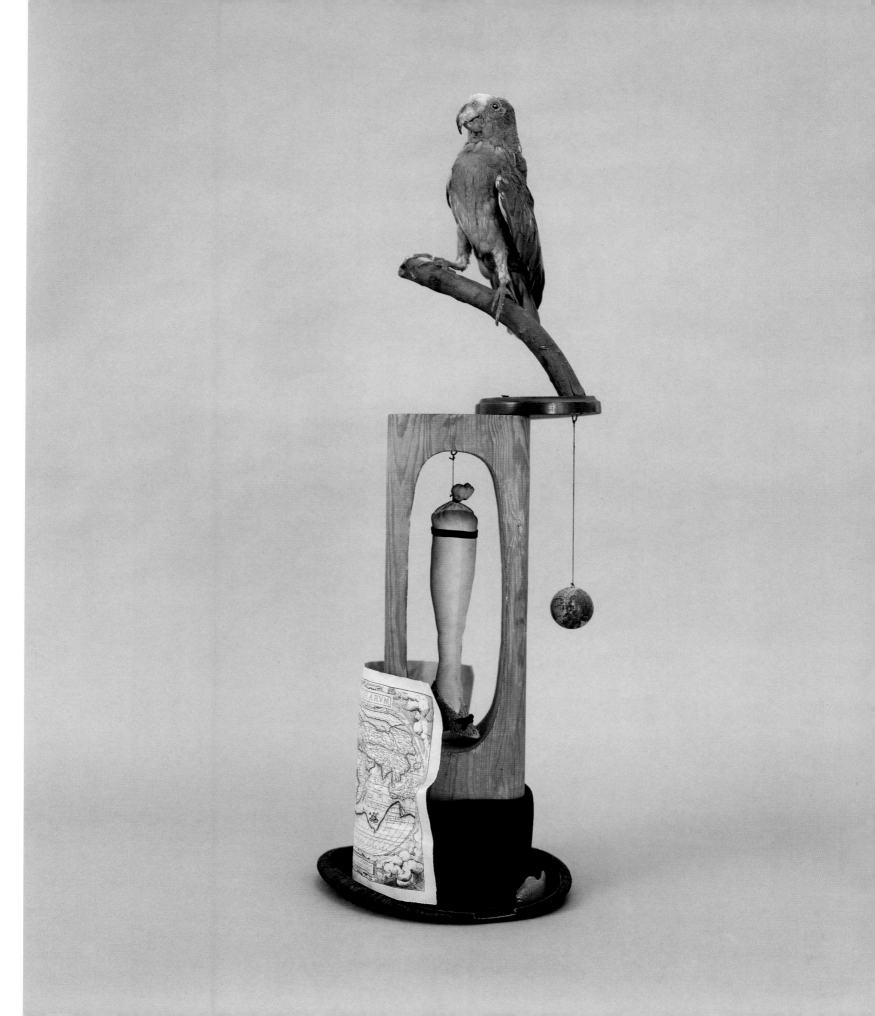

82. Salvador Dalí
Lobster Telephone, 1936
Painted plaster of paris with Bakelite base
7 x 12 x 4½" (17.8 x 30.4 x 11.4 cm)
Salvador Dali Museum,
St. Petersburg, Florida

83. Salvador Dalí
Telephone in a Dish with Three Grilled Sardines
at the End of September, 1939
Oil on canvas
18 x 21⅝" (45 x 55 cm)
Salvador Dali Museum,
St. Petersburg, Florida

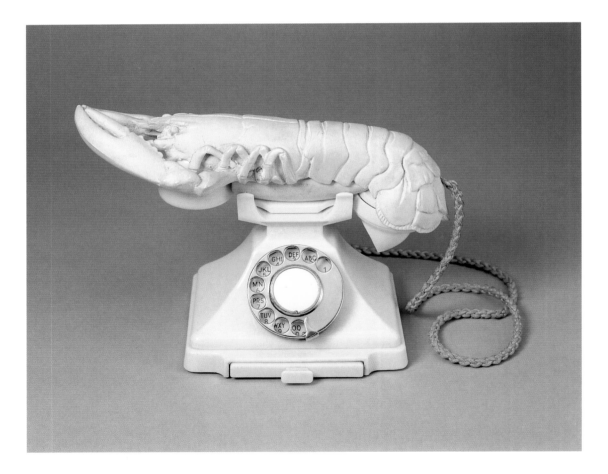

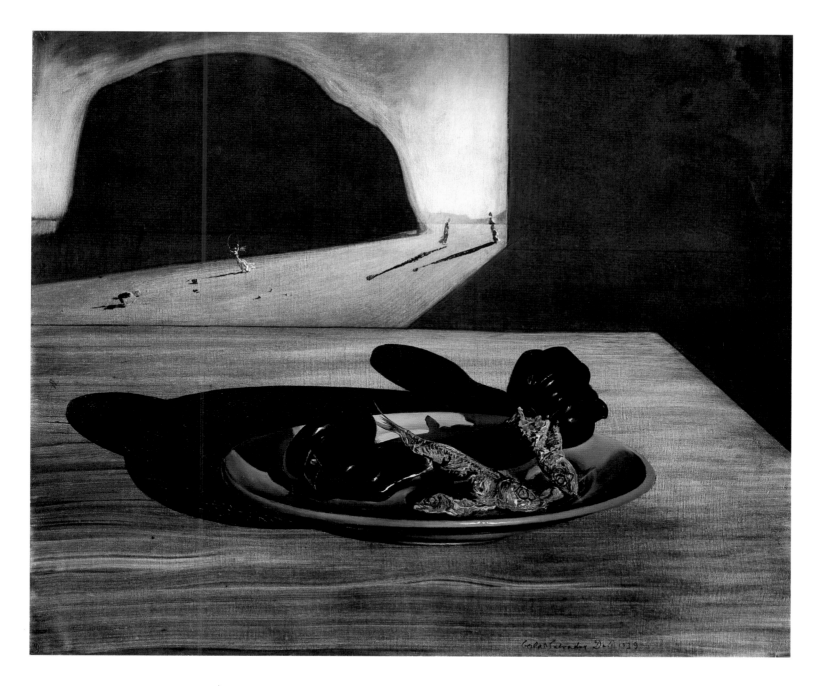

84. Joseph Cornell
Taglioni's Jewel Casket, 1940
Construction
4 ¾ x 11 ⅞ x 8 ½" (12 x 30.2 x 21 cm)
The Museum of Modern Art, New York

85. Joseph Cornell
Beehive (Thimble Forest), 1943–48
Construction
3 ½" high x 7 ½" diameter
(8.8 cm high x 19 cm diameter)
Collection Richard L. Feigen

86. Joseph Cornell
Untitled (Multiple Cubes), 1946–48
Construction
14 x 10 ⅜ x 2 ⁵⁄₁₆" (36.5 x 26.3 x 6 cm)
Collection Mrs. Edwin A. Bergman

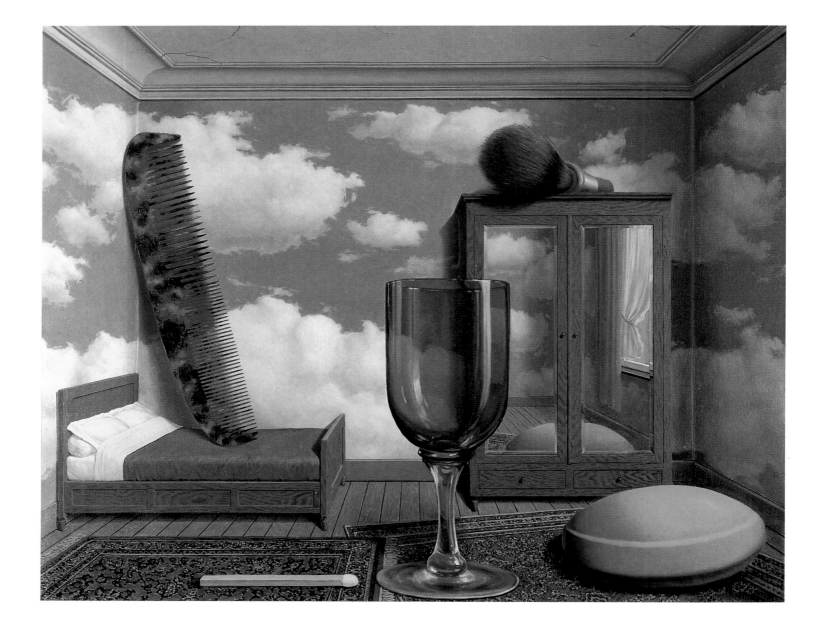

87. René Magritte
 Personal Values, 1952
 Oil on canvas
 32 x 40" (81.2 x 101.6 cm)
 Private collection

88. René Magritte
 The Listening Room, 1952
 Oil on canvas
 17 ⅝ x 21 ⅝" (45 x 55 cm)
 The Menil Collection, Houston

89. Lucio Fontana
Crab, 1936–38
Polychrome ceramic
9 1/16 x 15 3/4 x 14 9/16"
(23 x 40 x 37 cm)
Collection Capuani, Milan

90. Lucio Fontana
Still Life, 1938
Polychrome ceramic
7 1/4 x 14 15/16 x 14 9/16"
(18.5 x 38 x 37 cm)
Archivio Fontana, Milan

91. Frida Kahlo
Still Life with Prickly Pears, 1938
Oil on sheet metal
7 1/2 x 9 1/2" (18.5 x 24 cm)
Private collection

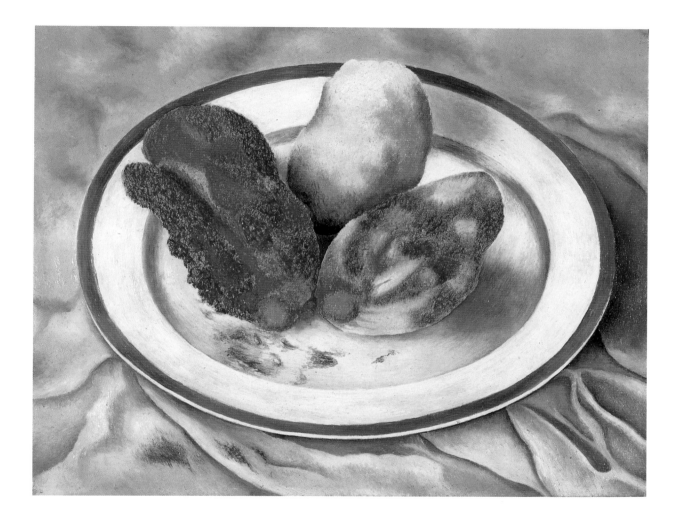

92. Jean Dubuffet
*Table Covered with Natural
History Specimens*, 1951
Oil and various pastes
on canvas
57 x 45" (144.7 x 114.3 cm)
Private collection

THE MECHANISMS OF CONSUMER CULTURE

Sometime in the mid-1950s, the subject and manner of the still life radically changed. The dominant modes of painting in the mid-1940s to '50s, whether abstract or figurative, had reflected postwar and post-Surrealist interrogations into not only what to paint but how to paint it. Yet most figurative (and indeed still life) artists bent on transgressing or transcending all earlier subjects and styles nonetheless remained in some way bound to earlier codes of representation and meaning. Only a younger generation of artists who came of age in the late 1950s and early '60s would succeed in making a break with the formal, technical, and semantic systems of the past.

For these artists, the prewar and wartime years were part of a history in which they had not participated. Their reality would be a peacetime economy, without existential angst. Jasper Johns, Robert Rauschenberg, Jim Dine, and the Pop artists in America and London, and the New Realist generation in continental Europe, as different as their respective cultural contexts and immediate artistic antecedents may have been, would look for their conceptual and formal inspiration toward the values and images of their immediate present—that of a consumer-oriented society. At the same time, in their attempts to build a fresh, new, and transgressive future, many of them looked to Duchamp and Surrealism, presences felt on both sides of the Atlantic.

Whereas Johns and Rauschenberg are often considered the fathers of Pop art in America, they were catalysts more than models for ensuing generations. Seeking an alternative to American Abstract Expressionism, they were influenced by Duchamp and John Cage in their deliberate choices of unconventional subject matter and unprecedented methods of working. Johns and Rauschenberg would adopt the philosophy that there is no subject in the world unworthy of interest, and that freely choosing (presumably) indifferent subject matter is as valid an artistic gesture as painting on canvas, or the practice of sculpture. Furthermore, going beyond Duchamp, they perceived these two mediums of expression as compatible rather than mutually exclusive.

Johns was intrigued by the borderline between common objects and modern myths, not only the myths embedded in certain all-too-familiar popular icons but the myths of the handcrafted artwork. Although his subjects and approach were of his generation and his time, his work

shows several analogies with that master of subversive techniques and ambivalence, Magritte. So that an early work by Johns—*Flag* (1958, plate 93) or *Painted Bronze* (ale cans) (1960, plate 94)—prompts a Magrittean register of inquiry, in regard to which the answers are again not easily forthcoming: "Is it a flag or is it a painting?," as Alan Solomon asked in 1964.[1]

Formally speaking, in Johns's early sculptures the objects presented dutifully respect the scale and appearance of their original models, and affect to operate in an experiential space. They are ordinary, and their literalness appears irrefutable. But almost simultaneously, it becomes clear that they are not what they seem: for they are copies, painted or sculpted, not found objects in the Duchampian sense. Yet they obey none of the conventions of painting or sculpture, most basically the transformation of a reality into an illusion, through the mediating process of personal interpretation governed by a personal subjectivity or "exposure of feeling."[2] So that the viewer is confounded, querying, Where is that imaginary boundary between reality and illusion which triggers that shift in the mind's cognitive patterns from the experience of reality to the experience of fiction? That borderline between reality and art, recognition and discovery, belief and disbelief, is so deliberately slim, even blurred, that perception remains suspended, in a state of "perpetual oscillation"[3] between one impression and the other, unable to fix its focus on either. But then, as Fred Orton has recently written, "In order to see *Flag* it seems necessary to make a decision about what you are looking at—content or form, subject or surface, subject or picture, flag or painting, life or art—even as you are kept off balance and prevented from deciding upon what you are looking at."[4]

In these objects, Johns appears to have so closed the gap between the model and the fiction that he has collapsed the two, integrating the signified and the signifier, the object and its sign. In so doing, one might argue, he has repudiated the fictional system that defines the structure of desire, a system based on the deferment of lived experience and its objects—a deferment that generates the formation of symbols. One might also argue, however, that Johns has not disavowed the system but transformed it: if "fiction subverts the myth of presence"[5]

(presence being understood as that of an original model or material referent), here the myth of presence subverts the fiction. For the perceived presence of the flag, the ale cans, or the light bulb subverts the image of each as art. Inverting the relationship between the material referent and its fictional image, Johns has created another experience of desire, one in which the symbolic, while persisting tenaciously, also becomes tenuous, ambiguous, and elusive.

Rauschenberg's approach was somewhat different, although his avowed aspiration to act "in the gap between art and life" also challenges the ideal of transcendence inherent in earlier artistic systems and codes. Using actual objects, real materials, and mechanical techniques, he sought to project the paradoxes between the ideologies and the reality of modern urban life. His yellowed photographs, transfers, printed documents, and newsprint, coupled with the detritus of worn or discarded commodities, may recycle certain experiences of our lives according to principles of free association but are nonetheless "combined" according to collage and assemblage techniques, and often overpainted, thereby compounding the real world and the "art"

Robert Rauschenberg
Monogram, 1959
Construction
48 x 72 x 72" (121.9 x 182.8 x 182.8 cm)
Moderna Museet, Stockholm

experience (plate 100). Yet this is an art experience of another order: not a world of illusionistic depth but a world of surface and textual incident, not a window on the world but a piece of the world, with its shifting indexes of time, space, emotion, and significance. It is not a fiction imagined and contained in a frame but exists both inside and outside the frame, violating the sacred boundaries between life and art. At the same time, Rauschenberg's "combine paintings" may indeed be seen as metaphors for the incoherence, fragmentation, and contradictory signals that define modern experience. Both Rauschenberg and Johns tread the fine line between art and life, although differently: one through seamless entities that do not belong comfortably and explicitly to either realm, the other through the registration of distinctly disparate experiences in radically different concrete forms, precariously yet judiciously rejoined. Their vision is of the present; there is little distance, transcendence, or nostalgia.

The kind of coded ideology seen in the ambivalent physicality, conflicting conceptual messages and signals, and as well, one might say, the social and cultural commentary that informs these pieces is also inherent in works by contemporaneous European artists such as Arman, Christo, Daniel Spoerri, Piero Manzoni, and Marcel Broodthaers. If one might venture to say that Johns's and Rauschenberg's approaches to the modern myths of art and life were positivist and ironic, these artists manifest a distance, an indirectness, and a more critical irony. Their works formulate their vision of the flip side of consumer culture as perceived in Europe: its artificial mechanisms and the absurdity of its effects. These include accumulation or quantity for its own sake, the mysterious appeal of packaging notwithstanding the contents, and the effects of fickleness, disaffection, and accelerated obsolescence, among them deliquescence and decay. The artists' vehicles of expression are actual objects taken from the normal domestic scene: organic foods such as eggs, mussels, or rolls, authentic household garbage and abandoned meals, obsessively collected grooming accessories, and real tables, real cloth, real string. Their themes are the public systems of consumption that infiltrate private life, transforming and congealing its vital forces, its natural motivations and functions, and ultimately the sociopsychological framework of modern existence.

These victimized objects, subtly manipulated with an undeniable humor (at times a black humor, one might say) and transposed according to new systems of representation, are not assembled as a eulogy to modernity. The submerged yet perceptible presence of desire, manifest in the objects' inaccessibility, their transcendence of banality, and their distinctive poetry, suggests, on the contrary, a world suspended on the edge of loss; and the affectionate tribute implicit in the manner of their portrayal transforms the artists' ironic statements, almost despite themselves, into a nostalgic ode to almost obsolete humanistic values.

A relationship to the objects and mechanisms of consumer culture is altogether differently coded in American Pop art, exemplified here by Roy Lichtenstein, Andy Warhol, and Ed Ruscha. This same subject matter is explored, although from a different viewpoint and in a different context, by Richard Hamilton in London. These artists' subjects are the mythic representation of the consumer-tailored object, the processing of its emblematic imagery, and the "hidden persuasions" of its signals and messages.

Consumer culture is by definition object-oriented and market-driven. Its specific and insidious mechanisms are designed to render objects appealing, attractive, and seductive, the ultimate objective being to arouse the acquisitive instinct. Its promotional vehicles are packaging and advertising; its techniques include larger-than-life scale, insistent repetition, aggressive color, stereotyped forms, and clear, reassuringly conventional typefaces, all of these designed to project irresistible imagery. The potential customer or consumer must identify this imagery instantly as an object of urgent desire and pleasure, to be possessed. It is the pleasure principle made tangible, immediate, real.

The vehicles of pop art are articles of mass consumption seen through a marketing screen—mechanically reproduced at real or enlarged scale, outlined with crisp contours, repeated ad infinitum and ad nauseam, boldly and mechanically colored, and captioned with comforting legibility. Here too the instantly recognizable model is not the paintings' true subject: the real subject is once again the mechanisms of desire, coolly packaged in mythologized modern icons.

Hamilton has stated explicitly that his original *Still Life* of 1965 (which included part of a toaster like the one presented here [plate 115],

although there it was combined with other objects) was inspired by Duchamp's readymades. "Whereas Duchamp's readymades were chosen with a deliberate avoidance of concern with the aesthetic merits of the object, 'Still-life' takes a highly stylized photograph of an example of high style in consumer goods to raise the question: 'Does the neutrality of Duchamp or the studied banality, even vulgarity, of the subject matter in most American Pop significantly exclude those products of mass culture which might be the choice of a NY Museum of Modern Art "Good Design" committee?'"[6] Unlike, say, Lichtenstein, Hamilton did not handcraft his image as an ironic painted replica of a mechanized (photographic) image. Rather, he displaced a mechanical technology (photography, as well as chromed-steel and Perspex sheets) to the format of a painting and identified it as a painting, producing a variation on the theme of the assisted readymade. Hamilton goes even farther in that the "painting" of the toaster produces a non-Duchampian spatial illusionism through reflection. This, too (which would have pleased Duchamp), appears as "ready-made."

Whereas the subject matter of Claes Oldenburg's early works also derives from the landscape of consumer society, his personal approach to and translation of the objects of mass culture are radically different. For the classic form of Pop art to function, it was necessary virtually to clone the commercial image or model, which was of itself a fiction. This of course meant circumventing or abandoning most of the traditional artistic values and criteria of the past: for example, those of an original vision, a unique and subjective interpretation, and a personal facture or technique. All these were replaced by the appropriation of prefabricated imagery and mechanical reproductive processes, their features usually enlarged or exaggerated to an unprecedented degree. Oldenburg's 1960s sculptures, in canvas, vinyl, cardboard, and plaster (plates 113 and 114), show little respect for traditional artistic conventions, and as little for the brand-new conventions of his American contemporaries. Indeed his commonplace objects, brightly colored, sometimes shellacked, and glistening with technological glamour, carry another message. Appearing at once as unself-consciously assertive and modestly self-denigrating, they establish a distance from their fictive models that generates a symbolic image of a "future-past"

utopia.[7] Their often overblown scale, and their crudely contoured, softened, sometimes even collapsed silhouettes (plate 114), embody and symbolize the absurdity, triviality, and inherent disbelief characteristic of modern materialist culture.

If the still life may be interpreted as a reflection or measure of evolving social attitudes and cultural perceptions, translated by artistic concepts and styles that conform to the spiritual and intellectual realities of a moment in time, the diverse and singular art forms that emerged in the late 1950s and the '60s in both America and Europe demonstrate the conviction that the essential truths of that reality are untruths, deliberately duplicitous, superficial and ephemeral; and that the space for the mechanisms of desire and its symbols has been radically reduced and transformed in the new order of priorities. These considerations notwithstanding, the strength and significance of the art of this period, whether created from actual objects or from mechanical production processes, lie in the authentic ambivalence it embodies between belief and disbelief, humor and cynicism, truth and fiction, an ambivalence that finally constitutes the true vision of reality during those decades.

1. Alan R. Solomon, "Jasper Johns," *Jasper Johns,* exh. cat. (New York: The Jewish Museum, 1964), p. 8, and (London: The Whitechapel Gallery, 1964), p. 9.

2. Fred Orton, *Jasper Johns: The Sculptures*, exh. cat. (Leeds: The Henry Moore Institute, 1996), p. 30.

3. The term, used somewhat differently in the same context, is Leo Steinberg's, in "Jasper Johns: The First Seven Years of His Art," *Other Criteria: Confrontations with Twentieth-Century Art* (New York: Oxford University Press, Inc., 1972), p. 25. This essay first appeared, in a somewhat different form, in *Metro* (Milan) no. 4/5 (May 1962).

4. Orton, *Jasper Johns: The Sculptures*, p. 16.

5. Susan Stewart, *On Longing* (Durham, N.C., and London: Duke University Press, 1993), p. 20.

6. Richard Hamilton, in *Richard Hamilton*, exh. cat. (New York: The Solomon R. Guggenheim Museum, 1973), p. 61.

7. Stewart, *On Longing*, p. 23.

93. Jasper Johns
Flag, 1958
Encaustic on canvas
41 ¼ x 60 ¾" (103.1 x 151.8 cm)
Collection Jean-Christophe Castelli

94. Jasper Johns
Painted Bronze (ale cans), 1960; edition two
of two, cast and painted 1964
Painted bronze
5 ½ x 8 x 4 ½" (13.7 x 20 x 11.2 cm)
Collection the artist

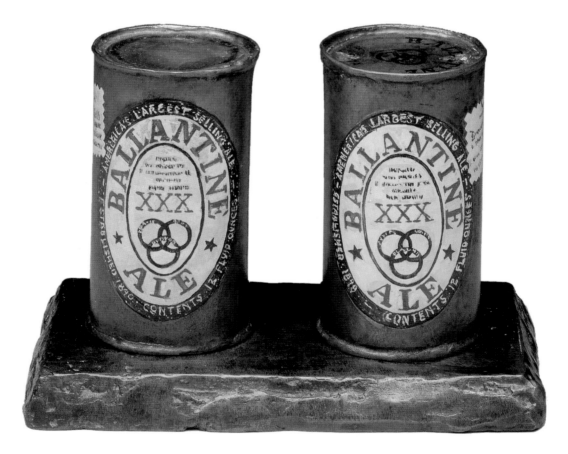

95. Jasper Johns
 Iron, 1962
 Encaustic on wood
 9 ¾ x 7 ⅛" (24.3 x 18 cm)
 Collection the artist

96. Jim Dine
 Pearls, 1961
 Oil and metallic-painted rubber balls
 on canvas
 70 x 60" (177.7 x 152.3 cm)
 Solomon R. Guggenheim Museum,
 New York

97. Jasper Johns
 Untitled (lightbulb), 1960–61
 Plaster and wire
 3 ¼ x 11 ½ x 6 ¼"
 (8.1 x 28.2 x 15.7 cm)
 Collection the artist

98. Robert Morris
 Metered Bulb, 1962
 Electric meter and lightbulb
 17 ¾ x 8 x 8 ¼"
 (45 x 20.3 x 20.9 cm)
 Collection Jasper Johns

99. Dan Flavin
 Barbara Roses, 1962–64
 Terra-cotta flower pot, porcelain
 receptacle with pull chain, and
 Aerolux Flowerlite
 8 ½" high x 4" diameter
 (21.6 cm high x 10 cm diameter)
 Courtesy Lance Fung Gallery,
 New York

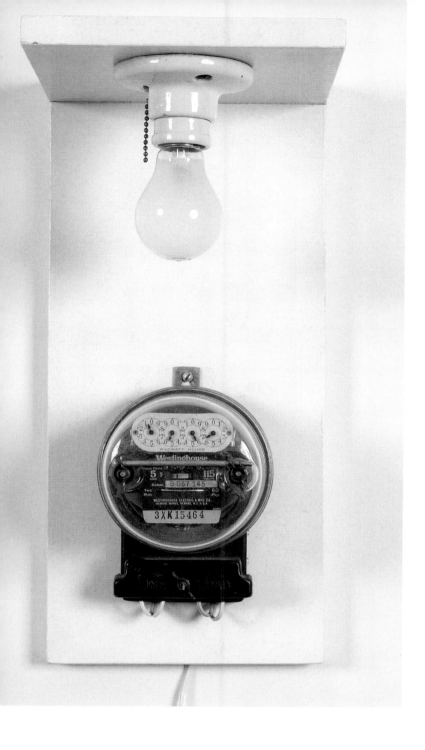

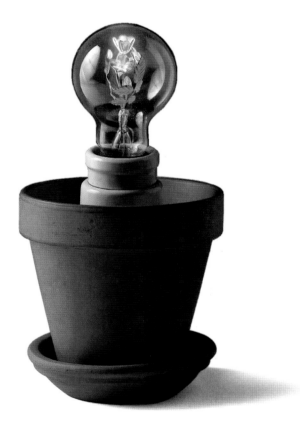

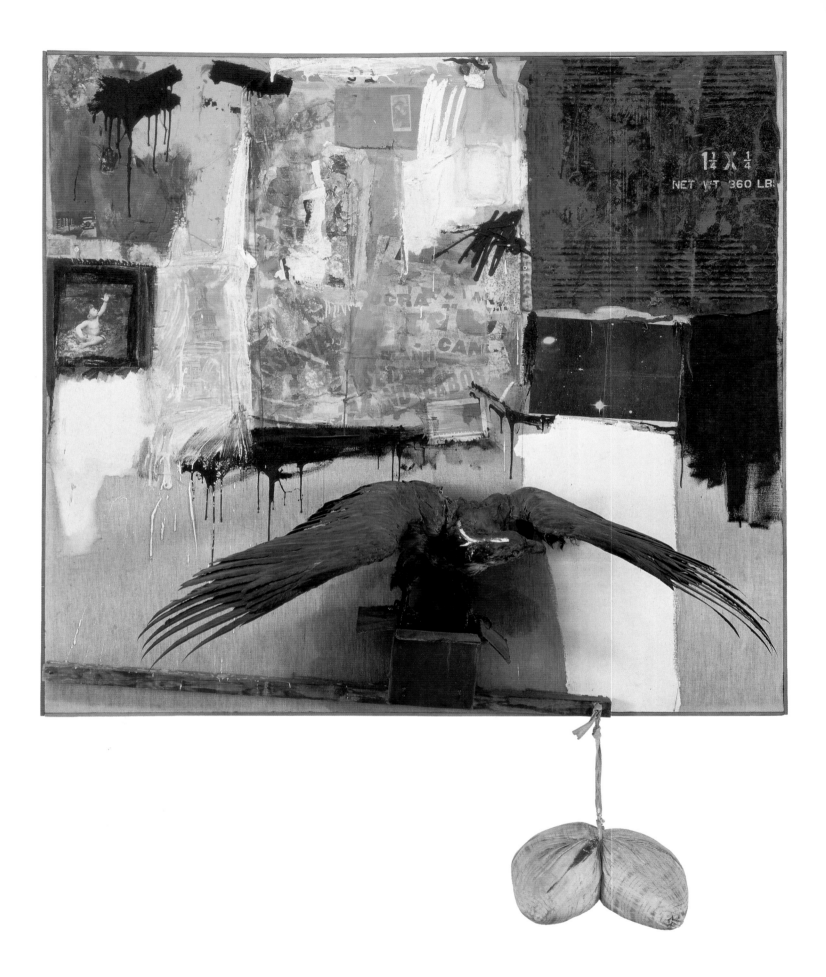

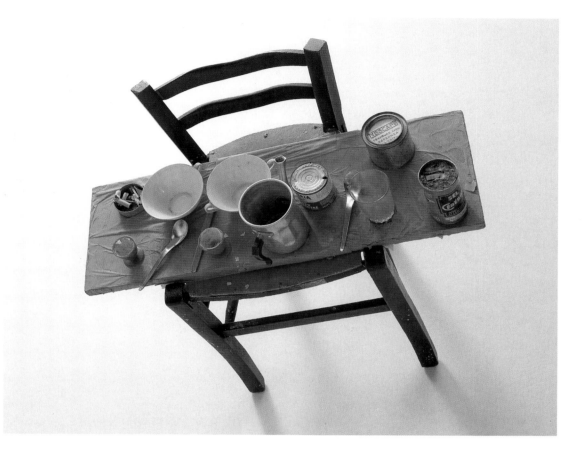

100. Robert Rauschenberg
Canyon, 1959
Combine painting: oil, graphite, and
collage on canvas with objects
81 ¾ x 70 x 24"
(207.6 x 177.8 x 60.9 cm)
Sonnabend Collection

101. Daniel Spoerri
Kichka's Breakfast, I, 1960
Assemblage: wood chair hung on wall
with board across seat, coffee pot,
tumbler, china, eggcups, eggshells,
cigarette butts, spoons, tin cans, etc.
14 ⅜ x 27 ⅜ x 25 ¾"
(36.6 x 69.5 x 65.4 cm)
The Museum of Modern Art, New York

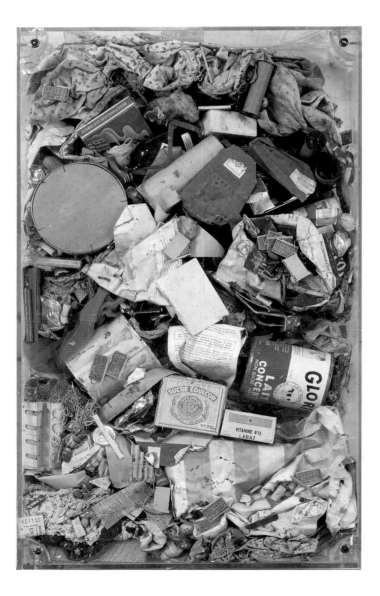

102. Arman
Household Trashcan, 1960
Trash in a Plexiglas box
24 x 16 x 4" (60.9 x 40.6 x 10.1 cm)
Collection Armand P. and Corice Arman

103. Arman
The Gorgon's Shield, 1962
Accumulation of silver-painted dog combs
53 x 37 ½" (132.5 x 93.7 cm)
Collection Armand P. and Corice Arman

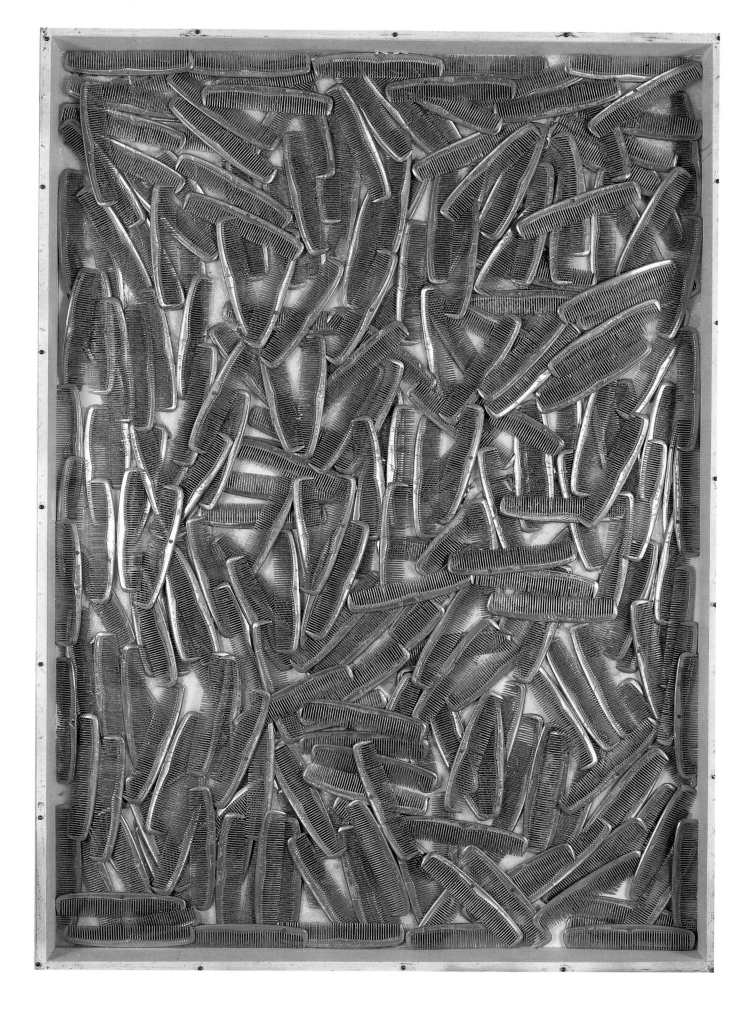

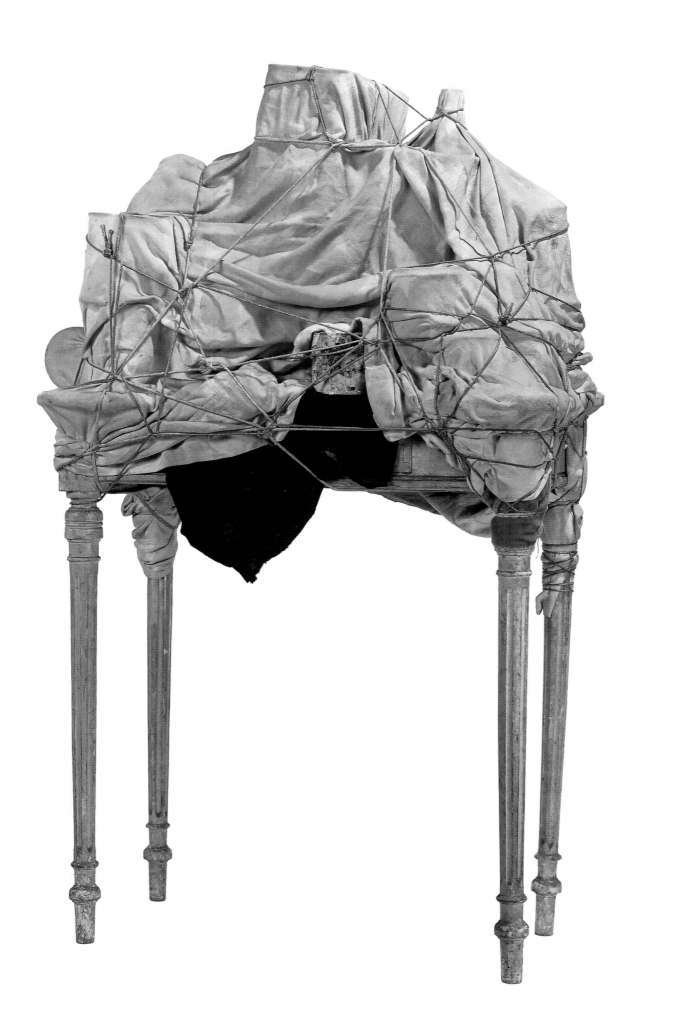

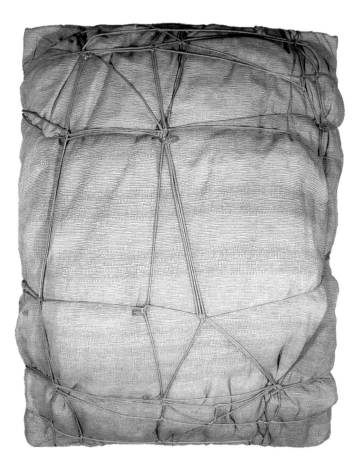

104. Christo
Package on a Table 1961, 1961
Wooden table, linen, canvas,
cans, and rope
48¾ x 24¼ x 11¾"
(123.8 x 61.6 x 29.8 cm)
Collection Christo and
Jeanne-Claude, New York

105. Christo
Package 1962, 1962
Fabric and rope mounted
on board
36⅝ x 26¾ x 12¼"
(93 x 68 x 31.3 cm)
Collection Christo and
Jeanne-Claude, New York

106. Piero Manzoni
Achrome, 1961–62
Bread covered with kaolin
13 1/8 x 16 7/8" (33 x 42 cm)
Gian Enzo Sperone Collection,
New York

107. Marcel Broodthaers
Casserole and Closed Mussels, 1964
Mussel shells, partly painted
with polyester resin, in painted
iron casserole
12 x 11 x 9 3/4"
(30.5 x 27.9 x 24.8 cm)
Tate Gallery, London

108. Marcel Broodthaers
Small Cage with Eggs, 1965–66
Wood, iron, eggshells, and string
9 3/8 x 8 7/8 x 6 1/2"
(24 x 22.7 x 16.5 cm)
Caldic Collection, Rotterdam

109. Roy Lichtenstein
Keds, 1961
Oil and pencil on canvas
47¾ x 34" (121 x 86.3 cm)
The Robert B. Mayer Family
Collection, Chicago

110. Ed Ruscha
Actual Size, 1962
Oil on canvas
72 x 67" (182.9 x 170.2 cm)
Los Angeles County
Museum of Art

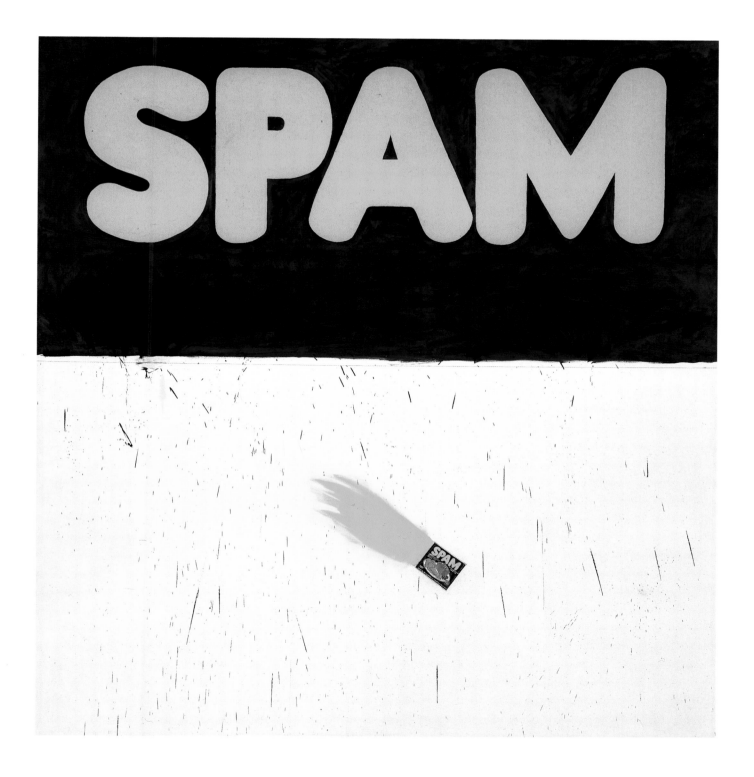

111. Andy Warhol
100 Cans, 1962
Oil on canvas
72 x 52" (182.9 x 132.1 cm)
Albright-Knox Art Gallery, Buffalo

112. Andy Warhol
Brillo Boxes, 1964
Synthetic polymer paint
and silk screen on wood
one 13 x 16 x 11 ½"
(33 x 40.6 x 29.2 cm),
the others each 17 x 17 x 14"
(43.2 x 43.2 x 35.6 cm)
The Andy Warhol Museum, Pittsburgh

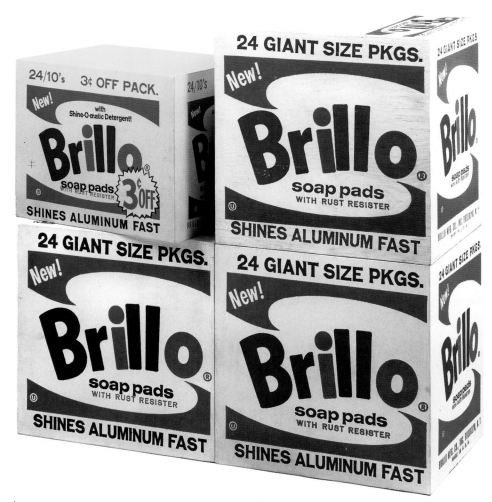

113. Claes Oldenburg
Pastry Case, I, 1961–62
Enamel paint on nine plaster
sculptures in glass showcase
20 ¾ x 30 ⅛ x 14 ¾"
(52.7 x 76.5 x 37.3 cm)
The Museum of Modern Art,
New York

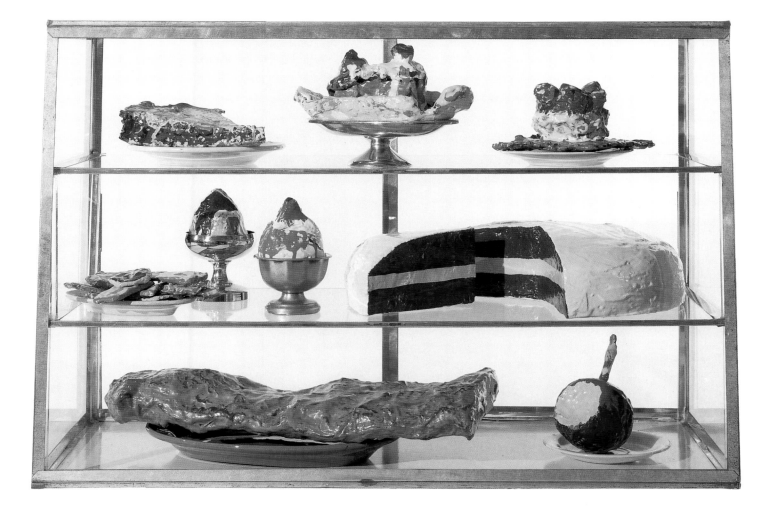

114. Claes Oldenburg
Soft Typewriter, 1963
Plexiglas, nylon cord, and vinyl
filled with kapok
9 x 26 x 27½"
(22.9 x 66 x 69.9 cm)
Private collection

115. Richard Hamilton
Toaster, 1969; reconstruction
of original of 1966–67
Chromed steel and Perspex
on color photograph
31⅞ x 31⅞" (81 x 81 cm)
Collection Richard Hamilton

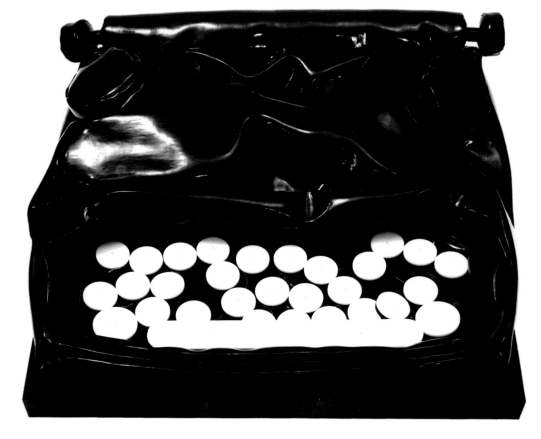

POSTMODERN
SIMULACRA

Historically, the still life, as a pictorial genre, was
invented and flourished in a Western leisure-class society in which art
played an accepted socioeconomic role. The art of the modernist avant-
garde, on the contrary, situated itself in opposition to society, and
developed means through which to criticize, even undermine, society's
values. The modern still life, understood here as the avant-garde still
life, has been seen to incorporate aspects of both of these positions.
The artists who have addressed this theme, illustrated here in its broadest
sense, both have referred to a traditional pictorial exercise rooted in the
conventions of middle-class private life and have attempted to challenge
it, not only in function of more problematic visions of the world but as
regards a distinct language of form.

It has therefore been suggested throughout this book that the
still life's subject matter has evolved in some proportion and relation
to social, cultural, and economic developments in the twentieth century,
and that its formal syntax has been restructured by constantly reviewed
and renewed codes of representation, and through technical advances
or emancipations from earlier modes. The issue of whether it has
developed in consonance with, in opposition to, or autonomously
from Western society, however, has rarely been specifically addressed;
more often, the still life's continuities with or fractures of its own
tradition have been the subject at hand. We have nonetheless observed
that in the second half of the century there was a tendency to produce
an art more directly in consonance (although still in disagreement)
with the arena of lived experience—that of late capitalism. In examining
the final decades of this century, then, it appears necessary to
discuss certain realities of our time, as a context for the art being
made today.

It goes without saying that the society we have lived in since the
1960s—its political and economic framework, its ideological priorities,
and its inventions and discoveries—is profoundly different from that of
the dawn of the century. The vocabulary of "postmodernism" is often
invoked in discussions of this period; the term may be understood,
according to Fredric Jameson, as "a periodizing concept whose function
is to correlate the emergence of new formal features in culture with
the emergence of a new type of social life and a new economic order—

what is often euphemistically called modernization, postindustrial or consumer society, the society of the media or the spectacle, or multinational capitalism."[1] The function of art in relation to this environment has by necessity changed dramatically. Art was once designed to address the bourgeoisie, whether by pleasing it and promoting its values or by provoking and scandalizing it—by whatever means, the effect was a dialogue or exchange (in the many senses of the term). Today's perceptions and ideologies, although superficially continuous with the past, are from the point of view of the artist somewhat (and sometimes altogether) different. It follows that the artist's objectives and their formulation often appear to have little to do with the visual and philosophical premises that were previously assumed to govern artistic activity.

Jameson, in his description of postmodernism, highlights and illustrates two concepts that will be briefly discussed here. The first is that of pastiche; the second, of schizophrenia. One bridge between them, according to Jameson, is "the death of individualism." In Jameson's own terms, "Pastiche is, like parody, the imitation of a peculiar or unique style...speech in a dead language: but it is a neutral practice of such mimicry, without parody's ulterior motive, without the satirical impulse, without laughter, without that still latent feeling that there exists something *normal* compared to which what is being imitated is rather comic." Pastiche is "blank parody," "blank irony."[2] In other words, pastiche is an anonymously (neutrally) contrived copy without a direct model or meaningful original.[3]

The possibility of pastiche—its neutrality and blankness— presupposes that individualism is dead. The copy is impersonal; the model is either indifferent, forgotten, or never existed. High modernism, however, was "predicated on the invention of a personal, private style....this means that the modernist aesthetic is in some way organically linked to the conception of a unique self and private identity, a unique personality and individuality, which can be expected to generate its own unique vision of the world and to forge its own unique, unmistakable style."[4] Yet today, scientists, social scientists, and cultural critics are "exploring the notion that that kind of individualism and personal identity is a thing of the past; that the old individual or

individualist subject is 'dead'; and that one might even describe the concept of the unique individual and the theoretical basis of individualism as ideological."[5] Thus the old models of modernism are no longer viable.

As we know, schizophrenia is defined as a general breakdown of relationships—between objects in a perceptual field, for example, or between words and their meaning or content, or between words and each other as a continuous fabric of meaning in a linguistic system. As a result, the schizophrenic has no concept of time as linear, interconnected, and sequential, and none either of personal identity as a selection and interrelation of certain specific human potentials at the expense of others. Conversely, because the schizophrenic does not (indeed cannot) search for meaning behind the object, behind the word, or within the unhierarchical unfolding of the field of experience, he or she has an experience of the present and of its objects that is "overwhelmingly vivid and 'material'...ever more material—or better still, literal—ever more vivid in sensory ways."[6]

We do not intend to push the works presented here into a strict postmodernist mold, only to remark that Jameson's discussion opens up a number of interesting and pertinent areas of inquiry. It is clear that many artists working in the 1970s and on through the 1990s, particularly but not solely in America, resisted and continue to resist the tenets of modernism.[7] They distrust originality, and distrust individual expression achieved through a personal facture, style, vision, or emotion. Like the Pop artist, they reject high-minded or culturally and socially approved subject matter, as well as traces of artistic labor. They are uninterested in the sacred convention of uniqueness.

The subject matter of the artists considered here, working in the 1970s, '80s, and '90s, may seem not unrelated to the themes of the past—the laid table, the object from the domestic landscape, even the *vanitas*—but its conception and execution have little to do with earlier manifestations. Concepts of individual style, vision, emotion, labor, and even uniqueness are circumvented in this art through the neutralizing effects of mechanical or industrial processes of fabrication and replication. Subjects appear to be chosen for their obvious banality or for their qualities of déjà vu; at times they

are treated generically, at others totally incongruously, but in all cases they are drained of their acquired or inherent cultural or emotional associations.

Many of these works, explicitly or implicitly, illustrate certain paradigms central to postmodernism. Warhol's and Gerhard Richter's reinventions of the *vanitas* (plates 116 and 117), Cindy Sherman's set table (plate 120), and Allan McCollum's *Perfect Vehicles* (1988–89, plate 124) may be identified as exemplary of the postmodern pastiche: intentionally neutral simulacra of still life compositions or components, they are "blankly" ironic, and are executed in anonymous mechanical techniques. Although they appear at first to translate or replicate original (historical) models and conventions, their relation to these presumed originals is tenuous at best. On the contrary, a strategic isolation and estrangement from any spatial or temporal, historical or cultural associations or references has enhanced their distinctive presence or physicality, their *literalness*, and reinforced their "meaninglessness" in relation to earlier modernist codes of meaning.

Choices of scale are neither arbitrary nor casual in the conception of these and other objects presented here. Whether produced at real scale (Kiki Smith's *Second Choice* of 1988, plate 121, Koons's *One-Ball Total Equilibrium Tank* of 1985, plate 123) or oversized (works by Warhol, McCollum, Robert Therrien, and Robert Gober, plates 116, 124, 125, and 126), these objects have no relation to *normal* reality but lay claim to another perception of reality. If somehow they echo the objects in Jameson's schizophrenic landscape—in which, as we lose touch with the significant interrelations in our experiential field, isolated objects emerge with a more persistent presence—they might also be envisaged according to other postmodern suppositions. The philosopher Jean Baudrillard has argued that the Western notion of reality (physical, sensory, relational, and spatiotemporal) is rapidly dissolving into a dematerialized network or a flickering unfocused screen. He further proposes that the virtual reality of today, in which all aspects of existence may be filmed (in both senses of the term) and digitized, irreversibly destroying the whole sphere of private experience (including pleasure and desire) as it translates it into smooth, stereotyped, synthetic images, is the reality of the future.

With this posthumanist vision in mind, one might be tempted to suggest that the emphasis on scale, literalness, and physicality seen in these works constitutes an ambivalent approach to reclaiming a tangible, phenomenal, sensory experience of things in the world. Although highly conceptualized, these objects do maintain a phenomenological presence, size, color, and weight in relation to ourselves, inspiring attraction or repulsion, recognition or alienation. For the moment, they appear still more "real" to us than the undifferentiated screen of "virtual" experience. This may be illusory, however, another manner of saying that we approach these artifacts with a longing for a traditional art experience; and in fact that the "reality" with which we invest these objects is ours, not theirs. Quite to the contrary, these stereotypes of stereotypes are at several removes from what we thought we saw as a copy of a familiar model. Pastiching the objects of desire of our traditional landscape, they set a film of meaning (or nonmeaning) between themselves and ourselves. In their deliberate displacement and disconnection from familiar circuits of meaning—whether aesthetic or real—these surrogates or simulacra embody another register of experience, that of the signs and systems of the postmodern world.

1. Fredric Jameson, "Postmodernism and Consumer Society," in Hal Foster, ed., *The Anti-Aesthetic: Essays on Postmodern Culture* (Seattle: Bay Press, 1983), p. 113.
2. Ibid., p. 114.
3. For a discussion of the notion of the copy without an original, see Rosalind Krauss, "Cindy Sherman: Untitled," in *Cindy Sherman, 1975–1993* (New York: Rizzoli, 1993), p. 17 ff.
4. Jameson, "Postmodernism and Consumer Society," p. 114.
5. Ibid., p. 115.
6. Ibid., p. 120.
7. Philip Guston, Georg Baselitz, and Tony Cragg, although working during the period discussed here, are exceptions to the following argument.

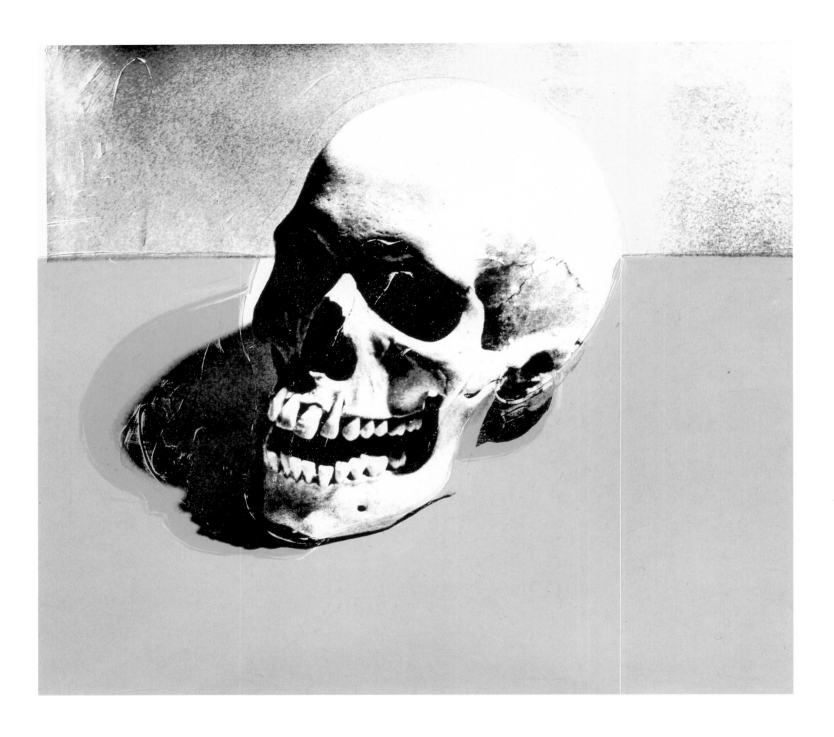

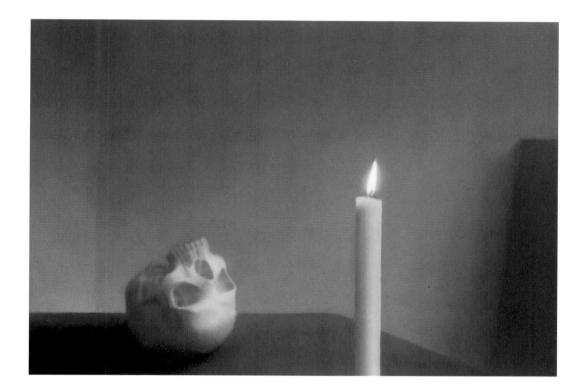

116. Andy Warhol
Skull, 1976
Synthetic polymer paint and silk screen
on canvas
72 ⅛ x 80 ½" (180.5 x 201.2 cm)
The Andy Warhol Museum, Pittsburgh

117. Gerhard Richter
Skull with Candle, 1983
Oil on canvas
39 ⅜ x 59 1/16" (100 x 150 cm)
Private collection, Berlin

118. Philip Guston
 Highball, 1979
 Oil on canvas
 36 x 32" (90 x 80 cm)
 The Estate of Philip Guston,
 courtesy McKee Gallery, New York

119. Georg Baselitz
 The Motif: Evening Atmosphere, 1988
 Oil on canvas
 64 ⅞ x 52" (162 x 130 cm)
 Collection Ann and Steven Ames

120. Cindy Sherman
Untitled #172, 1987 (number 5/6)
Chromogenic color print
73 ⅜ x 49 ¹⁄₁₆" (186.4 x 124.6 cm)
Museum of Contemporary Art, Chicago

121. Kiki Smith
Second Choice, 1988
Ceramic
6 x 2 ½ x 11" (15.2 x 6.3 x 27.9 cm)
Private collection

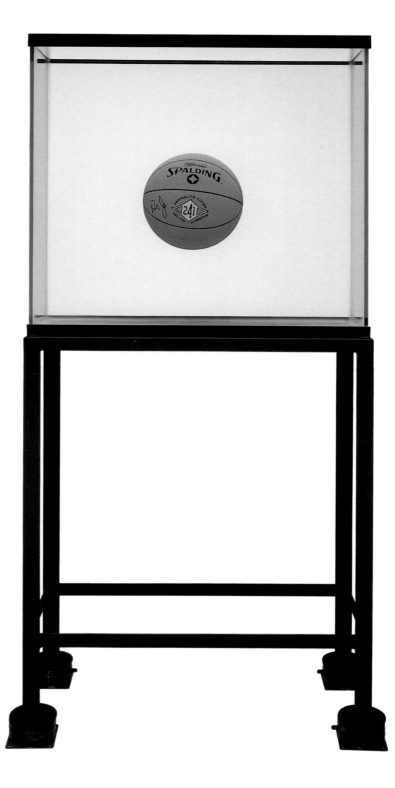

122. Tony Cragg
Eight Painted Objects, 1981
Stone, can, bottle, cushion,
satchel, foam, wood, and pipe
11' 8" (355.6 cm) long
Collection the artist, courtesy
Galerie Chantal Crousel, Paris

123. Jeff Koons
One-Ball Total Equilibrium Tank
(Spaulding Dr. J. 241 Series), 1985
Glass, steel, sodium chloride
reagent, distilled water,
and basketball
64 ¾ x 30 ¾ x 13 ¼"
(164.5 x 78.1 x 33.7 cm)
Collection of BZ and Michael
Schwartz, New York

124. Allan McCollum
 Perfect Vehicles, 1988–89
 Moorglo on concrete
 Each 80" high x 36" diameter
 (203.2 cm high x 91.4 cm diameter)
 Collection the artist

125. Robert Therrien
 Untitled (Stacked Plates), 1994
 Ceramic epoxy on fiberglass
 97 ½ x 61 x 61" (243.9 x 152.4 x 152.4 cm)
 Museum van Hedendaagse Kunst, Gent

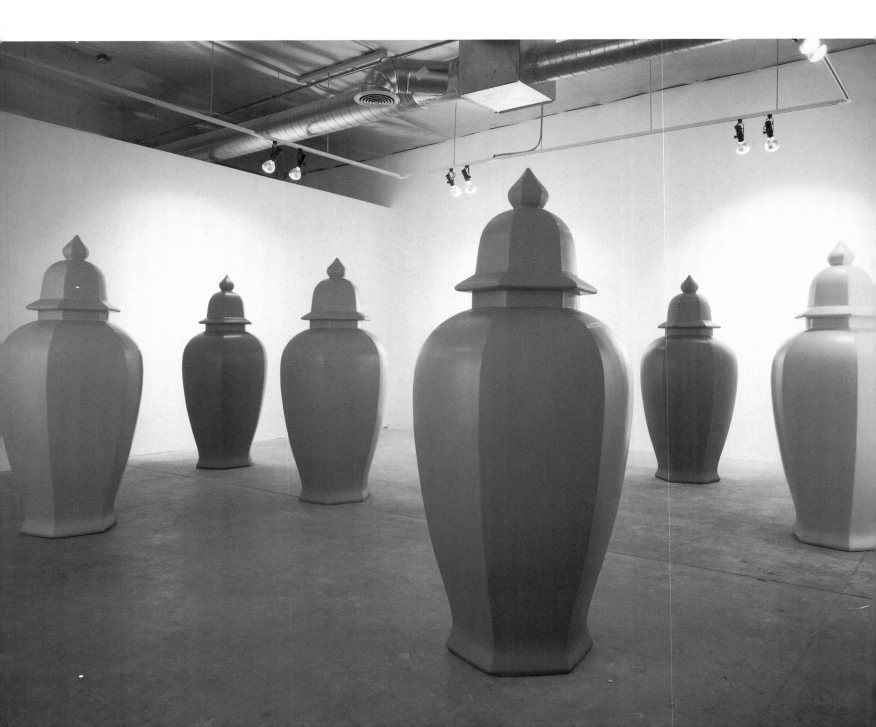

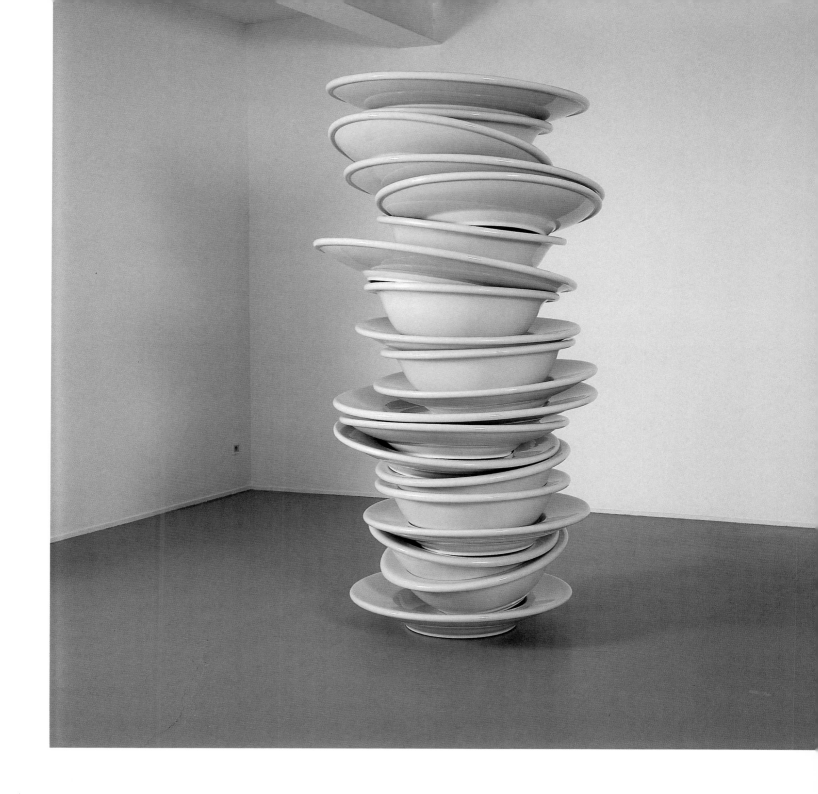

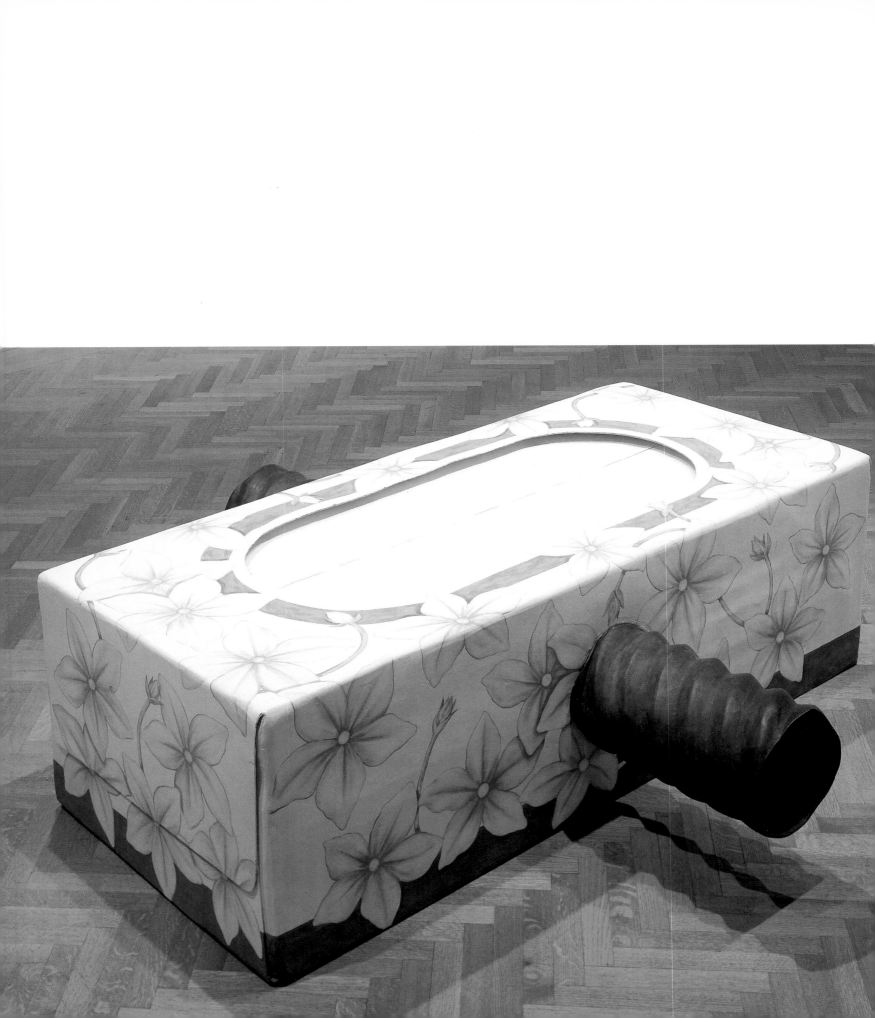

126. Robert Gober
Untitled, 1994–95
Wood, bronze, paint,
and handmade paper
24 x 71 x 73 ½" (61 x 180.3 x 186.7 cm)
The Art Institute of Chicago

CÉZANNE
AND
MAGRITTE
REVISITED

According to the canonical reading of the art history of eras prior to our own, the subject of the still life was an arrangement of familiar and inanimate objects on a table. Yet as we have observed, starting as early as the opening decades of this century, although objects from our daily life (be it private or public) may have continued to prevail in artists' interpretations of this genre, their relation to the symbolic and formal framework of the domestic table was radically transformed, often even supplanted by a distinct system of relationships to the canvas surface or its frame, or else, in the case of sculpture, to existential or actual space. When the table was maintained as a viable structural system, it was usually utilized as a deliberate reference to the past, a reference filtered through new semantic and formal codes.

This is clearly visible in many works throughout this exhibition. Two works in the present section bear it out in an exemplary manner: Therrien's *Untitled (Saucer Table)* of 1990 (plate 129) and Charles Ray's *Tabletop* of 1989 (plate 128). Therrien's piece appears as a fairly predictable proposition, a commonplace object precariously balanced on a table. Yet on closer investigation one discovers a fictive system. The saucer is handmade, and although the table is generic, the artist has adapted it for his own purposes: whereas from a distance this unremarkable subject seems to function according to the accepted laws of single-vanishing-point perspective, as one approaches it one realizes that its scale is not conventional (its height, width, and depth bearing no familiar relation to each other), and that it contains its own "queered" perspective which has nothing to do with that of normal knowledge or perception. Therrien has rendered in three dimensions the distortions and illusionistic tricks of two-dimensional perspective, with the result that the natural and the ordinary seem to be conceived and transposed according to a bizarrely incongruous structure and vision. Uncannily, *Untitled* brings to mind Cézanne's peculiarly sized and tilted tabletops, and his skewed perspectives. The objects are of course different, but the system of representation, and that of *seeing*, are virtually the same. So that one might say that Therrien's saucer and table represent a revisiting of Cézanne in the present tense.

Our first encounter with Ray's *Tabletop* produces an immediate sensation of déjà vu. The all-too-familiar objects and their unimaginative and "static" disposition challenge any attempts at formal or symbolic interpretation of what is there to be seen. The yellow bowl, a white plate, a lidded container, two open goblets (one of them transparent), and a plant with fan-shaped leaves appear to be taken literally from the domestic environment. Their reassuring silhouettes, colors, and textures echo those of traditional painted still lifes.

After leading the viewer into the comfortable assumptions of a still life composition, with all of the conventions in place, Ray instantly undermines the visual and verbal premises on which these assumptions were based. Because these objects are not "still." Equipped with an invisible motor, each object rotates slowly, almost imperceptibly, some clockwise, others counterclockwise. So the question to be asked is, Is this *still* a *still* life?

Ray's conventional arrangement of objects on a table perverts and subverts the time-honored system of the still life from within. His deadpan literalness combined with his insidious plays on preconceived ideas suggest that, consciously or unconsciously, he is a descendant of that other master of the visual conundrum, René Magritte. Yet his visual and linguistic games are played with objects of real scale in actual space, thereby channeling a factitious reality into a fictional system that is doubly uncanny—the model is conceptual whereas the fiction appears real.

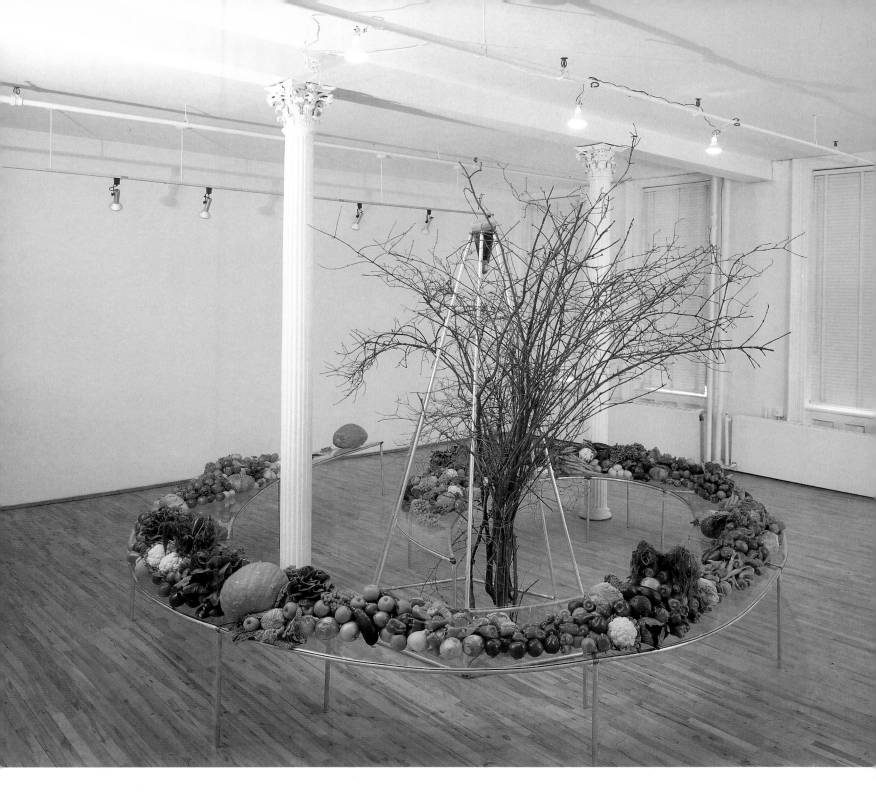

127. Mario Merz
Spiral Table, 1982
Aluminum, glass, fruit,
and vegetables
Up to 18' (548.6 cm) diameter
Courtesy Sperone Westwater,
New York

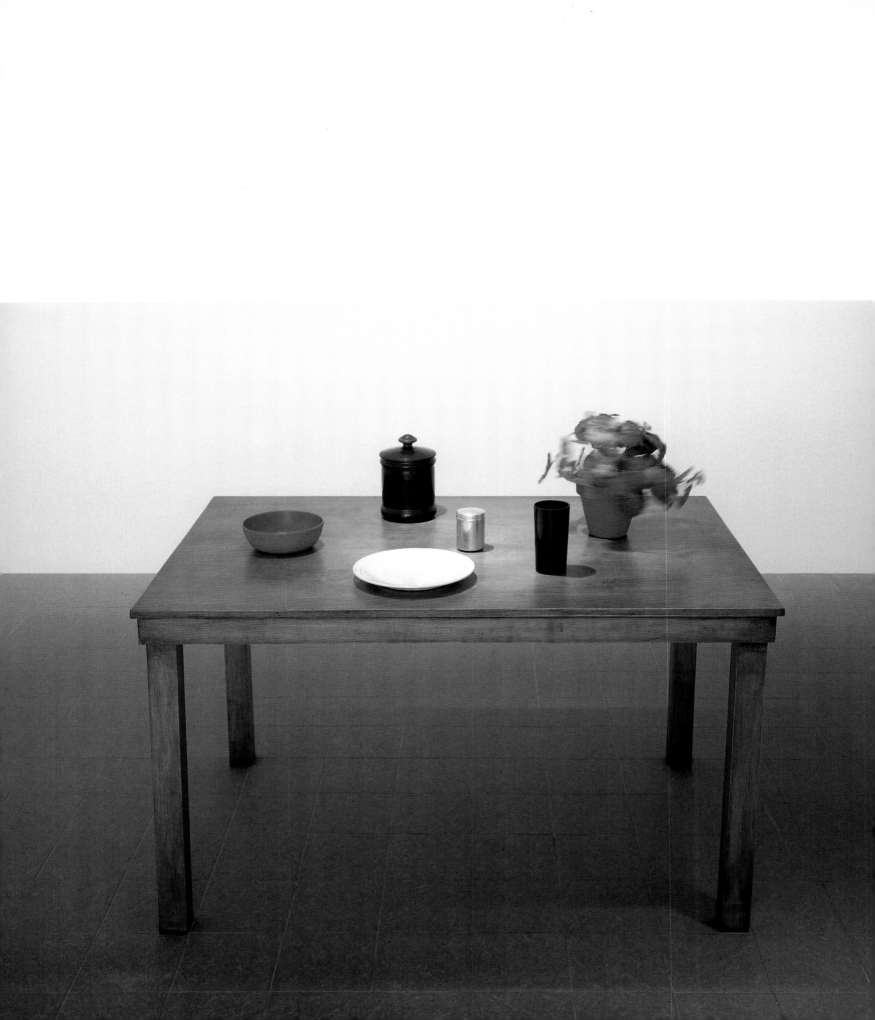

128. Charles Ray
Tabletop, 1989
Wood table with ceramic plate, metal canister,
plastic bowl, plastic tumbler, aluminum shaker,
terra-cotta pot, plant, and motors
43 x 52 ½ x 35"
(109.2 x 133.3 x 88.9 cm)
Lannan Foundation, Los Angeles

129. Robert Therrien
Untitled (Saucer Table), 1990
Wood and mixed mediums
34 x 54 x 35 ½"
(86.4 x 137.2 x 90.2 cm)
Private collection

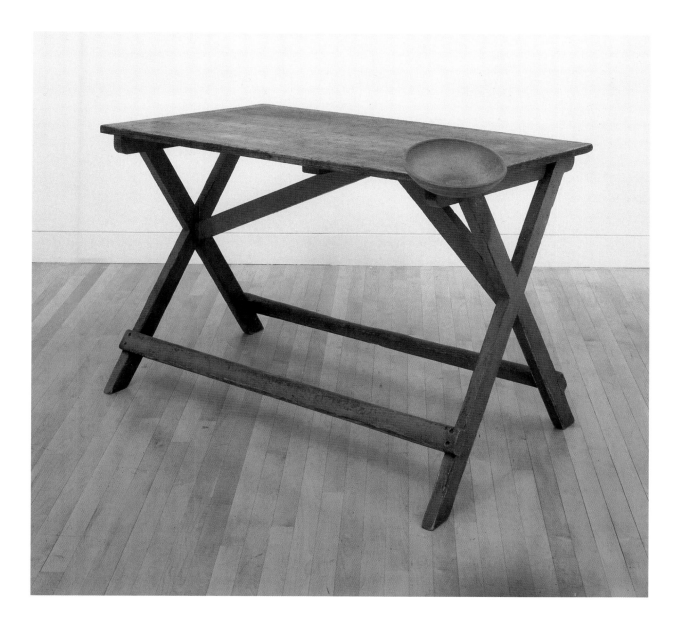

130. Domenico Gnoli
Without a Still Life, 1966
Synthetic polymer paint and sand on canvas
53^{15}/$_{16}$ x 79 ½" (137 x 202 cm)
Staatliche Museen zu Berlin,
Preussischer Kulturbesitz,
Neue Nationalgalerie, Berlin

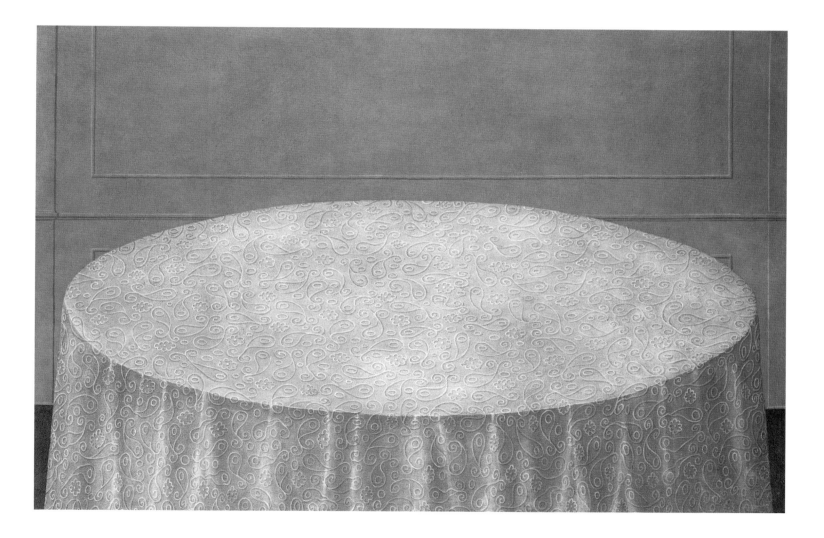

We have chosen to close this exhibition with a "still life" unlike any we have seen before. It may be defined neither as a metaphor nor as a surrogate, and may be associated with none of the perceptual or semantic systems that we have seen unfold throughout the twentieth century. And yet, whereas it appears to stand apart from the still life as described thus far, it nonetheless encompasses as it inverts several of the genre's basic premises.

Wolfgang Laib's pollen pieces, and the *Milkstone* of 1988 presented here, reconfigure a familiar, recognizable (natural) substance (pollen or milk) according to an abstract (manmade) semantic system. Living organic substances, milk and pollen are not inanimate and have no given form, yet in Laib's geometric reconfigurations they are modeled, stilled, and recast in a universal symbolic structure. Stripped of their functions and purified of their usual associations in the mundane world around us, they oblige us to focus on the essence of the substance, distilled and reshaped by a human hand.

As distinct as a *Milkstone* may appear, the creative process it embodies is comparable, although not identical, to that of the still life. These works introduce a distance between the natural world of the senses and ourselves. Yet in translating the physical into the metaphysical, and the impure into its purest manifestation, that of an abstract human vision, they do not lose their original appeal as organic substances. In obliging us to look differently at what we took for granted, they force us to "look at the overlooked," transformed and regenerated into an autonomous symbolic system of transcendent meaning, an object of desire.

131. Wolfgang Laib
Milkstone, 1988
Marble and milk
2 ½ x 23 ½ x 30 ½"
(6 x 60 x 77 cm)
Collection the artist,
courtesy Sperone Westwater,
New York

Arman
(American, born France 1928)

Household Trashcan, 1960 (plate 102)
Poubelle ménagère
Trash in a Plexiglas box
24 x 16 x 4" (60.9 x 40.6 x 10.1 cm)
Collection Armand P. and Corice Arman

The Gorgon's Shield, 1962 (plate 103)
Le Bouclier de la Gorgone
Accumulation of silver-painted dog combs
53 x 37½" (132.5 x 93.7 cm)
Collection Armand P. and Corice Arman

Iwan Babij
(German, born Ukraine, 1896–1974)

Geometric Still Life, c. 1924 (plate 57)
Rechenstilleben
Mixed mediums on wood
14½ x 18½" (36 x 46.5 cm)
Kunsthalle Mannheim

Georg Baselitz
(German, born 1938)

The Motif: Evening Atmosphere, 1988 (plate 119)
Das Motiv: Abendstimmung
Oil on canvas
64⅞ x 52" (162 x 130 cm)
Collection Ann and Steven Ames

Max Beckmann
(German, 1884–1950)

Still Life with Fallen Candles, 1929 (plate 69)
Stilleben mit umgestürzten Kerzen
Oil on canvas
22 x 24¾" (55.9 x 62.9 cm)
The Detroit Institute of Arts
City of Detroit Purchase

Still Life with Three Skulls, 1945 (plate 73)
Totenkopfstilleben
Oil on canvas
21¾ x 35¼" (55.2 x 89.5 cm)
Museum of Fine Arts, Boston
Gift of Mrs. Culver Orswell

Umberto Boccioni
(Italian, 1882–1916)

Development of a Bottle in Space, c. 1912;
cast 1931 (plate 15)
Sviluppo di una bottiglia nello spazio (Natura morta)
Silvered bronze
15 x 23¾ x 12⅞" (38.1 x 60.3 x 32.7 cm)
The Museum of Modern Art, New York
Aristide Maillol Fund

Georges Braque
(French, 1882–1963)

Fruit Dish, 1908–9 (plate 5)
Le Compotier
Oil on canvas
21¼ x 25½" (54 x 65 cm)
Moderna Museet, Stockholm
Gift 1966 from Director Rolf de Maré

Pedestal Table, 1911 (plate 6)
Le Guéridon
Oil on canvas
45⅞ x 32" (116.5 x 81.5 cm)
Musée national d'art moderne,
Centre Georges Pompidou, Paris
Gift of Raoul La Roche

Guitar, c. 1913 (plate 26)
Guitare et bouteille
Gesso, pasted paper, charcoal, pencil,
and gouache on canvas
39¼ x 25¾" (99.7 x 65 cm)
The Museum of Modern Art, New York
Acquired through the Lillie P. Bliss Bequest

Still Life with Tenora, 1913 (plate 28)
La Clarinette
Pasted paper, oil, charcoal, chalk, and
pencil on canvas
37½ x 47⅜" (95.2 x 120.3 cm)
The Museum of Modern Art, New York
Nelson A. Rockefeller Bequest

Marcel Broodthaers
(Belgian, 1924–76)

Casserole and Closed Mussels, 1964 (plate 107)
Casserole et moules fermées
Mussel shells, partly painted with polyester resin,
in painted iron casserole
12 x 11 x 9¾" (30.5 x 27.9 x 24.8 cm)
Tate Gallery, London

Small Cage with Eggs, 1965–66 (plate 108)
Petite cage avec oeufs
Wood, iron, eggshells, and string
9⅜ x 8⅞ x 6½" (24 x 22.7 x 16.5 cm)
Caldic Collection, Rotterdam

Patrick Henry Bruce
(American, 1881–1936)

Painting, c. 1919 (plate 50)
Oil and pencil on canvas
23½ x 28⅜" (59.7 x 72 cm)
Private collection

Carlo Carrà
(Italian, 1881–1966)

Still Life with Triangle, 1917 (plate 47)
Natura morta con la squadra
Oil on canvas
18⅛ x 24" (46 x 61 cm)
Civiche Raccolte d'Arte, Milan

Paul Cézanne
(French, 1839–1906)

Still Life with a Ginger Jar and Eggplants, 1890–94 (plate 1)
Nature morte, pot de gingembre et aubergines
Oil on canvas
29⅞ x 36½" (72.4 x 91.4 cm)
The Metropolitan Museum of Art, New York
Bequest of Stephen C. Clark, 1960

Christo
(Christo Javacheff) (American, born Bulgaria 1935)

Package on a Table 1961, 1961 (plate 104)
Wooden table, linen, canvas, cans, and rope
48¾ x 24¼ x 11¾" (123.8 x 61.6 x 29.8 cm)
Collection Christo and Jeanne-Claude, New York

Package 1962, 1962 (plate 105)
Fabric and rope mounted on board
36⅝ x 26¾ x 12¼" (93 x 68 x 31.3 cm)
Collection Christo and Jeanne-Claude, New York

Le Corbusier
(Charles-Édouard Jeanneret) (French, born Switzerland, 1887–1965)

The Red Bowl, 1919 (plate 51)
Le Bol rouge
Oil on canvas
31⅞ x 25½" (81 x 65 cm)
Fondation Le Corbusier, Paris

Still Life, 1920 (plate 52)
Nature morte à la pile d'assiettes et au livre
Oil on canvas, 31⅞ x 39¼" (80.9 x 99.7 cm)
The Museum of Modern Art, New York
Van Gogh Purchase Fund

Joseph Cornell
(American, 1903–72)

Taglioni's Jewel Casket, 1940 (plate 84)
Construction
4¾ x 11⅞ x 8¼" (12 x 30.2 x 21 cm)
The Museum of Modern Art, New York
Gift of James Thrall Soby

Beehive (Thimble Forest), 1943–48 (plate 85)
Construction
3½" high x 7½" diameter
(8.8 cm high x 19 cm diameter)
Collection Richard L. Feigen

Untitled (*Multiple Cubes*), 1946–48 (plate 86)
Construction
14 x 10 ⅜ x 2 ⁵⁄₁₆" (36.5 x 26.3 x 6 cm)
Collection Mrs. Edwin A. Bergman

Tony Cragg
(British, born 1949)

Eight Painted Objects, 1981 (plate 122)
Stone, can, bottle, cushion, satchel, foam,
wood, and pipe
11' 8" (355.6 cm) long
Collection the artist
Courtesy Galerie Chantal Crousel, Paris

Salvador Dalí
(Spanish, 1904–89)

The Basket of Bread, 1926 (plate 59)
Panera del pa
Oil on panel
12 ½ x 12 ½" (31.3 x 31.3 cm)
Salvador Dali Museum, St. Petersburg, Florida

Lobster Telephone, 1936 (plate 82)
Téléphone-homard
Painted plaster of paris with Bakelite base
7 x 12 x 4 ½" (17.8 x 30.4 x 11.4 cm)
Salvador Dali Museum, St. Petersburg, Florida

*Telephone in a Dish with Three Grilled Sardines at the End of
September*, 1939 (plate 83)
Oil on canvas
18 x 21 ⅝" (45 x 55 cm)
Salvador Dali Museum, St. Petersburg, Florida

Stuart Davis
(American, 1892–1964)

Odol, 1924 (plate 60)
Oil on cardboard
24 x 18" (60.9 x 45.7 cm)
Cincinnati Art Museum
Edwin and Virginia Irwin Memorial

Giorgio de Chirico
(Italian, born Greece, 1888–1978)

The Transformed Dream, 1913 (plate 42)
Il sogno trasformato
Oil on canvas
24 ¾ x 59 ⅞" (63 x 152 cm)
The Saint Louis Art Museum
Gift of Mr. and Mrs. Joseph Pulitzer, Jr.

The Song of Love, c. 1914 (plate 43)
Canto d'amore
Oil on canvas
28 ¾ x 23 ⅜" (73 x 59.1 cm)
The Museum of Modern Art, New York
Nelson A. Rockefeller Bequest

André Derain
(French, 1880–1954)

Pears and Bananas in a Bowl, 1912 (plate 13)
Poires et bananes dans une coupe
Oil on canvas
12 ³⁄₁₆ x 14 ³⁄₁₆" (31 x 36 cm)
Private collection

Jim Dine
(American, born 1935)

Pearls, 1961 (plate 96)
Oil and metallic-painted rubber balls on canvas
70 x 60" (177.7 x 152.3 cm)
Solomon R. Guggenheim Museum, New York

Jean Dubuffet
(French, 1901–85)

Table Covered with Natural History Specimens,
1951 (plate 92)
Table aux pièces d'histoire naturelle
Oil and various pastes on canvas
57 x 45" (144.7 x 114.3 cm)
Private collection

Marcel Duchamp
(American, born France, 1887–1968)

Bicycle Wheel, 1951; third version,
after lost original of 1913 (plate 34)
Assemblage: metal wheel mounted on
painted wood stool
50 ½ x 25 ½ x 16 ⅝" (128.3 x 63.8 x 42 cm) overall
The Museum of Modern Art, New York
The Sidney and Harriet Janis Collection

Chocolate Grinder (No. 1), 1913 (plate 35)
Broyeuse de chocolat (No. 1)
Oil on canvas
24 ⅜ x 25 ⁹⁄₁₆" (62 x 65 cm)
Philadelphia Museum of Art
The Louise and Walter Arensberg Collection

Traveler's Folding Item, 1964; third version,
after lost original of 1916 (plate 36)
Readymade: Underwood typewriter cover
9 ¹⁄₁₆" (23 cm) high
Musée national d'art moderne,
Centre Georges Pompidou, Paris

Why Not Sneeze Rose Sélavy?, 1964;
replica of original of 1921 (plate 37)
Painted metal birdcage containing 151 white marble
blocks, thermometer, and piece of cuttlebone
Cage: 4 ⅞ x 8 ¾ x 6 ⅜" (12.3 x 22.1 x 16 cm)
The Museum of Modern Art, New York
Gift of Galleria Schwartz

Raoul Dufy
(French, 1877–1953)

Still Life with Oranges, 1910 (plate 12)
Oil on canvas
25 ½ x 21 ½" (65 x 54 cm)
Private collection

James Ensor
(Belgian, 1860–1949)

Still Life with Cabbage and Masks, 1928 (plate 68)
Nature morte au chou et masques
Oil on canvas
26 ¼ x 32 ½" (65.5 x 81.5 cm)
Sammlung Basler Kunstverein, Basel

Dan Flavin
(American, 1933–96)

Barbara Roses, 1962–64 (plate 99)
Terra-cotta flower pot, porcelain receptacle with
pull chain, and Aerolux Flowerlite
8 ½" high x 4" diameter
(21.6 cm high x 10 cm diameter)
Courtesy Lance Fung Gallery, New York

Lucio Fontana
(Italian, born Argentina, 1899–1968)

Crab, 1936–38 (plate 89)
Granchio
Polychrome ceramic
9 ¹⁄₁₆ x 15 ¾ x 14 ⁹⁄₁₆" (23 x 40 x 37 cm)
Collection Capuani, Milan

Still Life, 1938 (plate 90)
Natura morta
Polychrome ceramic
7 ¼ x 14 ¹⁵⁄₁₆ x 14 ⁹⁄₁₆" (18.5 x 38 x 37 cm)
Archivio Fontana, Milan

Domenico Gnoli
(Italian, 1933–70)

Without a Still Life, 1966 (plate 130)
Senza natura morta
Synthetic polymer paint and sand on canvas
53 ¹⁵⁄₁₆ x 79 ½" (137 x 202 cm)
Staatliche Museen zu Berlin, Preussischer
Kulturbesitz, Neue Nationalgalerie, Berlin

Robert Gober
(American, born 1954)

Untitled, 1994–95 (plate 126)
Wood, bronze, paint, and handmade paper
24 x 71 x 73 ½" (61 x 180.3 x 186.7 cm)
The Art Institute of Chicago
Watson F. Blair Prize Fund

Juan Gris
(Spanish, 1887–1927)

Still Life with Oil Lamp, 1912 (plate 14)
Nature morte avec lampe à pétrole
Oil on canvas
18 ⅞ x 13" (48 x 33 cm)
Kröller-Müller Museum, Otterlo

Glass and Bottle, c. 1913 (plate 22)
Ink, gouache, watercolor, charcoal, and
pencil on gray paper
18 ¼ x 12 ¼" (46.3 x 31.1 cm)
The Museum of Modern Art, New York
Celeste and Armand P. Bartos (fractional gift)

Flowers, 1914 (plate 32)
Les Fleurs
Cut and pasted papers, oil, and crayon on canvas
21 ⅝ x 18 ½" (53.7 x 46.2 cm)
Private collection

The Newspaper, 1914 (plate 31)
Le Journal
Oil, pasted paper, and pencil on canvas
21 ⅝ x 18 ⅛" (55 x 46 cm)
Private collection

Philip Guston
(American, born Canada, 1913–80)

Highball, 1979 (plate 118)
Oil on canvas
36 x 32" (90 x 80 cm)
The Estate of Philip Guston
Courtesy McKee Gallery, New York

Richard Hamilton
(British, born 1922)

Toaster, 1969;
reconstruction of original of 1966–67 (plate 115)
Chromed steel and Perspex on color photograph
31 ⅞ x 31 ⅞" (81 x 81 cm)
Collection Richard Hamilton

Hannah Höch
(German, 1889–1978)

Glasses, 1927 (plate 58)
Gläser
Oil on canvas
31 x 31" (77.5 x 77.5 cm)
Neue Galerie, Staatliche Museen Kassel

Alexei von Jawlensky
(Russian, 1864–1941)

Still Life with Colored Tablecloth, 1910 (plate 8)
Stilleben mit bunter Decke
Oil on cardboard laid down on wood
34 ⅜ x 28 ⅛" (87.5 x 72 cm)
Private collection

Jasper Johns
(American, born 1930)

Flag, 1958 (plate 93)
Encaustic on canvas
41 ¼ x 60 ¾" (103.1 x 151.8 cm)
Collection Jean-Christophe Castelli

Painted Bronze (ale cans), 1960;
edition two of two, cast and painted 1964 (plate 94)
Painted bronze
5 ½ x 8 x 4 ½" (13.7 x 20 x 11.2 cm)
Collection the artist

Untitled (lightbulb), 1960–61 (plate 97)
Plaster and wire
3 ¼ x 11 ½ x 6 ¼" (8.1 x 28.2 x 15.7 cm)
Collection the artist

Iron, 1962 (plate 95)
Encaustic on wood
9 ¾ x 7 ⅛" (24.3 x 18 cm)
Collection the artist

Frida Kahlo
(Mexican, 1910–54)

Still Life with Prickly Pears, 1938 (plate 91)
Tunas
Oil on sheet metal
7 ½ x 9 ½" (18.5 x 24 cm)
Private collection

Paul Klee
(German, 1879–1940)

Still Life with Four Apples, c. 1909 (plate 11)
Stilleben mit vier Früchten in schale vor dunkelgrünem Grunde
Oil and wax on paper mounted on cardboard
13 ½ x 11 ⅛" (34.3 x 28.2 cm)
The Museum of Modern Art, New York
Gift of Mr. and Mrs. Peter Rübel

Still Life (Jars, Fruit, Easter Egg, and Curtains), 1927
(plate 76)
Stilleben (Töpfe, Frucht, Osterei, und Gardinen)
Oil on gypsum construction
18 ⅞ x 25 ¼" (47.9 x 64.1 cm)
The Metropolitan Museum of Art, New York
The Berggruen Klee Collection, 1984

Colorful Meal, 1928 (plate 75)
Bunte Mahlzeit
Oil and watercolor on canvas
33 x 26 ⅜" (84 x 67 cm)
Private collection

Jeff Koons
(American, born 1955)

One-Ball Total Equilibrium Tank
(Spaulding Dr. J. 241 Series), 1985 (plate 123)
Glass, steel, sodium chloride reagent,
distilled water, and basketball
64 ¾ x 30 ¾ x 13 ¼" (164.5 x 78.1 x 33.7 cm)
Collection of BZ and Michael Schwartz, New York

Wolfgang Laib
(German, born 1950)

Milkstone, 1988 (plate 131)
Marble and milk
2 ½ x 23 ½ x 30 ½" (6 x 60 x 77 cm)
Collection the artist
Courtesy Sperone Westwater, New York

Mikhail Larionov
(Russian, 1881–1964)

Glass, 1912 (plate 16)
Steklo
Oil on canvas
41 x 38 ¼" (104.1 x 97.1 cm)
The Solomon R. Guggenheim Museum, New York

Henri Laurens
(French, 1885–1954)

Fruit Bowl with Grapes, c. 1918 (plate 30)
Le Compotier de raisins
Painted sheet metal and wood
27 ⅛ x 24 ⅞ x 18 ⅞" (68 x 62 x 47 cm)
Private collection

Fernand Léger
(French, 1881–1955)

Table and Fruit, 1909 (plate 7)
Le Compotier sur la table
Oil on canvas
33 x 39" (82.5 x 97.5 cm)
The Minneapolis Institute of Arts
The William Hood Dunwoody Fund

Composition, 1919 (plate 33)
Composition
Oil on canvas
32 x 25 ½" (81 x 65 cm)
Collection Hester Diamond

Still Life (The Bowl of Pears), 1925 (plate 62)
Nature morte (Le Compotier de poires)
Oil on canvas
36¼ x 25½" (92 x 65 cm)
Staatliche Kunsthalle, Karlsruhe

Still Life with Compass, 1925 (plate 63)
Nature morte au compas
Oil on canvas
25½ x 19⅝" (65 x 50 cm)
Moderna Museet, Stockholm

Composition with Two Typewriters, 1927 (plate 64)
Composition à deux machines à écrire
Oil on canvas
56½ x 41¾" (144 x 106 cm)
Private collection, Switzerland

Roy Lichtenstein
(American, born 1923)

Keds, 1961 (plate 109)
Oil and pencil on canvas
47¾ x 34" (121 x 86.3 cm)
The Robert B. Mayer Family Collection, Chicago

Alberto Magnelli
(Italian, 1888–1971)

Still Life with Apple, 1914 (plate 44)
Nature morte à la pomme
Oil on canvas
27½ x 21⅝" (70 x 55 cm)
Musée national d'art moderne,
Centre Georges Pompidou, Paris
Bequest of the artist

René Magritte
(Belgian, 1898–1967)

Table, Ocean, and Fruit, 1927 (plate 77)
La Table, l'océan et le fruit
Oil on canvas
19¹³⁄₁₆ x 25¾" (50.3 x 65.4 cm)
Private collection
Courtesy Patrick DeRom Gallery, Brussels

The Interpretation of Dreams, 1930 (plate 78)
La Clef des songes
Oil on canvas
31⅞ x 23⅝" (80.7 x 59.8 cm)
Private collection

Portrait, 1935 (plate 79)
Le Portrait
Oil on canvas
28⅞ x 19⅞" (73.3 x 50.2 cm)
The Museum of Modern Art, New York
Gift of Kay Sage Tanguy

The Listening Room, 1952 (plate 88)
La Chambre d'écoute
Oil on canvas
17⅝ x 21⅝" (45 x 55 cm)
The Menil Collection, Houston
Gift of Philippa Friedrich

Personal Values, 1952 (plate 87)
Les Valeurs personnelles
Oil on canvas
32 x 40" (81.2 x 101.6 cm)
Private collection

Man Ray
(American, 1890–1976)

Gift, c. 1958; replica of original of 1921 (plate 39)
Cadeau
Painted flatiron with row of thirteen tacks, heads glued to the iron's bottom
6⅛ x 3⅝ x 4½" (15.3 x 9 x 11.4 cm)
The Museum of Modern Art, New York
James Thrall Soby Fund

Piero Manzoni
(Italian, 1933–63)

Achrome, 1961–62 (plate 106)
Bread covered with kaolin
13⅛ x 16⅞" (33 x 42 cm)
Gian Enzo Sperone Collection, New York

Henri Matisse
(French, 1869–1954)

Still Life with Blue Tablecloth, c. 1908–1909 (plate 9)
Nature morte au camaïeu bleu
Oil on canvas
34⅝ x 46½" (87.8 x 118 cm)
The Hermitage Museum, Saint Petersburg

Spanish Still Life, 1910–11 (plate 10)
Nature morte (Espagne)
Oil on canvas
35 x 45⅝" (89 x 116 cm)
The Hermitage Museum, Saint Petersburg

Purple Cyclamen, 1911–c. 1913 (plate 19)
Cyclamen pourpre
Oil on canvas
28¾ x 23⅝" (73 x 60 cm)
Private collection

The Blue Window, 1913 (plate 20)
La Fenêtre bleue
Oil on canvas
51½ x 35⅝" (130.8 x 90.5 cm)
The Museum of Modern Art, New York
Abby Aldrich Rockefeller Fund

Goldfish and Palette, 1914 (plate 45)
Poissons rouges et palette
Oil on canvas
57¾ x 44¼" (146.5 x 112.4 cm)
The Museum of Modern Art, New York
Gift of Florene M. Schoenborn and
Samuel A. Marx

Gourds, 1915–16 (plate 46)
Les Coloquintes
Oil on canvas
25⅝ x 31⅞" (65.1 x 80.9 cm)
The Museum of Modern Art, New York
Mrs. Simon Guggenheim Fund

Apples, 1916 (plate 21)
Les Pommes
Oil on canvas
46 x 35³⁄₁₆" (116.8 x 89.4 cm)
The Art Institute of Chicago
Gift of Florene May Schoenborn and
Samuel A. Marx

Still Life with Shell, 1940 (plate 71)
Nature morte au coquillage
Paper, string, and mixed mediums on canvas
23⅝ x 36" (60 x 91.4 cm)
Private collection

Allan McCollum
(American, born 1944)

Perfect Vehicles, 1988–89 (plate 124)
Moorglo on concrete
Each 80" high x 36" diameter
(203.2 cm high x 91.4 cm diameter)
Collection the artist

Mario Merz
(Italian, born 1925)

Spiral Table, 1982 (plate 127)
Tavola a spirale
Aluminum, glass, fruit, and vegetables
Up to 18' (548.6 cm) diameter
Courtesy Sperone Westwater, New York

Joan Miró
(Spanish, 1893–1983)

Still Life with Rabbit (The Table), 1920–21 (plate 54)
La Table
Oil on canvas
51⅛ x 43¼" (130 x 110 cm)
Private collection

Still Life I (The Ear of Grain), 1922–23 (plate 55)
Nature morte I (L'Épi de blé)
Oil on canvas
14⅞ x 18⅛" (37.8 x 46 cm)
The Museum of Modern Art, New York
Purchase

Still Life II (The Carbide Lamp), 1922–23 (plate 56)
Nature morte II (La Lampe à carbure)
Oil on canvas
15 x 18" (38.1 x 45.7 cm)
The Museum of Modern Art, New York
Purchase

Poetic Object, 1936 (plate 81)
Objet poétique
Assemblage: stuffed parrot on wooden perch,
stuffed silk stocking with velvet garter and doll's
paper shoe suspended in hollow wood frame,
derby hat, hanging cork ball, celluloid fish,
and engraved map
31⅞ x 11⅞ x 10¼" (81 x 30.1 x 26 cm)
The Museum of Modern Art, New York
Gift of Mr. and Mrs. Pierre Matisse

Still Life with Old Shoe, 1937 (plate 70)
Nature morte au vieux soulier
Oil on canvas
32 x 46" (81.3 x 116.8 cm)
The Museum of Modern Art, New York
Gift of James Thrall Soby

Piet Mondrian
(Dutch, 1872–1944)

Still Life with Ginger Pot II, 1912 (plate 17)
Stilleven met gemberpot
Oil on canvas
36 x 47¼" (91.5 x 120 cm)
Haags Gemeentemuseum, The Hague
On loan to The Solomon R. Guggenheim Museum,
New York

Giorgio Morandi
(Italian, 1890–1964)

Still Life, 1919 (plate 48)
Natura morta
Oil on canvas
23⅝ x 23¼" (60 x 59 cm)
Pinacoteca di Brera, Milan
Gift of Emilio and Maria Jesi

Robert Morris
(American, born 1931)

Metered Bulb, 1962 (plate 98)
Electric meter and lightbulb
17¾ x 8 x 8¼" (45 x 20.3 x 20.9 cm)
Collection Jasper Johns

Gerald Murphy
(American, 1888–1964)

Razor, 1924 (plate 61)
Oil on canvas
32⅝ x 36½" (82.8 x 92.7 cm)
Dallas Museum of Art
Foundation for the Arts Collection, gift of the artist

Claes Oldenburg
(American, born Sweden 1929)

Pastry Case, I, 1961–62 (plate 113)
Enamel paint on nine plaster sculptures
in glass showcase
20¾ x 30⅛ x 14¾" (52.7 x 76.5 x 37.3 cm)
The Museum of Modern Art, New York
The Sidney and Harriet Janis Collection

Soft Typewriter, 1963 (plate 114)
Plexiglas, nylon cord, and vinyl filled with kapok
9 x 26 x 27½" (22.9 x 66 x 69.9 cm)
Private collection

Meret Oppenheim
(Swiss, born Germany, 1913–85)

Object, 1936 (plate 80)
Le Déjeuner en fourrure
Fur-covered cup, saucer, and spoon
Cup: 4⅜" (10.9 cm) diameter; saucer:
9⅜" (23.7 cm) diameter; spoon: 8" (20.2 cm)
long; overall height: 2⅞" (7.3 cm)
The Museum of Modern Art, New York
Purchase

Amédée Ozenfant
(French, 1886–1966)

The Vases, 1925 (plate 53)
Les Vases
Oil on canvas
51⅜ x 38⅜" (130.5 x 97.5 cm)
The Museum of Modern Art, New York
Acquired through the Lillie P. Bliss Bequest

Francis Picabia
(French, 1879–1953)

Resonator, c. 1922 (plate 41)
Résonateur
Gouache and ink on composition board
28½ x 21" (72.4 x 53.3 cm)
Grey Art Gallery & Study Center, New York
University Art Collection
Gift of Frank J. Bradley

Pablo Picasso
(Spanish, 1881–1973)

Pitcher, Bowl, and Lemon, 1907 (plate 2)
Cruche, bol et citron
Oil on panel
24⅜ x 18⅞" (62 x 48 cm)
Private collection, courtesy Galerie Beyeler, Basel

Still Life with Death's Head, 1908 (plate 3)
Composition à la tête de mort
Oil on canvas
45¼ x 34⅝" (115 x 88 cm)
The Hermitage Museum, Saint Petersburg

Fruit Dish, 1908–9 (plate 4)
Le Compotier
Oil on canvas
29¼ x 24" (74.3 x 61 cm)
The Museum of Modern Art, New York
Acquired through the Lillie P. Bliss Bequest

Siphon, Glass, Newspaper, and Violin, 1912 (plate 23)
Siphon, verre, journal, violon
Pasted paper and charcoal
18½ x 24⅝" (47 x 62.5 cm)
Moderna Museet, Stockholm

Guitar, 1912–13 (plate 24)
Guitare
Sheet metal and wire
30½ x 13⅛ x 7⅝" (77.5 x 35 x 19.3 cm)
The Museum of Modern Art, New York
Gift of the artist

Guitar, 1913 (plate 25)
Guitare
Oil on canvas mounted on panel
34¼ x 18¾" (87 x 47.5 cm)
Musée Picasso, Paris

Glass of Absinthe, 1914 (plate 29)
Verre d'absinthe
Painted bronze with found absinthe spoon
9½" (23.7 cm) high
Private collection

Still Life, 1914 (plate 27)
Nature morte
Construction of painted wood with
upholstery fringe
10 x 18 x 3⅝" (25.4 x 45.7 x 9.2 cm)
Tate Gallery, London

Still Life with Pitcher and Apples, 1919 (plate 49)
Nature morte au pichet et aux pommes
Oil on canvas
25½ x 17⅛" (65 x 43.5 cm)
Musée Picasso, Paris

Studio with Plaster Head, 1925 (plate 65)
Atelier avec tête et bras de plâtre
Oil on canvas
38⅝ x 51⅝" (97.9 x 131.1 cm)
The Museum of Modern Art, New York
Purchase

Still Life with Skull, Leeks, and Pitcher, 1945 (plate 74)
Crâne, poireaux, pichet
Oil on canvas
28¾ x 45⅝" (73 x 116 cm)
Fine Arts Museums of San Francisco
Museum Purchase, Whitney Warren, Jr.
Fund, in memory of Mrs. Adolph B. Spreckels,
Grover A. Magnin Bequest Fund, Roscoe and
Margaret Oakes Income Fund, and Bequest of
Mr. and Mrs. Frederick J. Hellman by exchange

Still Life with Three Apples and a Glass, 1945 (plate 72)
Nature morte aux trois pommes et verre
Charcoal, colored and printed cut and
torn papers
13 x 17" (33 x 43.2 cm)
Museum Ludwig, Cologne, Ludwig Collection

Goat Skull and Bottle, 1951; cast 1954 (plate 66)
Crâne de chèvre, bouteille et bougie
Painted bronze (after assemblage of bicycle
handlebars, nails, metal, and ceramic elements)
31 x 37⅝ x 21½" (78.8 x 95.3 x 54.5 cm)
The Museum of Modern Art, New York
Mrs. Simon Guggenheim Fund

Iwan Puni
(Jean Pougny) (Russian, born Finland, 1892–1956)

Still Life—Relief with Hammer, c. 1920;
reconstruction of original of 1914 (plate 38)
Nature morte—Relief au marteau
Gouache on cardboard with hammer
31⅝ x 25¾ x 3½" (80.5 x 65.5 x 9 cm)
Collection Herman Berninger, Zurich

Robert Rauschenberg
(American, born 1925)

Canyon, 1959 (plate 100)
Combine painting: oil, graphite, and collage on
canvas with objects
81¾ x 70 x 24" (204.3 x 175 x 60 cm)
Sonnabend Collection

Charles Ray
(American, born 1953)

Tabletop, 1989 (plate 128)
Wood table with ceramic plate, metal canister,
plastic bowl, plastic tumbler, aluminum shaker,
terra-cotta pot, plant, and motors
43 x 52½ x 35" (109.2 x 133.3 x 88.9 cm)
Collection Lannan Foundation, Los Angeles

Odilon Redon
(French, 1840–1916)

Yellow Flowers, c. 1912 (plate 18)
Fleurs jaunes
Pastel on paper
25½ x 19½" (64.6 x 49.4 cm)
The Museum of Modern Art, New York
Acquired through the Mary Flexner Bequest

Gerhard Richter
(German, born 1932)

Skull with Candle, 1983 (plate 117)
Schädel mit Kerze
Oil on canvas
39⅜ x 59¹/₁₆" (100 x 150 cm)
Private collection, Berlin

Ed Ruscha
(American, born 1937)

Actual Size, 1962 (plate 110)
Oil on canvas
72 x 67" (182.9 x 170.2 cm)
Los Angeles County Museum of Art
Anonymous Gift through Contemporary
Arts Council

Morton Schamberg
(American, 1881–1918)

Painting VIII (Mechanical Abstraction), 1916 (plate 40)
Oil on canvas
30 x 20¼" (76.2 x 51.4 cm)
Philadelphia Museum of Art
The Louise and Walter Arensberg Collection

Cindy Sherman
(American, born 1954)
Untitled #172, 1987 (number 5/6) (plate 120)
Chromogenic color print
73⅜ x 49¹/₁₆" (186.4 x 124.6 cm)
Museum of Contemporary Art, Chicago
Gift of Susan and Lewis Manilow in honor of
Gerald S. Elliott

Kiki Smith
(American, born Germany 1954)

Second Choice, 1988 (plate 121)
Ceramic
6 x 2½ x 11" (15.2 x 6.3 x 27.9 cm)
Private collection

Chaim Soutine
(French, born Lithuania, 1893–1943)

The Carcass of Beef, c. 1924 (plate 67)
Le Boeuf écorché
Oil on canvas
46½ x 32½" (118.1 x 82.5 cm)
The Minneapolis Institute of Arts
Gift of Mr. and Mrs. Donald Winston and an
anonymous donor

Daniel Spoerri
(Swiss, born Romania 1930)

Kichka's Breakfast, I, 1960 (plate 101)
Assemblage: wood chair hung on wall with board
across seat, coffee pot, tumbler, china, eggcups,
eggshells, cigarette butts, spoons, tin cans, etc.
14⅜ x 27⅜ x 25¾" (36.6 x 69.5 x 65.4 cm)
The Museum of Modern Art, New York
Philip Johnson Fund

Robert Therrien
(American, born 1948)

Untitled (Saucer Table), 1990 (plate 129)
Wood and mixed mediums
34 x 54 x 35½" (86.4 x 137.2 x 90.2 cm)
Private collection

Untitled (Stacked Plates), 1994 (plate 125)
Ceramic epoxy on fiberglass
97½ x 61 x 61" (243.9 x 152.4 x 152.4 cm)
Museum van Hedendaagse Kunst, Gent

Andy Warhol
(American, 1928–87)

100 Cans, 1962 (plate 111)
Oil on canvas
72 x 52" (182.9 x 132.1 cm)
Albright-Knox Art Gallery, Buffalo
Gift of Seymour H. Knox

Brillo Box, 1964 (plate 112)
Synthetic polymer paint and silk screen on wood
13 x 16 x 11½" (33 x 40.6 x 29.2 cm)
The Andy Warhol Museum, Pittsburgh
Founding Collection, Contribution The Andy
Warhol Foundation for the Visual Arts, Inc.

Brillo Boxes, 1964 (plate 112)
Synthetic polymer paint and silk screen on wood
Each 17 x 17 x 14" (43.2 x 43.2 x 35.6 cm)
The Andy Warhol Museum, Pittsburgh
Founding Collection, Contribution The Andy
Warhol Foundation for the Visual Arts, Inc.

Brillo Boxes, 1964
Synthetic polymer paint and silk screen on wood
Each 9 x 15 x 11¾" (22.8 x 38.1 x 29.8 cm)
Sonnabend Collection

Skull, 1976 (plate 116)
Synthetic polymer paint and silk screen on canvas
72⅛ x 80½" (180.5 x 201.2 cm)
The Andy Warhol Museum, Pittsburgh
Founding Collection, Contribution Dia Center
for the Arts

SELECTED BIBLIOGRAPHY

The still life in the modern era has only rarely been the subject of major independent studies. This Selected Bibliography includes books, articles, and essays that were useful in different ways to the author (although they bear on the topic to varying degrees), as well as exhibition catalogues addressing both the still life itself and some of the individual artists represented in *Objects of Desire*.

BOOKS

Baudrillard, Jean. *The System of Objects*. Trans. James Benedict. London: Verso, 1996.
——. "The Precession of Simulacra." In *Art After Modernism: Rethinking Representation*, ed. Brian Wallis, pp. 253–82. New York: The New Museum of Contemporary Art, 1984.

Bryson, Norman. *Looking at the Overlooked: Four Essays on Still Life Painting*. London: Reaktion Books, Ltd., 1990.

Comte, Hubert. *Natures mortes de l'antiquité à nos jours: La Vie silencieuse*. Paris: Casterman, 1992.

Foucault, Michel. *This Is Not a Pipe*. Berkeley: University of California Press, 1983.

Fry, Roger. *Cézanne*, 1927. Reprint ed. Chicago: at the University Press, 1989.

Gerdts, William H., and Russell Burke. *American Still Life Painting*. New York: Praeger, 1971.

Krauss, Rosalind E. *Passages in Modern Sculpture*. Cambridge, Mass., and London: The MIT Press, 1977.
——. *Cindy Sherman 1975–1993*. New York: Rizzoli, 1993.

Rilke, Rainer Maria. *Letters on Cézanne*. Trans. Joel Agee. New York: Fromm International Publishing Co., 1985.

Rubin, William S. *Dada, Surrealism, and Their Heritage*. New York: The Museum of Modern Art, 1968.

Sterling, Charles. *Still Life Painting: From Antiquity to the Twentieth Century*, 1959. Rev. ed. New York: Harper & Row, 1981.

Stewart, Susan. *On Longing*. Durham, N.C., and London: Duke University Press, 1993.

ESSAYS AND ARTICLES

Bartsch, Ingo. "*Stilleben und Avantgarde*." In *Stilleben in Europa*, exh. cat., pp. 514–39. Münster: Aschendorff, 1979.

Carlson, Eric Gustav. "Still Life with Statuette by Henri Matisse." In *Yale University Art Gallery Bulletin* 31 no. 2 (Spring 1967): 4–13.

Fourcade, Dominique. "*Rêver à trois aubergines*." In *Critique* 28 no. 324 (1974): 467–89.

Germer, Stefan. "Retrospective Ahead." *Gerhard Richter*, exh. cat. pp. 22–32. London: Tate Gallery, 1991.

Gibson, Eric. "American Still Life." In *New Criterion* 3 no. 2 (October 1984): 70–73.

Jameson, Fredric. "Postmodernism and Consumer Society." In *The Anti-Aesthetic: Essays on Postmodern Culture*, ed. Hal Foster, pp. 111–25. Seattle: Bay Press, 1983.

Lanchner, Carolyn, and William S. Rubin. "Henri Rousseau and Modernism." In *Henri Rousseau*, exh. cat., pp. 35–89. New York: The Museum of Modern Art, 1984.

Lukach, Joan M. "De Chirico and Italian Art Theory, 1915–1920." In *De Chirico*, exh. cat., pp. 35–54. New York: The Museum of Modern Art, 1982.
——. "Giorgio Morandi and Modernism in Italy between the Wars." In *Italian Art in the Twentieth Century*, pp. 155–64. London: Royal Academy of Arts, and Munich: Prestel Verlag, 1989.

Reff, Theodore. "Matisse: Meditations on a Statuette and Goldfish." In *Arts* 51 no. 3 (November 1976): 109–15.

Rosenblum, Robert. "Modernist Still Lifes—American Experiments with Radical European Ideas." In *Architectural Digest* 47 (November 1990): 244–49.

Rowell, Margit. "*Histoire d'un genre: Quelques réflexions sur la nature morte au 20e siècle*." In *ArtPress* 173 (October 1992): 24–28.

Rubin, William S. "De Chirico and Modernism." In *De Chirico*, exh. cat., pp. 55–80. New York: The Museum of Modern Art, 1982.

Schapiro, Meyer. "The Apples of Cézanne: An Essay on the Meaning of Still Life." *Modern Art: 19th and 20th Centuries*, pp. 1–39. New York: Braziller, 1978.

Schmied, Wieland. "Neue Sachlichkeit and German Realism of the Twenties." In *German Realism of the Twenties*, exh. cat., pp. 41–56. Minneapolis: The Minneapolis Institute of Arts, 1980.

Sheeler, Charles. "Still Life." Unpublished, undated MS, Forbes Watson Papers, Archives of American Art, reel D56, frames 1092–94.

Steinberg, Leo. "Jasper Johns: The First Seven Years of His Art," 1962. Revised in *Other Criteria*, pp. 17–54. New York: Oxford University Press, 1972.

EXHIBITION CATALOGUES

1973: *Richard Hamilton*. Solomon R. Guggenheim Museum, New York (September 14–November 4). Texts by Richard Hamilton.

1978: *Der Stille Dialog: Das Stilleben im 20. Jahrhundert*. Galerie Beyeler, Basel (October–February 1979). Text by Reinhold Hohl. Also published by Galerie Beyeler in English, as *The Silent Dialogue: The Still Life in the Twentieth Century*.

1979: *Stilleben in Europa*. Westfälisches Landesmuseum für Kunst und Kulturgeschichte, Münster (November 25, 1979–February 2, 1980); Staatlichen Kunstalle Baden-Baden (March 15–June 15, 1980). Texts by Ingo Bartsch, Joseph Lammers, et al.

1980: *German Realism of the Twenties*. The Minneapolis Institute of Arts, Minneapolis (September 18–November 9); The Museum of Contemporary Art, Chicago (November 22, 1980–January 17, 1981). Texts by Istvan Deak, Peter Selz, Wieland Schmied, and Emilio Bertonati.

1980: *Stilleben im Wallraf Richartz-Museum und im Museum Ludwig*. Museen der Stadt Köln (n.d.). Edited by Roswitha Neu-Kock.

1982: *De Chirico*. The Museum of Modern Art, New York (March 30–June 29); Haus der Kunst, Munich (November 17–January 30, 1983); Musée national d'art moderne, Centre Georges Pompidou, Paris (February 24–April 23, 1983). Texts by Maurizio Fagiolo dell'Arco, Joan M. Lukach, William S. Rubin, Marianne W. Martin, Wieland Schmied, and Laura Rosenstock.

1983: *American Still Life, 1945–1983*. Contemporary Arts Museum, Houston (September 20–November 20). Text by Linda Cathcart.

1984: *Henri Rousseau*. Galeries nationales du Grand Palais, Paris (September 14–January 7, 1985); The Museum of Modern Art, New York (February 21–June 4, 1985). Texts by Roger Shattuck, Henri Béhar, Michel Hoog, Carolyn Lanchner, and William S. Rubin.

1989: *Italian Art in the Twentieth Century: Painting and Sculpture 1900–1988*. Royal Academy of Arts, London (January 14–April 9). Texts by Joan M. Lukach, Germano Celant, Norman Rosenthal, et al.

1990: *Alberto Magnelli*. Fundació Joan Miró, Barcelona (June 28–September 16). Texts by Patrice Bachelard, Margit Rowell, and Maria Lluisa Borràs.

1990: *Allan McCollum*. Rooseum, Malmö (September 11–October 21). Texts by Lars Nittve, Lynne Cooke, Anne Rorimer, and Selma Klein Essink.

1991: *Gerhard Richter*. Tate Gallery, London (October 30, 1991–January 12, 1992). Texts by Sean Rainbird, Stefan Germer, and Neal Ascherson.

1992: *Henri Matisse: A Retrospective*. The Museum of Modern Art, New York (September 24, 1992–January 12, 1993). Catalogue with text by John Elderfield.

1992: *Picasso and Things*. Cleveland Museum of Art (February 26–May 3); Philadelphia Museum of Art (June 4–August 30); Galeries nationales du Grand Palais, Paris (September 29–December 28). Texts by Jean Sutherland Boggs, Brigitte Léal, and Marie-Laure Bernadac.

1994: *Charles Ray*. Rooseum, Malmö (March 5–May 8). Text by Bruce W. Ferguson.

1994: *Still Life Painting in the Museum of Fine Arts, Boston*. Museum of Fine Arts, Boston (September 14, 1994–January 1, 1995). Texts by Karen Esielonis, Theodore Stebbins, and Eric Zafran.

1995: *Cézanne*. Galeries nationales du Grand Palais, Paris (September 25, 1995–January 7, 1996); Tate Gallery, London (February 8–April 28, 1996); Philadelphia Museum of Art (May 30–August 18, 1996). Texts by Joseph Rishel et al.

1995: *Stilleben*. Nationalmuseum, Stockholm (February 16–May 1). Texts by Bo Nilsson et al.

1996: *Jasper Johns: The Sculptures*. The Menil Collection, Houston (February 16–March 31); Leeds City Art Gallery (April 18–June 29). Text by Fred Orton.

1997: *Still Life: The Object in American Art, 1915–1955. Selections from the Metropolitan Museum of Art*. Marsh Art Gallery, Richmond, Va. (January 3–February 28); The Arkansas Arts Center, Little Rock, Ark. (March 28–May 23); Newport Harbor Art Museum, Newport Beach, Ca. (June 20–August 15); Philbrook Museum of Art, Tulsa, Okla. (September 12–November 7); The Society of the Four Arts, Palm Beach, Fla. (January 9–February 8, 1998); Salina Art Center, Salina, Kans. (March 6–May 3, 1998). Texts by Lowery Stokes Sims and Sabine Rewald.

ACKNOWLEDGMENTS

Objects of Desire: The Modern Still Life, due to the ambition of its theme and the diversity of its contents, has solicited the collaboration of a vast number of individuals and institutions to whom I wish to extend my deepest thanks. In the first instance I would like to thank the lenders, without whose exceptional generosity the exhibition would not exist in its present state. They have agreed to part with historically significant works of art that must also be institutionally consequential or personally meaningful, and for this we are extremely grateful. Many of them are listed separately on p. 230; for those who have wished to remain anonymous, our thanks are equally heartfelt and sincere. I also want to thank all the living artists whose work appears in this exhibition.

Special thanks are due to the directors, curators, and administrators of the museums and institutions that lent so generously, including: at the Basler Kunstverein, Kunsthalle Basel, Peter Pakesch; at the Neue Nationalgalerie, Staatliche Museen, Berlin, Angela Schneider; at the Museum of Fine Arts, Boston, Malcolm Rogers and George Shackelford; at the Albright-Knox Art Gallery, Buffalo, Douglas G. Schultz; at the Museum of Contemporary Art, Chicago, Kevin Consey and Lucinda Barnes; at the Cincinnati Art Museum, Barbara K. Gibbs and Jean Feinberg; at The Art Institute of Chicago, James Wood, Jeremy Strick, and Madeleine Grynsztejn; at the Museum Ludwig, Cologne, Marc Scheps, Evelyn Weiss, and Alfred Fischer; at the Dallas Museum of Art, Jay Gates and Dorothy Kosinski; at the Detroit Institute of Arts, Samuel Sachs II and Mary Ann Wilkinson; at the Museum van Hedendaagse Kunst, Gent, Jan Hoet and Rom Bohez; at The Menil Collection, Houston, Paul Winkler and Walter Hopps; at the Staatliche Kunsthalle, Karlsruhe, Klaus Schrenk; at the Staatliche Museen Kassel, Neue Galerie, Marianne Heinz; at the Tate Gallery, London, Nicholas Serota; at the Los Angeles County Museum of Art, Graham Beal and Stephanie Barron; at the Kunsthalle Mannheim, Manfred Fath; at the Archivio Fontana, Milan, Valeria Ernesti; at the Pinacoteca di Brera, Milan, Luisa Arrigoni; at the Civiche Raccolte d'Arte, Maria Teresa Fiorio; at The Minneapolis Institute of Arts, Evan Maurer and Charles Stuckey; at The Grey Art Gallery and Study Center, New York University, Frank Poueymirou and Lynn Gumpert; at the Solomon R. Guggenheim Museum, New York, Thomas Krens and Lisa Dennison; at The Metropolitan Museum of Art, New York, Philippe de Montebello, William S. Lieberman, and Gary Tinterow; at the Rijksmuseum Kröller-Müller, Otterlo, E. J. van Straaten; at the Fondation Le Corbusier, Paris, Evelyne Tréhin; at the Musée national d'art moderne, Centre Georges Pompidou, Paris, Germain Viatte and Isabelle Monod-Fontaine; at the Musée Picasso, Paris, Gérard Régnier and Hélène Seckel; at the Philadelphia Museum of Art, Anne d'Harnoncourt and Ann Temkin; at The Andy Warhol Museum, Pittsburgh, Tom Sokolowski and Mark Francis; at the Saint Louis Art Museum, James Burke and Sidney Goldstein; at the Fine Arts Museums of San Francisco, Steven Nash; at the Moderna Museet, Stockholm, Olle Granath and David Elliot; at the Salvador Dali Museum, Saint Petersburg, Florida, Marshall Rousseau and Joan Krops; and at the Hermitage Museum, Saint Petersburg, Russia, Mikhail Piotrovsky and Albert Kostenevich.

Other individuals were instrumental in researching, locating, and securing obscure or delicate loans. In this respect I would like to thank the following individuals in particular: William Acquavella, New York; Ernst Beyeler, Basel; Irène Bizot, Paris; Frances Beatty, New York; Jon Bourassa, New York; Emily Braun, New York; Marianne Brouwer, Otterlo; Paula Cooper, New York; Maria de Corral, Madrid; Dudley Del Balso, New York; Patrick DeRom, Brussels; Patricia Edgar, Cologne; Marcel Fleiss, Paris; Richard Francis, Chicago; Marian Goodman, New York; Brett Gorvy, London; Antonio Homem, New York; Diane Kelder, New York; Elizabeth Kujawski, New York; Carolyn Lanchner, New York; Quentin Laurens, Paris; Jeremy Lewison, London; Matteo Lorenzelli, Milan; Rainer M. Mason, Geneva; Lucia Matino, Milan; Tobias Meyer, London; Lucy Mitchell-Inness, New York; Jacqueline Munck, Paris; David Nash, New York; Claudia Neugebauer, Basel; Suzanne Pagé, Paris; Nan Rosenthal, New York; William Rubin, New York; Jole de Sanna, Milan; James Snyder, New York and Jerusalem; Sarah Taggart, Sharon, Conn.; Adam A. Weinberg, New York; Angela Westwater, New York; Sarah Whitfield, London; and Juliane Willi-Cosandier, Lausanne.

It goes without saying that an exhibition of this complexity has made inordinate demands on the Museum's staff, including many individuals beyond those directly involved. In this context I would especially like to thank Kirk Varnedoe for permitting me to deplete his Painting and Sculpture galleries, thereby allowing me to include many masterpieces from within the Museum's own walls. For his generosity and its implications—the rethinking and rehanging of whole portions of the permanent collection—I am infinitely grateful. I owe further thanks to the Museum's conservators, and in particular to James Coddington, Anny Aviram, Lynda Zycherman, Patricia Houlihan, and Karl Buchberg for preparing many of the works for exhibition.

The production of the exhibition was initiated by Richard L. Palmer, who is no longer at the Museum but who guided us in the project's preliminary stages. Jennifer Russell and Linda Thomas have seen the project through (including arrangements for its appearance at the Hayward Gallery, London) with ability and commitment, assisted untiringly by Eleni Cocordas and Maria DeMarco. Jay Levinson and Elizabeth Streibert of the International Program participated in the arrangements for the London venue. Elizabeth Addison, John Wolfe, and Alexandra Partow have shown great sensitivity in promoting and communicating the public image of the exhibition, just as Michael Margitich and Monika Dillon have exerted unstinting efforts to secure funding. Beverly M. Wolff and Stephen W. Clark have overseen the legal and contractual aspects of the exhibition and catalogue. Meryl Cohen has exercised her customary intelligence and efficiency in accomplishing the sometimes daunting tasks of the Registrar.

The clearly articulated installation was insightfully imagined and realized by Jerold Neuner. Pete Omlor and his crew prepared and mounted the exhibition with dedication and care. John Calvelli designed the handsome graphic elements that highlight the overall presentation. Patterson Sims and Hadley Palmer, of the Education and Research Department, contributed significantly to the exhibition's outreach and impact by preparing educational activities and materials.

The exhibition's accompanying publication has required as much energy and investment as the show itself. I would like to begin by expressing my intellectual debt to two authors who were particularly inspiring to me in the writing of the essay, Norman Bryson and Susan Stewart. I read Bryson's book *Looking at the Overlooked: Four Essays on Still Life Painting* many years ago; although it does not deal with the still life in the twentieth century, it reinforced my belief in the necessity and importance of tracing the modern and contemporary developments of the genre. Stewart's *On Longing*, a more recent discovery, helped me to formulate and expand the concept of an "object of desire." In this context I would finally like to thank John Elderfield, Chief Curator at Large, for reading my essay and providing useful comments leading to its improvement.

The production of the book—conceived around a broad diversity of objects of far-flung provenance yet at the same time demanding a rigorous thematic structure—was particularly problematic. I would like to express my thanks to all who collaborated on this publication for their exceptional patience, understanding, and flexibility, each in his or her area of specialization: Osa Brown, then the Director of Publications; Harriet S. Bee, Managing Editor; Jody Hanson, Director of Graphics; Nancy T. Kranz, Manager, Promotion and Special Services; Marc Sapir, Assistant Production Manager; Mikki Carpenter, Director of Photographic Services and Permissions; and last but not least, David Frankel, my editor, whose sensitive and knowledgeable collaboration made this a better book in many ways. The publication's ingenious design, conceived by J. Abbott Miller and implemented with the assistance of Paul Carlos of Design/Writing/Research, successfully reflects the unusual approach to the still life genre that is germane to the exhibition. I am further grateful to the Blanchette Hooker Rockefeller Fund for a major subsidy for the book.

The Museum owes special thanks to our colleagues at the Hayward Gallery, in particular to Susan F. Brades, Director, and Martin Caiger-Smith, Head of Exhibitions, for their overwhelmingly enthusiastic response to the project. Especially given the complexities of the venture, their commitment and professionalism have made it a rare pleasure to work with them and their staff.

Penultimately, it is safe to say that the exhibition would not be what it is in either its New York or London showing without the unflagging energy, initiative, and intelligence of Christina Houstian, who oversaw with maturity and authority many aspects of the project and its accompanying publication. This exhibition is as much hers as mine, and I am unable to express adequately my thanks for her selfless and responsible dedication. We were further aided in many day-by-day tasks by Michele Wyckoff, Kathleen Curry, and Miki Yoda in the Department of Drawings.

Finally, my special thanks go to Glenn Lowry, this Museum's Director, for being present on all occasions to see the project through. His vision and support in all areas of this endeavor have been inestimable.

Margit Rowell

LENDERS TO THE EXHIBITION

Basler Kunstverein, Kunsthalle Basel
Staatliche Museen zu Berlin, Preussischer
 Kulturbesitz, Neue Nationalgalerie, Berlin
Museum of Fine Arts, Boston
Albright-Knox Art Gallery, Buffalo
Cincinnati Art Museum
The Art Institute of Chicago
Museum of Contemporary Art, Chicago
Museum Ludwig, Cologne
Dallas Museum of Art
Detroit Institute of Arts
Museum van Hedendaagse Kunst, Gent
Haags Gemeentemuseum, The Hague
The Menil Collection, Houston
Staatliche Kunsthalle, Karlsruhe
Neue Galerie, Staatliche Museen Kassel
Tate Gallery, London
Los Angeles County Museum of Art
Kunsthalle Mannheim
Archivio Fontana, Milan
Pinacoteca di Brera, Milan
Civiche Raccolte d'Arte, Milan
The Minneapolis Institute of Arts
Grey Art Gallery & Study Center,
 New York University
Solomon R. Guggenheim Museum, New York
The Metropolitan Museum of Art, New York
Kröller-Müller Museum, Otterlo
Fondation Le Corbusier, Paris
Musée national d'art moderne,
 Centre Georges Pompidou, Paris
Musée Picasso, Paris
Philadelphia Museum of Art
The Andy Warhol Museum, Pittsburgh
The Saint Louis Art Museum
The Fine Arts Museums of San Francisco
Moderna Museet, Stockholm
Salvador Dali Museum,
 Saint Petersburg, Florida
The Hermitage Museum,
 Saint Petersburg, Russia

Ann and Steven Ames
Armand P. and Corice Arman
Celeste and Armand Bartos
Mrs. Edwin A. Bergman
Herman Berninger
Caldic Collection
Marco Capuani
Jean-Christophe Castelli
Christo and Jeanne-Claude
Tony Cragg
Hester Diamond
Richard L. Feigen
The Estate of Philip Guston
Richard Hamilton
Jasper Johns
Wolfgang Laib
The Lannan Foundation
The Robert B. Mayer Family Collection
Allan McCollum
Michael and BZ Schwartz
Gian Enzo Sperone
Sonnabend Collection

Anonymous lenders

Lance Fung Gallery, New York
Galerie Chantal Crousel, Paris
McKee Gallery, New York
Sperone Westwater, New York

Jorg P. Anders, Berlin: plate 130. © Arman: plates 102, 103. © 1997 Artists Rights Society (ARS), New York/ADAGP, Paris: plates 5–7, 12–14, 16, 22, 26, 28, 30–32, 38, 41, 44, 54–56, 62–64, 67, 70, 81, 92, 98. © 1997 Artists Rights Society (ARS), New York/VG Bildkunst, Bonn: plates 11, 58, 69, 73, 75, 76. Courtesy Dudley Del Balso, New York: plate 129. Basler Kunstverein, Basel: plate 68. © Georg Baselitz: plate 119. Museum of Fine Arts, Boston: plate 73. © Marcel Broodthaers: plates 107, 108. Albright-Knox Art Gallery, Buffalo: plate 111. © Estate of Carlo Carrà/Licensed by VAGA, New York, NY: plate 47. Luca Carrà Studio, Milan: plates 47, 48. Leo Castelli Photo Archives: plate 93. © The Art Institute of Chicago: plates 21, 126. Museum of Contemporary Art, Chicago: plate 120. © Christo: plates 104, 105. © Cincinatti Art Museum: plate 60. Museum Ludwig, Cologne: plate 72. © Fondation Le Corbusier, Paris: plates 51, 52. © Tony Cragg: plate 122. Courtesy Galerie Chantal Crousel, Paris: plate 122. Dallas Museum of Art: plate 61. © Estate of Stuart Davis/Licensed by VAGA, New York, N.Y.: plate 60. © Foundation Giorgio de Chirico/Licensed by VAGA, New York, N.Y.: plates 42, 43. D. James Dee, New York: plate 99. Detroit Institute of Arts: plate 69. © Jim Dine: plate 96. © 1997 Artists Rights Society (ARS), New York/ADAGP, Paris/Estate of Marcel Duchamp: plates 34–37. Susan Einstein, Los Angeles: plate 128. © Estate of James Ensor/Licensed by VAGA, New York, N.Y.: plate 68. Vincent Everarts, Brussels: plate 77. © 1997 Estate of Dan Flavin/Artists Rights Society (ARS), New York: plate 99. © Fondazione Lucio Fontana, Milan: plate 90. Museum van Hedendaagse Kunst, Gent: plate 129. © Robert Gober: plate 126. © Estate of Philip Guston, courtesy McKee Gallery, New York: plate 118. Haags Gemeentemuseum, The Hague: p. 124. © Richard Hamilton: plate 115. © 1997 C. Herscovici, Brussels/Artists Rights Society (ARS), New York: plates 77–79, 87, 88. © The Menil Collection, Houston; photo by Paul Hester: plate 88. © Javlensky Archive: plate 8. © Jasper Johns/Licensed by VAGA, New York, N.Y.: plates 93–95, 97. Staatliche Museen Kassel: plate 58. Reto Klink Fotograf: plate 12. © Jeff Koons: plate 123. © Wolfgang Laib: plate 131. Endrik Lerch, Ascona: plate 8. © Roy Lichtenstein: plate 109. © Trustees of the Tate Gallery; Tate Gallery

Publishing, London: p. 26; plates 27, 107. Trustees of The National Gallery, London: p. 107. © Museum Associates, Los Angeles County Museum of Art: plate 110. The J. Paul Getty Museum, Malibu: p. 20. Kunsthalle Mannheim: plate 57. © 1997 Artists Rights Society (ARS), New York/ADAGP/Man Ray Trust, Paris: plate 39. © Piero Manzoni/Licensed by VAGA, New York, N.Y.: plate 106. © 1997 Succession H. Matisse, Paris/Artists Rights Society (ARS), New York: plates 9, 10, 19–21, 45, 46, 71. © Allan McCollum: plate 124. © Mario Merz: plate 127. Minneapolis Institute of Arts: plates 7, 67. © Giorgio Morandi/Licensed by VAGA, New York, N.Y.: plate 48. © Estate of Gerald Murphy: plate 61. Rudolf Nagel: plate 38. Grey Art Gallery & Study Center, New York University; photo by Sara Wells: plate 41. © The Metropolitan Museum of Art, New York: p. 106; plates 1, 76. © The Solomon R. Guggenheim Museum, New York; photos by David Heald: plates 16, 17, 96. © Claes Oldenburg and Coosje van Bruggen, New York: plates 113, 114. Rijksmuseum Kröller-Müller, Otterlo: p. 18; plate 14. Musée national d'art moderne, Centre Georges Pompidou, Paris: plates 6, 44. Douglas M. Parker, New York: plate 123. © Philadelphia Museum of Art; photos by Graydon Wood: pp. 72, 74; plates 35, 40, 94. © 1997 Estate of Pablo Picasso/Artists Rights Society (ARS), New York: plates 2–4, 23–25, 27, 29, 49, 65, 66, 72, 74. The Andy Warhol Museum, Pittsburgh; photos by Richard Stoner: plates 112, 116. © Robert Rauschenberg/Licensed by VAGA, New York, N.Y.: plate 100. © Charles Ray: plate 128. © Réunion des musées nationaux, France: pp. 48, 49; plates 25, 49. © Ed Ruscha: plate 110. The Saint Louis Art Museum: plate 42. © The Hermitage Museum, Saint Petersburg, 1996: plates 3, 9, 10. © Salvador Dali Museum, Saint Petersburg, Fla.: plates 59, 82, 83. San Diego Museum of Art: p. 14. Fine Arts Museums of San Francisco: plate 74. © Cindy Sherman: plate 120. © Kiki Smith: plate 121. Courtesy Sonnabend Gallery, New York: plate 100. Courtesy Gian Enzo Sperone, New York: plate 106. Courtesy Sperone Westwater, New York: plates 127, 131. © Daniel Spoerri: plate 101. Statens Konstmuseer, Stockholm: p. 165; photos by Tord Lund: plates 5, 23; photo by Per-Anders Allsten: plate 63. © Robert Therrien: plates 125, 129. Toledo Museum of Art: p. 15. Michael Tropea, Chicago: plate 109. Saverio Truglia, Chicago: plate 86. The Peggy Guggenheim Foundation, Venice: p. 75. Malcolm Varon, New York: plate 92. Wolfgang Volz: plates 104, 105. © 1997 Andy Warhol Foundation for the Visual Arts/ARS, New York: plates 111, 112, 116. Courtesy Galerie Michael Werner, Cologne: plate 119. Dorothy Zeidman, New York: plates 50, 87, 71, 103, 121. Kunsthaus Zurich: p. 27.